Critical Perspectives

Critical Perspectives

::: **WRITINGS ON ART AND CIVIC DIALOGUE**

Editors:

Caron Atlas and Pam Korza

Contributing Editors:

John Fiscella and
Barbara Schaffer Bacon

AMERICANS
for the ARTS

WASHINGTON, DC

Americans for the Arts, Washington, DC 20005
© 2005 Americans for the Arts
All rights reserved. Published 2005
13 12 11 10 09 08 07 06 05 1 2 3 4 5

The photograph on the cover is a detail of the installation
Ties That Bind, by Jennifer Ahn and Lissa Jones. *Ties That Bind*
was an exhibition and dialogue project implemented in 2002
by MACLA (*Movimiento de Arte y Cultura Latino Americana*).

Book design by studio e$_2$.

Library of Congress Cataloging-in-Publication Data
Critical perspectives : writings on art and civic dialogue / editors,
Caron Atlas and Pam Korza ; contributing editors, John Fiscella and
Barbara Schaffer Bacon.
 p. cm.
 Includes bibliographical references.
 ISBN-13: 978-1-879903-32-6 (alk. paper)
 1. Artists and community. 2. Community arts projects. 3.
Communication and the arts. I. Atlas, Caron. II. Korza, Pam. III.
Fiscella, John. IV. Bacon, Barbara Schaffer.

 NX180.A77C75 2005
 709'.051—dc22
 2005015269

ISBN-13: 978-1-879903-32-6
ISBN-10: 1-879903-32-6

Additional copies available at
www.AmericansForTheArts.org/bookstore

Critical Perspectives is a publication of Animating Democracy.

Animating Democracy, supported by the Ford Foundation,
is a program of Americans for the Arts

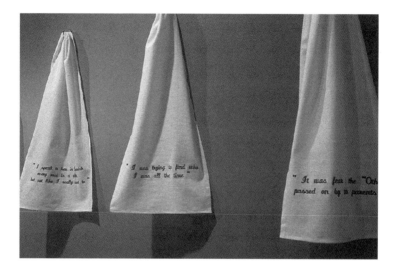

Detail of installation by
Jennifer Ahn and Lissa Jones.
Part of *Ties That Bind*,
an exhibition and dialogue
project implemented in
2002 by MACLA *(Movimiento
de Arte y Cultura Latino
Americana)*, San Jose, CA.
Photo © Bubu Alvarez.

Table of Contents

PREFACE . i

ACKNOWLEDGMENTS . vii

INTRODUCTION, *Caron Atlas* . ix

SHAMING THE DEVIL, *Lucy Lippard* . xvii

THE DENTALIUM PROJECT, **DELL'ARTE**

Project Overview . 1

Notes on *Wild Card,* Jim O'Quinn . 5

"To save paradise they put up a parking lot," *David Rooks* . 15

The Arts and Development: An Essential Tension, *Ferdinand Lewis* 25

A Response to the Essays, *Michael Fields* . 43

THE SLAVE GALLERIES PROJECT, **ST. AUGUSTINE'S EPISCOPAL CHURCH AND**

THE LOWER EAST SIDE TENEMENT MUSEUM

Project Overview . 53

The Colors of Soul, *Lorraine Johnson-Coleman* . 59

St. Augustine's Church *Slave Galleries Project,* Rodger Taylor 69

Freedom's Perch: The Slave Galleries and the Importance of

 Historical Dialogue, *John Kuo Wei Tchen* . 83

Building Upon a Strange and Startling Truth, *Lisa Chice* . 99

TIES THAT BIND, **MACLA (MOVIMIENTO DE ARTE Y CULTURA LATINO AMERICANA)**

Project Overview . 107

Intermarriage and Public Life, *Michael J. Rosenfeld* 109

Ties That Bind / Ties That Bond: A Community-Based Art Project in

 Silicon Valley, *Lydia Matthews* . 121

The Social Life of an Art Installation, *Renato Rosaldo* 135

Dialogic Gestures: Doing Artistic Things with Ethnographic Methods,

 Maribel Alvarez . 141

REFLECTIONS ON *CRITICAL PERSPECTIVES* . 153

CONTRIBUTORS . 165

CRITICAL PERSPECTIVES WRITERS

The Dentalium Project

Jim O'Quinn
editor-in-chief of American Theatre, composer

David Rooks
freelance writer and executive director of Loneman School Foundation

Ferdinand Lewis
urban planning scholar, arts writer, and playwright

Michael Fields
producing artistic director, Dell'Arte

The Slave Galleries Project

Lorraine Johnson-Coleman
storyteller, writer, and heritage preservation consultant

Rodger Taylor
historian, writer, and public librarian

John Kuo Wei Tchen
historian, educator, and cultural activist

Lisa Chice
*history museum programmer and former interpretation associate,
Lower East Side Tenement Museum*

Ties That Bind

Michael J. Rosenfeld
sociologist, educator, and former journalist

Lydia Matthews
educator in visual criticism, curator, and arts activist

Renato Rosaldo
anthropologist, poet, and educator

Maribel Alvarez
anthropologist, folklorist, curator, and former executive director, MACLA

Preface

CRITICAL PERSPECTIVES: WRITINGS ON ART AND CIVIC DIALOGUE is a collection of essays about three projects situated at compelling intersections of art and civic life. Each project participated in Animating Democracy, a program of Americans for the Arts, and supported by the Ford Foundation. In keeping with Animating Democracy's purpose, the projects employed the unique capacities of theater, visual art, or historic preservation to stimulate people to talk together in new ways about issues that matter in their communities.

The prevailing approach to critical writing through a single critic or authority rarely gives adequate focus to the many dimensions of civically engaged art—its reach into social and civic issues, its creative and community engagement practices, and its simultaneous aesthetic and civic goals. The various partners, community participants, and even the artists and cultural organizers who have interests in a project, rarely have the opportunity to offer reflections in a focused and serious way.

Critical Perspectives is an experiment in what artist and writer Suzanne Lacy has termed "multi-voiced" writing. Through the engagement of three writers for each project, and each of whom could offer different perspectives about the project, *Critical Perspectives* has sought to deepen understanding of cultural work that also has civic purpose. The contributing authors approached the project from various artistic, scholarly, and community vantage points. The project leaders, who in the standard critical paradigm would typically be considered subjects or sources for writing, rather than equal and valued writing voices, were each invited to write a piece—either independent of or in response to the writings about their projects.

In recent years, artists, cultural leaders, and scholars who have been long involved in community-based cultural practice have been challenging old paradigms for communicating about and assessing the aesthetics of civically engaged art. They have been calling for a new paradigm that more effectively considers the characteristics and intents of art that intersects with social and civic interests. Linda Frye Burnham of the Community Arts Network has facilitated virtual and live conversations about this need with community-based theater scholar-practitioner Jan Cohen-Cruz, theater scholar and critical writer Sonja Kuftinec, as well as others.[1] Additional explorations have occurred through Alternate ROOTS, a coalition of community-based artists and cultural workers.

In an article for Animating Democracy, Kuftinec captures some of these conversations that explore questions of how to think, talk, and write more responsibly and meaningfully about civically engaged art.[2] What would be valuable and challenging about a closer relationship between artist and critic—a relationship that allows for deeper insights into the artist's process, aesthetic, and civic intents, and that may frame mutual goals for the writing? What is the writer's role in holding artists and cultural organizations accountable, particularly the extent to which the art or project succeed at civic animation and community building, or the extent to which they are sensitive to the representation of traumatic events? What are the writer's responsibilities to "get it right," for example, by informing themselves about an art form's cultural history and formal aspects, being conscious of how language intersects with power, and recognizing biases, assumptions, and conventional frames of reference that influence their assessment of the work?

Artists working in this arena affirm that critical assessment is important—*vital*, in fact—to their aesthetic investigations. They want their work considered on its artistic merit and legitimized within the arts community, not marginalized from it. However, existing aesthetic standards, terminology, and models for critical analysis and writing rarely recognize the unique features of civically engaged art and are often inadequate for communicating the multidimensional nature of the work. While the existing framework has been inadequate, artists argue that it *is* possible to articulate excellence in artistic work and its processes—as well as to describe work that is inauthentic, exploitative, or ineffective—in relation to civic and artistic intents.

The projects supported by Animating Democracy have offered an opportunity, amid these conversations, to experiment with a different approach

to critical and reflective writing. Out of this opportunity, *Critical Perspectives* was conceived.

By design, *Critical Perspectives* provided writers (chosen for the most part by the project coordinators themselves) with the time, access, compensation, and feedback needed to deeply explore and write about the projects. At the beginning of the process, writers in each project met one another and the project director to become grounded in the project and its intents, as well as to talk about how each writer might focus their essay. To varying degrees, the writers connected to a project as it unfolded, attending planning meetings, public dialogues, meetings among project artists, and final events. All writers met at a midpoint in San Francisco to share their experiences.[3] At the end of the process, after reading each other's finished work, writers for each project talked about their essays and the challenges and rewards of the *Critical Perspectives* approach. These connections stimulated rich discussions about the nature of arts- and humanities-based civic dialogue work and the issues in writing about such work.

The goal of this book is to enhance the existing body of writing on socially and civically oriented art and to stimulate more and varied writing by others. It will make a contribution if it helps to satisfy the field's hunger for deep documentation and analysis of this exciting, complex work—and if it opens up new understanding of how the arts and humanities operate in the civic realm. Perhaps the book and the *Critical Perspectives* experiment will stimulate and advance field discourse about new models of critical and reflective writing—reframing the vocabulary, standards, and criteria suitable for creative work invested in process and aspiring to make a difference on both aesthetic and civic terms.

Each of the three parts of the book begins with an overview of a project, then followed by four essays:

The first set of essays explores *The Dentalium Project*. Through dialogues, production of a new play called *Wild Card*, and a video documentary, the Dell'Arte theater company explored the impact and future implications of a Native American casino constructed in its small rural community of Blue Lake, CA.

The next essays focus on the *Slave Galleries Restoration Project*. This project brought together community leaders, scholars, and preservationists to begin a long-term process of restoring and interpreting the 1828 slave galleries in

St. Augustine's Episcopal Church—cramped rooms where African American congregants were segregated during the nineteenth century. The project, a partnership with the Lower East Side Tenement Museum, helped establish the galleries as a setting and context for dialogues about marginalization and other issues on the Lower East Side of Manhattan.

The final set of essays examines MACLA's (Movimiento de Arte y Cultura Latino Americana) *Ties That Bind,* a photographic installation developed through an oral history and public dialogue project. Reflecting upon the history of intermarriage between Asians and Latinos in the Silicon Valley, it illuminated current civic issues of intra- and interethnic relations in California.

Framing the essays, Caron Atlas's Introduction draws from her unique insights as *Critical Perspectives* project co-director. She considers why projects like these three are emblematic of the role the arts can play in contemporary society. Atlas highlights key themes that emerged for the participating writers about civically engaged arts and humanities work and highlights writers' reflections in relation to the book's big questions: What is the promise and peril at the intersection of art and civic dialogue? Who gets to tell the story of these projects, and how is the story told? She reflects upon what is gained by having multiple perspectives in writing. How do multiple perspectives contribute to excavating meaning within the art, expanding perspectives on civic issues within communities, and understanding the nature of arts-based civic dialogue in general?

In "Shaming the Devil," the opening essay to *Critical Perspectives*, Lucy Lippard states, "Writers, like other artists, supposedly aspire to 'tell the truth and shame the devil.' But telling the *whole* truth, and telling it so well that people want to listen to it…that's the challenge." Lippard, writer, activist, and author of 20 books on contemporary art and cultural criticism, illuminates issues that have shaped her own choices: the dilemma of writing about art while remaining accessible to a broad audience; issues of authority in writing, and who has it; multiplicity of viewpoint, and how to negotiate different opinions (including those of funding sources); the possibility of a "critical regionalism"; and the ironies of "reciprocal ethnography." Having been directly involved in this history herself, Lippard makes the important historical link between Animating Democracy and the "movement for cultural democracy" in the '60s and late '70s.

Finally, the book's "Reflections" section shares Animating Democracy's thoughts about *Critical Perspectives* as a writing experiment, and in the process reveals

advantages as well as challenges in the project's concept and design. Drawing on the *Critical Perspectives* experiment, as well as on the broader range of projects involved in Animating Democracy, this closing section offers some elements that might be considered as the field pursues an expanded critical framework for writing about civically engaged art.

Pam Korza,
Co-director, Animating Democracy

[1] "Writing Deeply: A Discussion with Three Writers" http://www.communityarts.net In her book, *Local Acts: Community-based Performance in the United States* (Rutgers University Press, 2005), Jan Cohen-Cruz expands upon her online conversation with Burnham and Kuftinec and offers a substantial chapter reflecting on writing critically about community-based art.

[2] Sonja Kuftinec, "Critical Relations in Community-Based Performance: The Artist and Writer in Conversation," article commissioned by Animating Democracy, (Washington, DC: Americans for the Arts, 2002). http://www.AmericansForTheArts.org/AnimatingDemocracy

[3] A rich accounting of the discussion among writers that took place in San Francisco (November 2002) can be found in Andrea Assaf's "A Threshold Moment: Summary and Reflections from A Gathering of *Critical Perspectives* Writers," http://www.AmericansForTheArts.org/AnimatingDemocracy

Acknowledgments

CRITICAL PERSPECTIVES grew out of a stimulating gathering of artists, writers, scholars, and cultural leaders who were brought together in 2000 by Animating Democracy. We thank the field leaders who came to share their ideas and experiences regarding critical writing practices examining civically engaged art, and thereby inspiring the *Critical Perspectives* project. We offer special thanks to artist and writer Suzanne Lacy and performance critic, writer, and scholar Ann Daly, whose presentations and thinking at this meeting provided invaluable contexts and raised key questions that were core to the *Critical Perspectives* writing experiment. We also thank Amalia Mesa-Bains, Judy Baca, and Bill Rauch for candidly sharing their perspectives as artists about critical writing. Following this meeting, Ann Daly and Jan Cohen-Cruz—a community-based theater artist, scholar, and writer—provided invaluable advice for the design of the *Critical Perspectives* project, remaining key advisors and contributors throughout the effort. We appreciate feedback on the project concept from Tomas Ybarra-Frausto, Bob Leonard, Jawole Willa Jo Zollar, David Gere, and Erica Kohl.

We express our admiration of and appreciation to the 13 writers whose essays form this collection. Each brings a unique perspective to this unconventional writing task and an enthusiasm for its experimental nature. We wish to thank project leaders Michael Fields, Maribel Alvarez, and Lisa Chice, Deacon Edgar W. Hopper, and Liz Sevcenko, who—in addition to contributing their own essays—were willing to take the risk and open up their projects to such a close and layered look. Finally, we are honored by and grateful to Lucy Lippard for her essay. We appreciate her historical knowledge, deep understanding of the complexities of the work, and critical analysis, as well as her great candor and humor.

A sincere thank you is extended to Caron Atlas who co-directed the *Critical Perspectives* project. Involved from the inception, she was instrumental in conceiving, designing, and implementing it. Her vast experience within the realm of arts and social concerns and her thoughtful engagement with writers about their work contributed to the integrity and meaning of the effort. We thank John Fiscella for his sensitive editorial work with the material, as well as for his valuable advice in shaping the book as a whole. Our thanks also go to Andrea Assaf, former Animating Democracy staff member, who offered important thinking to the development of the *Critical Perspectives* project and especially in synthesizing what was learned.

Thank you to studio e$_2$ for a handsome book design and to the team at Americans for the Arts who helped bring this book to fruition, including Mara Walker, Pat Williams, Susan Gillespie, Kirsten Hilgeford, and Graham Dunstan. Our special thanks go to Michael del Vecchio on the Animating Democracy staff for the innumerable and instrumental ways he supported this book project. Finally, we recognize and thank Bob Lynch for his early vision and work, along with Christine Vincent of the Ford Foundation, toward conceiving and launching Animating Democracy, as well as Lynn Stern and Roberta Uno whose later encouragement from the Ford Foundation has been much valued. Without the Ford Foundation's support, this endeavor would not have occurred.

Introduction

BLUE LAKE, CA, a rural community of 1,300 people, includes two countries: the United States and the Blue Lake Rancheria sovereign nation. When the Rancheria opened a casino, the economic and power relationships in the community were turned on their heads. Dell'Arte, a theater that has been in Blue Lake for 30 years, asked, "What is the future of Blue Lake and who is going to drive it?" Through theater, they created a space for dialogue about this question in what had become a divided town.

On the Lower East Side of New York there is a church that embodies a hidden history of slavery. Behind the balcony are two slave galleries where African Americans sat unseen by the rest of the congregation. By restoring the slave galleries, St. Augustine's Church sparked a cross-cultural conversation about inclusion and exclusion in the neighborhood, and social injustice in the country. Historian Jack Tchen writes, "Freedom itself, not simply those remaining wooden benches, is the central discussion here—the meaning of freedom as it was, and still is, tied to fundamental U.S. values of property, ownership and identity."[1]

In San Jose, CA, the personal is political for intermarried Latino and Asian families. Their intimate tensions and desires are on public display every day as emblems of changing demographics and marriage taboos. MACLA (Movimiento de Arte y Cultura Latino Americana), an alternative, ethnic-centered arts space, set out to understand what stands behind the obvious. They asked whether "textured, seasoned insights into the dynamics of ethnicity, social identities and intimacy" in the Silicon Valley could be revealed in a manner that deepens social interaction, not social embarrassment.

Each of these projects overcame enduring silences: the evocative silence of a family secret, the disempowering silence of an unresponsive city council, and the "screaming silence" of systemic historic amnesia.[2] They revealed contending cultural, social, and political values underlying these issues, and brought people together to talk about them. Breaking the silence and moving beyond the polar extremes of issues became the beginning steps in a long-term process of reconciliation. Playwright and cultural planner Ferdinand Lewis concludes: "Art can recontextualize in ways that are liberating."

> Lord for all of 'em, the sisters and the brothers whose souls reside in this
> place, let them speak now. They shall no longer choke back the truth,
> disrespect their discontentment or be seen as less than human.
>
> —Lorraine Johnson-Coleman

In a time when media consolidation and diminishing civil rights are narrowing the range of voices heard, these projects supported by Animating Democracy encourage the exchange of multiple points of view about a community's—and the country's—deepest concerns. Animating Democracy seeks to support the potential of art and humanities to break silences and engage new voices in a creative and participatory civic dialogue. To extend the dialogue even further, Animating Democracy created *Critical Perspectives*, a multiperspective approach to critical and reflective writing that expands the scope of who has voice and authority in writing about civically engaged work.

The African proverb, "When the Lions Tell History," reminds us that when the lion tells his story, it is from an entirely different perspective than that of the hunter. Who tells the stories makes a significant difference in what stories get told and how they get told.[3] The language of the stories can include and exclude, or as writer Sekou Sundiata says, "conceal even when it seems to reveal."[4] Truth, knowledge, and meaning can be understood in various, and at times contradictory, ways, depending on who is telling the story. Stories can reinforce accepted mythologies and power relationships or contest them. Which stories are validated and which, as journalist David Rooks puts it, "make you the drooling uncle at the reunion" can determine what is heard or silent, and what is visible or invisible.

Critical Perspectives has explored how writing about civically engaged arts and humanities could be consistent with the values of the work itself. A primary value in the work is to create space for multiple points of view—not to neutralize different views, but to clarify them in relation to one another.

How can writing best reveal these different meanings and challenge readers to consider perspectives unlike their own? Recognizing that this is a lot to expect from one writer, *Critical Perspectives* invited four writers for each project, encouraging them to embrace their subjectivities and past experiences in their writing.

> *I was most moved by what was not said, by what I saw out of the corner of my eye.*
>
> —Renato Rosaldo

The stories in this book are captured through lived experience, interviews, social science research, and "clues and fragments." Some draw on facts—the census figures of intermarried families or the dates of manumission—and reveal that sometimes the facts don't necessarily align with perceptions. Others rely on emotional wisdom—the spirit of the slave gallery through the imagined slave woman bearing witness to it, the personal relationships and desires in a photograph. Sometimes imagination is the primary source. Storyteller Lorraine Johnson-Coleman gives voice to the slave gallery space and its ghosts. "There is no greater agony than having an untold story inside you." Renato Rosaldo, an "anthropoeta," draws on his poetic insights to imagine what wasn't said.

The writers consider the aesthetics as well as the social relationships inherent in creative process and artistic work. Aesthetic considerations include creative intent and vision. Theater critic Jim O'Quinn is "interested in getting into the minds of the artists themselves, to write about it from the event itself, through the lens of what the artists intended to do." The writers explore technique, craft, and style, as well as the use of images, metaphors, cultural nuances, stereotypes, and archetypes. Writers also consider innovation and the relationship of the work to cultural context, the ability of the work to invoke meaning, and artistic integrity. Several of the writers raise the issue of artistic risk taking. Is good art fearless art? Can safe art be good art? Does adding a goal of civic dialogue affect the artist's ability to take creative risks? Can certain artistic genres also be inhibiting?

> *Art is about taking a risk, and being inclusive from the beginning, so that we can create a new voice. I get a painful feeling when art is a dead letter. Celebratory art—what I call 'beads and feather art'—that becomes what you are—the new caricature. I want art to take more risk.*
>
> —David Rooks

The writers consider the social processes and civic contexts of these multilayered projects, recognizing the connection between the aesthetic and civic. Visual art critic Lydia Matthews draws on Nicolas Bourriaud's concept of "relational aesthetics," an understanding of art as an act of structuring social exchange. For her, the value of the *Ties That Bind* project is in creating a space where relationships between curators, artists, scholars, and publics were "actively renegotiated and perpetually discovered through human interactions." Rosaldo evokes "the social life of an art installation," in which the art does not give itself the last word. For him, the art is only fully realized through the civic dialogue that takes place in, and is generated by, the welcoming exhibit.

How did the people for whom the work was intended value the work? MACLA Executive Director Maribel Alvarez describes how *Ties That Bind* "touched a nerve" in the local community, leading to future conversations. Lisa Chice, a participant as well as an organizer of *The Slave Galleries Project* dialogues reflects on why busy community members kept returning. "This dialogue wasn't driven by conflict. Instead it was part of an affirmative project that galvanized participants."

The writers explore the relationship between aesthetics, ethics, and accountability when, as Rosaldo writes, there is among the subjects of the work, "a concern about display and exposure, trust and violation, fear and assurance, silence and speech, power and inequality." The writers recognize that the communities included in these projects are not monolithic, and they frequently question who is included in the framing of the projects and the issues addressed.

Critical Perspectives has surfaced questions of power, shared authority, and the writer's own accountability in relation to the impact of his or her work. Lucy Lippard asks, "How do writers take creative risks, remember 'one's responsibility to the people you're working with and at the same time keep the writing fresh and provocative?'" This was especially challenging for writers who had long-standing relationships with the organizations they described—or hoped to develop ongoing relationships with the organizations through this project. Johnson-Coleman reflects: "Anyone who is a writer or historian asks, 'do I have the right to speak for these people?'; that's the part of the process people don't see." Tchen asks: "How comfortable do we feel in airing out complicated issues that fix the way in which the artists and the other players are characterized?" When is exposing pain and tension good, and when might it do harm?

Why would community-based organizations like Dell'Arte, MACLA, St. Augustine's Church, and the Lower East Side Tenement Museum—all already working full throttle—choose to be part of this time-consuming and intense experiment? They, too, have expressed a need for writing about their work, and, through *Critical Perspectives*, they had the chance to play a direct role in defining a new framework and use for the writing.

> *The cultural climate is such that the time is now to look at this project. The whole question of being marginalized yet again is at issue.*
>
> —*The Reverend Deacon Edgar W. Hopper*

A key goal for the projects and for *Critical Perspectives* has been that the writing would have value for the projects. This has played out differently in each case:

St Augustine's Church was clear about their need for the writing to be useful for *The Slave Galleries Project*; they made it a precondition of participating in *Critical Perspectives*. The writing had the potential to increase attention not only to *The Slave Galleries Project*, but also to the impact of gentrification in the neighborhood. Deacon Hopper and his collaborators intended Johnson-Coleman's narrative to enhance a visitor's experience of the slave galleries, Tchen's essay to be a catalyst for cross-cultural dialogue, and Rodger Taylor's to give an insider's documentation of the restoration process by a committee member.

Dell'Arte wanted a theater critic to consider the art of "theater of place," and the art, dynamics, style, and community ramifications of creating a theater "that speaks specifically to a particular community in a particular time about a particular issue." They also wanted the perspective of a cultural planner and writer whom they already knew well to explore how an arts organization can or cannot shape the future of its community, and a Native American writer who could consider the complexities of Indian gaming from within a Native American culture.

MACLA was interested in developing a theoretical framework for articulating their hybrid methodology of merging ethnographic and artistic approaches, their role as a community-based cultural center, and the place they occupied in the local cultural ecology. MACLA Executive Director Maribel Alvarez engaged writers in a critical dialogue and encouraged them to take their criticisms even further. She wrote to Lydia Matthews: "Obviously your work is effective in the sense that it generates this kind of fruitful dialogic exchange— much like sociologist Michael Rosenfeld's well defended thesis of why MACLA

thought it was unique even though it wasn't—these are excellent provocations to further dialogue, which I welcome."

Not surprisingly, the mix of the project leaders' expectations, writers' expectations, and Animating Democracy's expectations—those said and those unsaid—presented challenges and tensions. Value and utility meant different things to different people, depending on how they understood the purpose of the essay. In one case, a disagreement about the inclusion or exclusion of charged material raised questions for both the project director and the writer about issues of integrity.

Each project took the lead in choosing their writers and then defined with them their roles and their degrees of interaction with the project's work. Writers ranged from theater critic, to demographer, to journalist. Several writers embodied hyphenated identities: anthropologist-poet, educator-activist, storyteller-historic site interpreter, playwright-community cultural planner, historian-church committee member. Some writers had vantage points from within the project; others, from without. Some were members of the community; some were not. This often depended on how community was defined—by geography, identity, or affinity.

> *I discovered that* The Slave Galleries Project *is a sensitive project, and my challenge was to be true to my point of view and maintain my relationships with the people I work with.*
>
> —Rodger Taylor

Being an insider or outsider offered advantages and disadvantages. While an inside position allowed for intimate knowledge, it also included the pressure of internal dynamics and the possibility of embarrassing one's colleagues with too much transparency or a challenging critique. Distance could help writers gain an overview and, in some cases, the validation of the outside "expert." But a lack of trust could inhibit outside writers from gaining key access and information. What complicated all of this is that most writers involved in *Critical Perspectives* occupied multiple positions—simultaneously insiders and outsiders. Rooks, for example, was not from Blue Lake, but had an insider view of Indian gaming and culture.

Many of the writers stretched outside of their professional comfort zones. The opportunities offered by *Critical Perspectives*—to cross disciplinary boundaries, write in dialogue with other writers and projects, question

assumptions, and shift power dynamics—were both liberating and frustrating. Said Rosaldo: "Writing about this work is like laying an egg (something I know nothing about). I like doing stuff I don't know how to do well." Rooks likened it to "mud wrestling with mad hens: a thousand urgent themes that cackled anarchy against all nests."

> In answer to the question: "Is the writer a collaborator, critic, witness, or advocate?" writer Jan Cohen-Cruz replied: "When we're lucky, all these multiple roles and aspects rub together in ourselves and our work; when we're not lucky, we become fragmented about who we are and what we bring.

Writers regularly questioned what their role was at any given moment during the project, and what role their essays would play and for whom. Some writers stood firm in their area of expertise, recognizing that it was for this expertise that they were selected. Others expressed how difficult it was to be accountable to themselves as well as to several people giving them what was, at times, contradictory feedback.

A challenge for the *Dentalium* writers was that *Critical Perspectives* began too late for them to follow the project from the start, leaving them without an experience of the project's dialogues. Dell'Arte's Producing Artistic Director Michael Fields notes, however, that the dialogues were designed as a safe space to build trust and community, and if the writers had been brought in earlier, it might have been inappropriate for them to attend. For Rooks, trying to represent this important dimension of the project, it was as if "I've invited a guest for dinner, the doorbell just rang, and I'm shuffling through the cupboard looking for ingredients I don't have." For Tchen, in writing about *The Slave Galleries Project*, "the fact that I wasn't there from the beginning and being invited in actually made this project more interesting for me to participate in. Lots of great ideas and agendas."

In some cases, writers had a more extended and collaborative role in the project. In the *Ties That Bind* project, two of the critical writers were already slated to be involved in the oral history research before asked to write as well. While this direct participation enriched their knowledge of the process, they themselves raised questions about whether the writer/scholars might interfere with the art. Concerned about imposing his facts on the imagination of the artists, Rosenfeld asks, "When do too many cooks spoil the broth? I wanted to see what they (the artists) were going to do, to trust their own intuition. I didn't want to be seen as the outside expert."

Alvarez concludes that, "the interventions of art/cultural scribes manipulate reality as much as deconstruct it." When do writers' manipulations further understanding and when do they get in the way? Writes Fields: "In reading these essays, it is clear they have a unique value as a prism that reflects and refracts a critical light on aspects of this work from specific entry points. They capture primary colors…And yet a prism must, by its nature, be split apart. And it is our work, our job, our art—to make a whole."

> *The slave gallery perch is a precarious, dangerous, but also privileged position. If we truly understand the power of these humble confines, this sacred place can generate profound insights and a community of conscience from which more freedom springs.*
>
> —Jack Tchen

At this moment in history, it's not easy to animate democracy. It takes art and humanities that stimulate our minds and liberate our souls. It takes dialogue and a transformative vision of human dignity and social justice. And it takes the risk of participation. In one way or another, each of the essays in this book arrives at the importance of taking this risk to create fearless art and an inclusive democracy, to tell the story. How can artists, writers, cultural organizations, and funders take these risks in a manner that is imaginative and active, responsible and ethical? One of the ways this can happen is by having spaces, as Alvarez describes, "for artistic/intellectual production that can give artists and ordinary people a chance to test 'uncooked' ideas, to borrow and stitch-up at random from a wide variety of approaches, and ultimately to fail and start anew." These are the spaces that animate democracy. We hope that this publication will serve as one of them.

Caron Atlas
Co-director, Critical Perspectives

[1] Quotes from writers are from their essays, written reflections on the process, conference calls, and comments made at a *Critical Perspectives* Writers' meeting held at the Tides Foundation in San Francisco, November 2–3, 2002. This meeting was documented in an essay by Andrea Assaf, "A Threshold Moment: Summary and Reflections from A Gathering of Animating Democracy's *Critical Perspectives* Writers." In addition to being a source of writers' quotes, Assaf's insights in this essay have helped to inform this introduction.

[2] "Screaming silence" is a phrase from Liz Sevcenko of the Lower East Side Tenement Museum, quoted by Rodger Taylor in reference to the slave galleries.

[3] Thanks to Urban Bush Women for drawing my attention to this proverb. Artistic Director Jawole Willa Jo Zollar uses it to describe the company's focus on "untold and under-told stories" from the lion's perspective.

[4] From "Thinking Out Loud: Democracy, Imagination, and Peeps of Color," keynote speech for Diversity Revisited: A Conversation on Diversity in the Arts, Pittsburgh, PA, June 8, 2004.

Shaming the Devil

LUCY R. LIPPARD

In memory of Jim Murray, cultural correspondent par excellence

WRITERS, LIKE OTHER ARTISTS, supposedly aspire to "tell the truth and shame the devil," as Lorraine Johnson-Coleman's grandmother advised her. But telling the whole truth, and telling it so well that people want to listen to it, so well that it shames not only the devil but the bigots and reactionaries, the warmongers, misogynists, hypocrites, homophobes, complacent liberals, and snobs; so that it provides the basis for social dialogue and change; so that it celebrates and uplifts the rest of us as well as shaming the devil—that's the challenge.

A defining moment in my own writing life came in 1980 as I sat at a round table in a lower Manhattan loft with Arlene Goldbard, Don Adams, and Jerry Kearns. We were discussing how to get three branches of hitherto isolated art together: community arts; street, guerrilla, and political arts; and the progressive avant-garde. The so-called high art world, even the politicized, "radical" branch of it, was thoroughly ignorant of groundbreaking work being done around the country (especially in the theater community) and somewhat dismissive of the achievements of community-based artists working not only *with* but *for* expanded audiences, deliberately avoiding the artworld career loop. None of these groups, in turn, knew much about some bold attempts within the art world to transform and/or escape it—models buried in conceptual, performance, feminist, and some public art.

While the four of us had been involved in all three of these areas individually since the 1960s, each one of us claimed our "expertise" primarily in one of them. Don and Arlene were pioneers in the field of community arts organizations and cultural policy—a term I had never heard until I met them; Jerry was an artist, a college professor, and worked with radical urban African American

and Puerto Rican groups; my activism was feminist and anti-establishment, but I made my living writing mostly within the art world. I'd had previous epiphanies in the anti-Vietnam War movement and especially in the feminist collective and journal *Heresies*. We were all frustrated by the lack of cultural policy in this country, with the limitations and presumption of art's "useless-ness" in western culture and its alienation from most audiences.

Process over product was a byword in the late '60s and early '70s. (As Judy Baca said later of one of her striking community murals, "If there were no mural, this would still be art.") Even then, however, artistic excellence and socio-political effectiveness were considered incompatible—an argument that drags on today. For years we and our cohorts had been talking about demythologizing art and changing the system in which it was cooped up, about making art that was *generous* as well as critical. I called myself an "advocacy critic," working from "a communal base to identify and criticize the existing social structures, to locate and evaluate the social and esthetic effect of the art." Years later, Animating Democracy, through *Critical Perspectives*, asks even more of their writers, and of their process.

The "movement for cultural democracy" that was being formed at the time in hopes of precipitating a national cultural policy had its roots generally in the '60s and specifically in the late '70s with NAPNOC (Neighborhood Arts Programs National Organizing Committee). Led by Goldbard and Adams, this group was renamed the Alliance for Cultural Democracy around 1982, in the face of knock-knock jokes. Among our goals were to make avant-garde art more accessible, to sharpen the formal edge of communi-ty/social arts, to turn political art toward more complicated issues instead of settling for mere opposition. Easier said than done. Passion and prag-

> For years we and our cohorts had been talking about demythologizing art and changing the system in which it was cooped up...

matism make uneasy bedfellows. Suzanne Lacy—a "social sculptor" dealing with the "*shape* of interactions" has remarked that "the people I work with share my values but don't share my esthetics."

The Animating Democracy Initiatives are among the direct heirs to that fledg-ling movement for cultural democracy. Many of the same people are involved and their work has grown in the interim into a layered, sophisticated practice. Although the ideal synthesis between community, political, and avant-garde

art has yet to take place (and may be just pie in the sky, thanks to the very different economic bases implied by all three branches), nevertheless the networking remains invaluable. *Critical Perspectives* has now undertaken to look at the role of writing itself in the development of "arts-based civic dialogue"—a longer, more current, more admirably specific, and perhaps more exclusive term for what we used to call "cultural democracy." I'll use the latter here when talking about the general phenomenon, or desired goal, in order to avoid the infelicitous mouthful of "arts-based civic dialogue," which for all its accuracy, verges on grantspeak.

While many of us in the movement for cultural democracy were writers, I think I was the only full-time freelance "art critic"—a term I've always hated because of its implications of confrontation and authority, antagonism between artist and critic. I call myself a "writer and activist." Political and avant-garde art I knew first hand, but at the time I was an admirer, not a practitioner, of community arts, and writing about it called for different skills than those cultivated in the artworld. I had already struggled with being an

> The Animating Democracy Initiatives are among the direct heirs to that fledgling movement for cultural democracy.

"artworker"—how to write with my left politics on my sleeve in the face of editorial disapproval; and how to be, worse yet, a "feminist art critic"—writing primarily on women artists and from the movement itself. "If you want to send a message, call Western Union" was a warning I became all too familiar with in my most earnest days of proselytizing. "Crowd-pleasers" and "lowest common denominator" (and now, of course, the dreaded "PC") were epithets tossed at those of us straining to respect and to be accessible to broader audiences.

Here at the tail end of *Critical Perspectives*, I find myself in the awkward position of being third in line. I have no first-hand experience of the three impressive projects around which this book is built, nor any first-hand experience in the complex process of reciprocity among the nine writers (and sometimes among the writers and project directors) that has taken place by e-mail, telephone, and within the San Francisco writers' gathering (though Andrea Assaf's cogent recapitulation was very helpful). Having always depended heavily on "lived experience," here I am entirely removed from the process (although I did sit in on two of the wrap-up phone conferences). I didn't hear any of the voices that were these writers' raw material. I hesitated to enter into yet

another series of dialogues for fear of capsizing the already overburdened ship of intercommunication. There's no point in my quoting much of the 12 skillful and insightful essays when you can read them for yourselves, but their voices and insights are the bedrock of this text.

Maribel Alvarez, while empathizing with the burden of "accurate represen-tation" that artists are unaccustomed to bearing, points out "the sobering recognition that as a way of looking at 'social facts,' art is still more comfort-able in the realm of the imagination." In arts-based civic dialogues, writers become surrogates for communities they may not even know, intuiting other people's dreams and desires and aspirations and hang ups. (This can be fine, so long as the limitations are made clear, but the actual "communities" may be heard snickering or snarling in the background at certain assumptions.) The rather utopian notion of "reciprocal ethnography" has been widely embraced, but sometimes only one party is inter-ested in knowing the other, or has the tools to dig beneath the surface. You can't force reciprocity and mutual curiosity. An outside writer's enthu-siasm about inside events may be totally honest, but her ignorance of all the layers can be perceived by insiders as exoticizing, sensationalizing, and patronizing. If the "lucky-you-I've-come-to-make-art-for-you" syndrome has finally, with consciousness rising over the years, given way to "lucky-you-I've-come-to-make-art-*with*-you," the ultimate goal of "lucky-me-I've-come-to-learn-from-making-art-with-you…if-it's-some-thing-you-think-will-be-useful-to-you?" still needs some fine-tuning. This is where the Animating Democracy and *Critical Perspectives* programs come in.

> Sometimes a broad base of knowledge works better as a silent, or invisible, base, than as a platform for scholarly display.

A familiarity with history, cultural geography, sociology, ethnography, or com-munity development may be useful, but it does not always appeal to those who prefer to think about esthetics, and vice versa for scholars who have to learn about art and find formalism off-putting. Sometimes a broad base of knowledge works better as a silent, or invisible, base, than as a platform for scholarly display. As Ferdinand Lewis says, these projects are at the opposite end of the scale from the "universality" presumed of high art. They are "made for a particular moment, place and audience…about how history has shaped a particular population's ability to live in a specific place at a given time…While

all art *includes* its audience (and critics) in a subjective experience, arts-based civic dialogue also *implicates* them."

The danger is that no matter how powerful, place-specific works may be seen from the outside as "merely regional." Even though one region could easily absorb us personally for a lifetime, outsiders won't be permanently fascinated; publishing opportunities dry up—"too regional." A group of local writers in New Mexico howled with bitter laughter when I said earnestly that it must be possible to make local writing interesting to the outside world "as a microcosm" of the larger picture. Yet unidealized regional passions put in a broader context can ride the next ripple outwards. I think of the Dakota Theatre Caravan's learning to find the hearts of the small towns where they visited and created pieces, becoming a model for other regions in the process. Or Alabama's Rural Studio, in which building inexpensively beautiful homes for poor people out of recycled materials offers an exemplary solution to the national crisis in affordable housing.

I still think what has been called a "critical regionalism" is possible. While it is possible to write from the outside and be critical of process and approach to regional issues, local historical context and social dynamics are much more labyrinthine. Those writing from the inside who want to shame the devil can run the risk of ostracism or being run out of town. A sensible approach shares credit and blame while trying to avoid both. Yet neutrality and objectivity are hard to come by and perhaps nonexistent in most situations. The most obvious—and perhaps still the most valuable—role of writing about arts-based civic projects, whether first-hand or come-lately, is descriptive reportage—a warp preferably threaded with the weft of participants' voices. (People talking like normal folks talk is a welcome antidote to internecine critical musings.) In many ways this is the most valuable role, since what our community of writers/artists needs is project models of both successes and failures, so the wheel

> The most obvious—and perhaps still the most valuable—role of writing about arts-based civic projects, whether first-hand or come-lately, is descriptive reportage—a warp preferably threaded with the weft of participants' voices.

isn't constantly reinvented. Aside from a few small periodicals, this work is too rarely documented. Already it's clear that younger writers are foggy about the three decades from the 1960s through the 1980s, when so many of these

models were created, absorbed, and apparently forgotten. If that's the story in the United States, imagine how little we know about Latin American, African, Asian, and European forays into this field (despite a certain amount of quasi colonialist toe-dipping into collaborative and community-referenced—rather than community-based—art within the global artworld). The assumption of a dichotomy between global and local overlooks the fact that the global is simply the sum of many locals. Books like Mady Schutzman's and Jan Cohen-Cruz's on Augusto Boal's recontextualized theater[1] become infinitely important to the further development of civic dialogue.

Spaces can play the same role. The high, cramped slave galleries, looking *down* on a white congregation that failed to practice Christian charity, have galvanized writers and viewers. Maribel Alvarez sees the evolution of MACLA's space as "a work of cultural production," occupying "a peculiar place in the ecology of the art-culture system—spaces where new interventions in civic society are workshopped." Dell'Arte's outdoor amphitheater provides a literally public platform for the community's concerns, where the company's 30-year commitment to a "theater of place" can be played out.

As Lydia Matthews points out, "If we regard the work of art more as a period of time to be *lived through* rather than merely a space to be *walked through* or an object to be collected, art practice becomes something like opening an unlimited discussion." In projects like these, writers, artists, participants, and readers/viewers all take part in a grand collaboration. An advocacy critic tries to be a catalyst, the medium through which a dialogue or exchange is facilitated. Strategizing, brainstorming, good honest mutual criticism are all grist to the mill. Collaboration makes individual work go faster, raising multiple ideas and viewpoints no one person would have alone. I can't speak for

> Avoiding the personal drains the juice out of those subjects that may be enhanced by it.

cyber collaborations since I prefer mine face to face, elbow to elbow, but I have friends who find that cyber media have opened their minds and cut the ties on their tongues, and there is no denying the positive effect of the web on social activism.

The other important facet of writing about Animating Democracy projects and their ilk is interpretation and analysis. Here we step into the quicksand. As writer Sonja Kuftinec has insisted, a critical point for all of us is to continue "to affirm that theory and thinking are not just academic concerns."[2] Are

theory and thinking the same thing? I must say I'm more interested in ideas than theories. Ideas seem more fluid, more practically adaptable, while theories do imply academia to me, a certain authoritative finality, locking ideas up into boxes to which not all of us have the key. The best theories evolve organically, from practice. And they evolve from each writer's background and lived experience, which keeps us from repeating each other. Avoiding the personal drains the juice out of those subjects that may be enhanced by it. The hardest thing about writing about art and civic dialogue is balancing accessibility and depth, remembering one's responsibility to the people you're working with and at the same time keeping the writing itself fresh and provocative, finding new ways to express and illustrate and dissect the basic (and therefore "same old") problems of raising consciousness in communities working for social change. Dancer Liz Lerman recommends that opinions be made into "neutral" questions as a way of offering feedback in a nonconfrontational manner.

Jim O'Quinn, aspiring as we all do to "writing that is multidimensional, politically informed, and rooted in a principled point of view," asks the hard question: "How does a writer's voice create an implicit or explicit relationship with the reader?" Writing, like art, should evoke, invoke, provoke. Irony and Brechtian distancing are useful in some circumstances, but intimacy works better in most community situations. A talking writer (or writing performer) like Lorraine Johnson-Coleman takes the material at hand and creates art from it, an avenue that should be open in both directions so that journalists, critics, and historians can be as inventive as storytellers and dramatists, just as Johnson-Coleman can be an African American history scholar within her art. Then back in the other direction, how evocative can the writer get without overwhelming his subject and smothering the dialogue? American writers are trained to be rugged individualists. As one-time outlaws becoming in-laws through civic dialogue, we are still easily seduced by our own words, carried away by our own flights of conceptual imagination.

Like any endeavor that has a long history, the art of civic dialogue or movement for cultural democracy has acquired its own vocabulary. Sometimes it's evocative and sometimes it's stultifying. Academic overtheorizing must take some of the blame. So must editors who want everyone to sound alike and are frightened by quirky individual styles. Practitioners can learn from the complexities exposed by postmodernism while rejecting the seductions of incomprehensible jargon. Most small groups and organizations have spent a

lot of time learning to write grants; institutionalized language always threatens to infect expository prose. Artists' writings are often the most valuable sources of information, but not all artists can or want to write.

Following a long-term trend in other academic disciplines, and especially in cultural studies, interdisciplinary crossovers and dialogue are particularly valuable to the kind of hybrid being created here. In the last couple of decades, a lot of us have been dashing across borders to borrow each other's ideas and vocabularies. Ethnography and anthropology are frequently raided. Sometimes this is truly useful. Sometimes we just acquire more complicated terms with which to veil our lived experiences. The more convoluted the argument, the more esoteric the jargon, the smaller the audience. If the analysis isn't carried forward by deepening complexities, it becomes boring. If it's carried forward on a wave of unfamiliar words, it becomes intimidating.

Fear of print can be an obstacle to dialogue, even in this day and age of cyber-casual. A native resident of the *hispano* village where I live and edit the monthly newsletter once told me, "They'll never tell you all the stories, and if they did you couldn't print them." Among many of those who read little or are oppressed, underprivileged, and/or illiterate, the notion of seeing their words in print is not always an exhilarating honor; it can be scary and sometimes offensive. I am often confused as to who among the longtime locals likes to be quoted, have their family events mentioned, their family histories explored—and who doesn't. It isn't easy to understand everyone's current circumstances—to be sensitive to their needs, fears, desires, problems, prides at the moment—and also provide the information necessary to the public interest. Mistakes are inevitably made, and sometimes forgiven. (Rodger Taylor: "people would say things in interviews and really freak out when they saw it in writing.") Participants see writers by definition as powerful and authoritative. (Maribel Alvarez: "The interventions of art/cultural scribes 'manipulate' reality as much as deconstruct it.") For all our society's dismissal of print media, it remains the tool of the privileged. However humble we writers try to be, we can't deny that we are getting (some of) the last words. Selection is power. Those to whom writers in this field are "giving voice" rarely have any choice in the matter, though this does not mean that trust cannot be built and barriers overturned. Lorraine Johnson-Coleman gets down to brass tacks when she asks, "Where is the community voice in *Critical Perspectives?*"

Writers trying to make a living at the crossroads of community, culture, and class need to speak several languages, to know how to change codes in mid-

stream, to come into each situation with fresh eyes and mind, to navigate the shoals of historical enmities, to give up the role of final arbiter, especially about cultures not our own. Karuk cultural historian Julian Lang offers an example, quoted here by Ferdinand Lewis, of how to relate the contradictions between modernity and ancient myths: "I am not so much into entertaining, but just presenting a big fat myth and letting people think about it. In order for you, a non-Indian, to understand my culture, you are going to have to walk away...thinking 'Jesus Christ, what was that?' Not in a negative sense, but it is just like—there are too many things in there. You can understand it on one hand, but on the other hand, it is too deep." Hiphop dancer Rennie Harris (quoted by Sonja Kuftinec) is eloquent about language and power: he makes sure he speaks the language of the dominant culture so he will be heard. But, he says, "I'm also going to challenge critics to come to my neighborhood. Can you stay there? Can you hang in there? Can you keep on going and learn how to have an appreciation and not an appropriation of the culture?"

> However humble we writers try to be, we can't deny that we are getting (some of) the last words.

None of us in the movement for cultural democracy are free of deeply held beliefs that, when simply expressed, become platitudes. How do we make our writing more varied, avoid monotonously hammering away on our fundamental values and shared goals? For instance, even the word civic is not always felicitous. For my generation, at least, it has oppressive connotations of "civics class" in high school—too often a mind-numbing reiteration of mainstream platitudes and conservative values. How about "post civic"? (Just kidding.) Similarly, the fetishization of dialogue as something momentous that transcends mere discussion can be problematic. All dialogue is welcome, some is highly effective, but it is not all worth recording or even remembering. Just as there is small talk, there is small dialogue. The *act* of meaningful dialogue can be more important than anything that is actually said. (Jack Tchen: "The art of the dialogic process is being able to share authority...the form of how we do things can be more important than what we say.") From there, however, often comes frustration with the fact that not much *is* getting said. As writers, we have to forage among the thickets and weeds to pick out those aspects of a dialogue (no matter how few) that seem to lead somewhere. For me, the more quotations from Animating Democracy's original dialogues the better, no matter how rough they may sound, and if that is missing in much of the writing here, it is because the

primary sources weren't always available to them. (*Critical Perspectives* organizers Pam Korza and Caron Atlas concede that it would have been better to select the writers earlier in the process so that they would have had access to all the dialogues.)

The Animating Democracy Initiatives are the latest foray into social energies not yet recognized as sources of art. Each of the three Animating Democracy projects lent themselves differently to the process set up for *Critical Perspectives*. Each seems to have sparked a different methodology, a different kind of dialogue, a different result. In each case the relationship to the project directors and artists was also different. Jack Tchen's meticulous but accessible historical take on *The Slave Galleries Project*, in which he negotiates the African American history in place, and the Chinese American histories entering the neighborhood, is a model of nontraditional, community-based history, and a breath of fresh air. Rodger Taylor's inside view is enhanced by solid research and soul searching that make his text a richly woven account of a congregation haunted by a space. Along with Lorraine Johnson-Coleman's (Wisdom Woman's) powerful monologue backed by scholarship, these were ideal vehicles with which to embrace the educational/interpretive mission at St. Augustine's Church. Project Director Deacon Edgar Hopper played an integral role throughout; the Lower East Side Tenement Museum's initial support and reluctant exit from formal involvement offered still another layer of internal dialogue, suggesting some of the tensions inevitable in every such enterprise.

> We all pull our punches for various sensible reasons, but the balance is truly hard to find.

In *The Dentalium Project*, Jim O'Quinn's outside theater expertise, Ferdinand Lewis's ability to bring together community development and theoretical/esthetic concerns, and David Rooks's particularly valuable view of the implications of Casino gaming for native and other communities (Greed or Hope?) again perfectly complimented each other to expose the successes and failures of the play, *Wild Card*, which was later reprised in modified form. This seemed to me at once the most flawed (or most difficult) and best-analyzed project; its built-in obstacles giving the writers something to sink their teeth into. A report from Dell'Arte Director Michael Fields from the inside, or the hot seat, eloquently describes what it is like to live and work in the

place where you are stirring up honest dialogues about the future: "We see all these people daily…We will live with the consequences of our actions and this creation for years to come…the complexity, nature and culture of *this* place informs all that we do."

Ties That Bind, the most elusive subject of the three because of the deeply personal character of marriage itself, gained from Lydia Matthews's breadth of experience and knowledge on new genre public art and contemporary art history, Michael Rosenfeld's straightforward treatise on the sociology of intermarriage, and Renato Rosaldo's own hybrid "anthropoetics." I found myself wondering why the voices of the two artists—Lissa Jones and Jennifer Ahn, handpicked to create the handsome installation—were almost inaudible.

The word "team" seems a bit inappropriate as a description of the three writers on each project. Some were more like a support group, others like a workshop. Although all of them met at the San Francisco gathering, the *Dentalium* three were the only ones to share a common experience, since they all saw the play, *Wild Card*, at the same time. This was obviously an advantage; their coverage gained from an agreed-upon division of labor and the discussions led to long-distance friendships. Each team worked out its own *modus vivendi* within the framework set by *Critical Perspectives*. One group felt it would have been more productive to start working together after San Francisco, since the discussions there crystallized their roles and "made it clear how it all fit together." And what difference would it have made if a larger proportion of the writers had been women?

The limitations of an art context and the constraints an art form can put on social content like Asian-Latino intermarriage is obvious in *Ties That Bind*, where specific stories were generalized in aid of art. Having said that, I can also turn it on its head: the limitations of detailed research can be opened up and made vibrant by such a sensitive visual presentation (though more "Asian" than "Latino" inspired) which brings the high art of installation to the usual dreary artlessness of educational displays. Similarly, the virtues and limitations of an open-ended educational project and a space that inspires through a visceral rather than expository connection to its content is obvious in *The Slave Galleries Project*. (Lorraine Johnson-Coleman: "I see the colors of soul splattered here, there and everywhere, cradled in crevices we ain't even begun climbin' into. I see ghosts, too, leftovers and leavin's of folks who waited for their spirits to be lifted clear up to the Lord." Rodger Taylor, in the galleries

with his nine-year-old son and friend: "For a minute I felt like we were flying, being bathed in our history.")

And the virtues and limitations of a very public expose of local politics that lampoons almost everybody but had to pussyfoot around the thousand-pound gorilla of native absence are obvious in *Wild Card*. Dell'Arte's highly stylized comedy is not everyone's cup of tea and was apparently foreign to those in the Rancheria whom they had hoped to draw into the process. (I have come to love and respect "Indian humor" as a subtle critical weapon; it is hard to imagine, in turn, how it would have fit into this framework; but that is precisely the task ahead.) Nevertheless, because of *Wild Card*, a new city council member ran and was elected and became a liaison to the Rancheria, a community group is meeting monthly to talk about the town's future, and the city and the Rancheria are talking to each other. Few artworks can point to such direct results.

As writers we can remind each other to let go, to say what we really saw and really think, and let the chips fall where they may. I read this over and it sounds irresponsible—accountability cast to the winds. Yet risk taking is constantly invoked as a trademark of "real art." Why should *this* kind of writing be cautious? And then again…irresponsible art, whether it flatters or bludgeons, can sacrifice its effectiveness. So how do we draw the line? The writer needs to know the community well enough to be able to joke with it (not necessarily about it). Witness the problems that arose within *The Dentalium/Wild Card Project* due to the history of strained relations between Blue Lake City and the Blue Lake Rancheria. The songs "You Can't Say That!" and "Why There's No Indians In This Show" took the bull by the horns but never threw him. In a phone conference, Lakota writer David Rooks said something that made an impression on me, something to the effect of: jokes are great after you are comfortable with each other, but first you have to be serious about serious things.

We all pull our punches for various sensible reasons, but the balance is truly hard to find. Self-censorship is lousy for any kind of creative activity. (Lorraine Johnson-Coleman: "I don't think our preschool teachers were referencing historical interpretation when they said…if we can't say something nice, we shouldn't say anything at all.") Yet funding sources can't be insulted, community leaders have been invited to participate and can't be offended either, and so forth. If we pull too many punches, somewhere along the line we find our writing about this kind of work beginning to sound textbooky, pollyanna-ish, or pompous. Rodger Taylor, a writer but also a historical researcher and

longtime parishioner of St. Augustine's Church, comments on having to please several different entities within the same project, the difficulties of "trying to do an insider piece with insiders all around you that you have dynamic relationships with…it was almost like I had to run everything by four heads, which was weird." But in the end, he knew he had gained from the dialogues.

In all of these cases the notion of soliciting multiple viewpoints has worked well. I suspect that at times the regulated process was exhilarating and other times annoying. And if, from the outside, the *Critical Perspectives* process seems inordinately elaborate, possibly overdetermined, the participants enjoyed it and learned from it, so who am I to carp? Most important, writers of any kind are rarely so lucky as to receive the gifts offered by *Critical Perspectives*: a meeting of minds with other professionals, constructive feedback from people with shared interests and goals, a chance to step back and observe our own roles and goals, and a publication at the end of it all. This book will be successful if it draws other writers, other scholars, other artists into the web of the Animating Democracy Initiatives.

> "Don't listen to what they say, watch what they do."
>
> —*native saying quoted by David Rooks*

[1] Mady Schutzman and Jan Cohen-Cruz, eds., *Playing Boal: Theatre, Therapy, Activism* (New York: Routledge, 1994).

[2] Sonja Kuftinec, "Critical Relations in Community-Based Performance: The Artist and Writer in Conversation," Americans for the Arts, http://www.AmericansForTheArts.org/AnimatingDemocracy

The Dentalium Project

::: **DELL'ARTE INTERNATIONAL**

This summary of The Dentalium Project *is excerpted and adapted from a report written by Michael Fields, producing artistic director of Dell'Arte.*

IN JUNE 2002, the Blue Lake Rancheria, a small reservation comprising about 50 members from several local tribes, opened a casino in the small rural community of Blue Lake in northern California. Cultural politics, as played out over hundreds of years of exclusionary practices against indigenous Native Americans, had created a political and cultural divide between the Rancheria and the city of Blue Lake (population 1,300). Coexisting but separate political entities, neither the city nor the Rancheria consulted the other on developments affecting quality of life and economic viability of the total community. With the casino a done deal and construction imminent, Dell'Arte, a theater of the Blue Lake community for 30 years, saw an opportunity to find the potential bridges across political and cultural divides. *The Dentalium Project* was conceived to open new pathways to determine the future of this community.

The project had three components. A series of eight dialogues that occurred while the casino was under construction brought together city and Rancheria leaders and community members. A documentary video was shot over a year featuring five people who held different views on the casino. The civic dialogues and video process fueled the creation of a new play by Dell'Arte called *Wild Card,* which shows Blue Lake 10 years in the future, following a full decade of changes sparked by the opening of the new casino. It features a local boy who has made the big time returning to host a radio show.

THE DIALOGUES

In August 2001, Dell'Arte began work with the locally based Cascadia Forum, a leadership development and community-building organization, to design and facilitate the community dialogues. The partners agreed that, before trying to bring people together in dialogue, some "detective work" would have to be done. The volatility of the issue was well known, but what people's perceptions would be about being in dialogue about the issue was less clear. So Cascadia had one-on-one conversations with community members spanning age, employment, cultural orientation, and class to ascertain feelings about the casino issue, about participating in a dialogue, and about Dell'Arte creating a play based on this issue. The reactions were varied and passionate, from "It is something that must happen," to "Dell'Arte should have been run out of town years ago."

Given what was learned, the first dialogue was an internal one among the entire Dell'Arte staff, most of whom live in Blue Lake. It served as both a practice round in structuring a dialogue and an opportunity to hear company members' own thoughts about the issues. A second and key dialogue was by invitation only and included six members who were a cross section of the Blue Lake community and six members of the Rancheria.

A subsequent dialogue involved several of the small business owners in town as well as the former postmaster, two City Council members, the financial officer of the Rancheria, two Dell'Arte representatives and others who hold a strong stake in the future of the place. Two points crystallized in this dialogue. One, the bad blood between the city government and the Rancheria went back generations and to this day has never truly been resolved. It occurred to all present that a dialogue between the right people from the city and the Rancheria could be very useful. Two, the City is "reactive" and is not presenting a future vision. Michael Fields, Dell'Arte's producing artistic director recalled, "Both the Rancheria and Dell'Arte had

'plans' for the future that the City seemed shocked by, since neither [the Rancheria nor Dell'Arte] had ever been consulted about planning and development of the town."

The meetings revealed a common appreciation for the unique, old-fashioned quality of life in Blue Lake and a deep division among non-Indian members of the community about whether the casino was a good development. While tribal members also expressed some ambivalence, many felt they had no other choice for successful economic development. Perhaps the most dramatic information to come out of the meetings/interviews was the deep divides in this tiny community between white and Indian. Many people simply never interacted with other segments of the community. Within this context, "the artist's role with the dialogue was primarily one of listening," said Fields.

WILD CARD

Fields began to draft a script for the play. The show evolved as a comic musical in the format of a live radio broadcast, hosted by Buddy O'Hanlan (played by Fields), a Blue Lake native and former log truck driver. It is set 10 years in the future, with Blue Lake a booming metropolis fueled by the development of the casino. Performed outside in Dell'Arte's amphitheatre to create a welcoming atmosphere, the play was simulcast on the local public radio station to reach more people. A good deal of the content existed in original music and songs under the premise that truths sometimes can be stated more bluntly in a song than in dialogue or explication.

Utilizing the comic skills of Dell'Arte, there was satire of an inept City Council (lyrics: "No, we don't have a plan, but we're the only ones who ran...") and a gung-ho Chamber of Commerce leader (lyrics: "I never met a development I didn't like"). Songs included "The Ballad of Blue Lake," an explanation of how this town with no lake got its name, and "Why There's No Indians In This Show?"

Because casino construction had been delayed, the casino and the play ended up opening one day apart in June 2002. *Wild Card* sold out each performance. Two people immediately announced their bid to run for city council, motivated, they proclaimed, by the play. One won and subsequently created and filled the position of City Council liaison with the Rancheria. The play provoked a series of community visioning meetings run by the county that brought many people into discussion about the future.

THE DOCUMENTARY

The original goal of the documentary video, produced by Jan Kraepelien in conjunction with local public television affiliate KEET TV, was to follow five people with differing points of view on the casino through its construction, opening, and operation. Questions focused on how the stages of casino development affected their lives and their points of view. The scope of the documentary expanded beyond these interviews and ultimately included extensive interweave of the *Wild Card* performance as well as the casino construction. At the center of the documentary are the differing perspectives of Arla Ramsey, Rancheria chairwoman, and Kit Mann, local businessman and community organizer. The video gives voice to the dimensions of the issue, providing insight into the Native American views in a way the play could not achieve. Two preview screenings of the rough edit were held for the community in January 2003, seven months after the play was mounted, each followed by audience dialogues facilitated by the Cascadia Forum. The dialogues were intense and led to an ad hoc group forming to consider the future of the community, with a goal to improve communication among different community segments, particularly including the Rancheria. KEET later broadcast it in summer 2003 in conjunction with the premiere of *Wild Card 1.5*.

OPENINGS

The Dentalium Project stimulated and provoked, via art, new opportunities and ways to talk about and imagine the future of the community. As far as anyone knew, the dialogues held to inform the development of the play were the first time that many long-time residents of this place had ever sat down and heard each other's stories. An opening was created to continue to connect. The theater company is more keenly aware of its relationship to the whole. Our practice as artists is to "envision." That is what we do in the creation of a theatrical work, in the design of our training, in the construct of our organization. It seems to me imperative then that we bring that same skill, as an integral partner, to the table of community envisioning. I think this is critical to our role as artists.

Notes on *Wild Card*

JIM O'QUINN

"...until the roof rose and left its foundations and floated up into the night sky. At least that's the way I heard it."

—Buddy O'Hanlan in Wild Card

"Our work tackles themes that spring from this place but have the potential to flow into the larger currents in the streams of American life."

—Dell'Arte company mission statement

JUNE 28, 2002, 7:15 P.M.
We're in Blue Lake, CA (pop. 1,300), and out behind the Dell'Arte company's H Street headquarters and school—a triple-story wood-frame building that dates back to 1912 and once served as an Odd Fellows Hall—folks are gathering on the gently sloping curve of grass that forms the performing troupe's outdoor amphitheatre. The sun hasn't set yet behind the low hills off to the west, and its horizontal rays fall in warm yellow bars on the shoulders of the milling playgoers and on the mostly bare expanse of stage where *Wild Card* is about to be performed for a paying audience for the first time. As these theater patrons make places for themselves on the curved slope in folding chairs or on blankets or patches of grass, I make mental notes about just who they seem to be. There are:

- tattooed teens in clusters
- mothers carrying babies in blankets
- old couples in matching sun-visors, arranging their aluminum loveseats
- deeply tanned hipsters with thermoses of tea and quarts of beer
- whole families stretched out on quilt pallets
- well-dressed couples who could have been headed to classy restaurants
- rangy fellows in jeans and boots who are probably loggers
- a young woman reading a book
- acquaintances who greet each other with shouts and slaps on the back
- lots of groups of three and four and five, people of all ages

Behind them, at the apex of the grassy hill, has been erected a boxy scaffolding, shaded by a tent of netting, that encloses the production's sound equipment and a single monster follow-spot. *Wild Card*, which is billed as a "radio play," promises to be a low-tech production, but its third-night performance will be broadcast live over the local PBS radio station, KHSU-FM, located on the campus of Humboldt State University in nearby Arcata. KEET TV, the county's PBS television station, is developing a documentary about the show and the Blue Lake community's involvement in its creation.

> "The traffic island I call home/Is now a giant orange cone/Get me Governor Chesbro on the phone!"
>
> —*from the song, "It Sucks for Jane"*

Why all the interest? First and foremost, the show's subject is the impact of a large and what many in Blue Lake see as ostentatious Native American casino that is about to become the biggest financial interest in this small northern California town. Second, a unique community dialogue process preceded the show, which for the first time brought together townspeople; civic leaders; and representatives of the Blue Lake Rancheria, the approximately 50-member Native American tribal group that initiated the casino. And third, feelings in this part of Humboldt County are running high: As the winds of change blast Blue Lake, what will be the future of this place? And who will be controlling that future?

Shortly before the 8:00 p.m. "curtain time," *Wild Card*'s five-member band trots out on stage. Decked out in glittery, campily futuristic matching pantsuits of green, red, blue, purple, and yellow, these musicians announce themselves to be onetime grads of Arcata High School, arriving at the studio of a fictional radio

station, KRUD, for an on-the-air variety-show celebration of the 10th anniversary of the opening of the Blue Lake Casino. The year, we learn, is 2012.

> *"The 45,000-square-foot casino on Chartin Road, owned and operated by the Blue Lake Rancheria, has more than 300 slot machines and 132 table games, including Let It Ride, Spanish 21, Three-Card Poker, and Blackjack. Profits from the casino will be directed toward programs that help the Rancheria and the surrounding community of Blue Lake."*
>
> —The Times-Standard, June 28, 2002

In actuality, the musicians are members of the local Joyce Hough Band, familiar to many in the audience from area concerts and roadhouse gigs (as well as from previous Dell'Arte productions), and their low-key country songs soon have their listeners clapping along and calling out requests. Joyce Hough herself, introduced as Blue Lake's own "Little Sally Mulligan," leads on vocals: "Seems like this whole town's insane," suggests one of her pithier (and more prescient) lyrics.

With the blustery entrance of Richard ("Dick") Dick, the infelicitously named fictional president of the Blue Lake Chamber of Commerce (played by veteran comedic mime Daniel Stein), *Wild Card* is off and running. "Welcome to this carnival of commerce! Smells like a city to me!" Dick declares, working the crowd like a hungry campaigner, exercising his Groucho Marx eyebrows. Every inch the politician, Dick fills Blue Lakers in on the events of the 10 years that have passed since 2002: a decade of progress, economic development, flash floods, financial reversals, boom-and-bust.

The advent of the $30-million Blue Lake Casino project, that great leap forward that the audience is experiencing in real time (its opening, just a stone's throw away over on Chartin Road, virtually coincides with these first performances of *Wild Card*), will mark a new era for Blue Lake, Dick reveals from his one-decade-on perspective—an era of change for the better, and sometimes for the worse as well. "We've got what people want—space, infrastructure, safety, smart growth," Dick reasons with an air of desperately mustered confidence, as he wittily commends the audience for so accurately observing "Dress Up Like 2002 Day."

> *"There could be more people at the casino at any given time than there would be living in the rest of the town."*
>
> —Blue Lake city councilman Brian Julian, Wild Card *video*

Sensing he may be wearing out his welcome with the constituency, Dick introduces *Wild Card*'s leading man: garrulous radio personality and Blue Lake native son Buddy O'Hanlan (played with irresistible panache by Dell'Arte producing artistic director Michael Fields, who's also credited on the program as *Wild Card*'s script writer). Resplendent in shoulder-length gray hair and a sequined red-white-and-blue jumpsuit that Elvis might have envied, Buddy—who confesses that he left the region back in 2002 "in search of a paycheck and some perspective"—takes charge as emcee of the radio show, which is to feature a parade of local personalities, a theatrical troupe called the No Lake Players, and other "surprises."

But first, between the good-natured drug jokes and the barbed reminiscences, Buddy draws some surprisingly eloquent comparisons between the Blue Lake his audience knows today and the region as it was mid-twentieth-century (when the town had an opera house, a real railway station, and six bars), and as it might have been 100 or even 1,000 years ago, when Native Americans shared the land with pristine, silent redwoods. What, Buddy wonders, is the attitude of the white citizens of the area about the new casino and the changes it has wrought?

The answers he gets are comments gleaned directly from carefully structured dialogues conducted under the direction of a local community-building orga- nization called the Cascadia Forum over the several months of *Wild Card*'s development, first without Dell'Arte artists present (to alleviate participants' initial worries that their words might end up on stage), and later in sessions with the artists taking part. These dialogues, eight in all, aspire to have an impact on Blue Lake that extends far beyond the *Wild Card* script, but tonight we can hear their echoes in the laconic voices of Buddy's cronies: The station-master of KRUD grumbles about the loss of peace and quiet. A band member wishes his Rancheria neighbors all the best. "Between my music and my garden, I don't have a lot of space to think about things like that," intones Little Sally Mulligan.

"I'm interested in how the dialogue translates into art. How does it influence, shape, respond, provoke the form, the art itself?"

—*Michael Fields*

The down-to-earth opinions expressed by *Wild Card*'s homegrown characters aren't the only elements in the show gleaned from the months of community dialogue, as I learn later by pouring over Fields's final report on the project (submitted to Animating Democracy, Americans for the Arts' four-year project funded by the Ford Foundation that is supporting both *Wild Card* and

a multifaceted critical response to it, of which this essay is one part). In his report, Fields makes a crucial point: Not only did the dialogues inform the show's content, as would be expected—but, less obviously, the dialogues had a direct bearing on Dell'Arte's choices about the formal aspects of the production. The decision was made to stage *Wild Card* in the less-formal *outside* atmosphere of the amphitheatre, thus increasing the comfort level of spectators and encouraging "as much celebration and laughter as possible"; to do it as a *musical*, making it "less heavy and didactic"; to fashion it as a *radio show*, with simultaneous live broadcast, thereby reaching a wider audience; and to fashion it as *satire*, provoking "a biological response of recognition," namely laughter. All these choices, Fields says, "were strongly influenced by listening to the dialogues." In the same vein, the craft-centered company was intent upon avoiding "the elevation of dialogue over art"—the thorny issues at hand would remain important, naturally, but Dell'Arte would be sure to "entertain, not preach" and to "make the art provoke the questions."

"There could be more people at the casino at any given time than there would be living in the rest of the town."

—*Blue Lake city councilman Brian Julian,* Wild Card *video*

All those performative elements are on bold display as Buddy plays emcee, welcoming some stylish guest performers: Here's Slim Weisenheimer, the casino's gambler of the year (played by lithe dancer Richard Lloyd Cambier), recounting his winning streak in a slick dance number choreographed to creative percussion and spoken word. He's followed by Jane (Dawn Falato), an agitated "artiste" who lives just "50 yards from roulette table #8" (a situation shared, not incidentally, by *Wild Card* director Joan Schirle). "I remember when Blue Lake freeway was a little street lined with fennel," Jane sings nostalgically, then turns furiously bipolar: "The traffic island I call home/Is now a giant orange cone/Get me Governor Chesbro on the phone!"

On troops the No Lake Players, a befuddled sextet of theater types (including one fellow in a clown nose, a reference to Dell'Arte's own roots in "traditional, popular physical theater forms"). Somebody produces a FedEx envelope from the imaginary Edsel Foundation containing news of an arts grant—and a stinging satire of group creativity is the upshot. Hamstrung by political correctness, the troupers discover, in a furiously funny number called "You Can't Say That," that words like "fascist," "vegan," "redneck," "retarded," and "gay"

are too hot to handle on stage. What does that say, we're left wondering, about the challenge of broaching the sensitive racial divide that is the essential subtext of the show we're watching?

And now a word from our sponsor: In a laugh-packed sketch, butcher-hatted Mike Dick (David Ferney) of Mike's Meats plays dodge-the-hatchet with a puppet chicken—and induces more reminiscences of Blue Lake's salad days, back before the logging industry failed and there were three ("count 'em, three!") butchers in town. Mike's commercial is interrupted by the noisy entrance through the audience of a quartet of "buff guys in togas" bearing a pallet, Cleopatra-style—on which is discovered Buddy's deceased (but very talkative) aunt Dorothy Dugan (Dawn Falato again, reprising a role that has clearly made a comic impression in previous Dell'Arte shows). Aunt Dorothy has some pithy philosophical advice for all those who are worried about the importunate changes occurring in Blue Lake: "Get your keisters in gear and do something about keeping it special."

> "…in this space/there have been moments that have transcended just about/ everything we know."
>
> —poem by Peter Buckley, former Dell'Arte school director, 1996

The visit from beyond of Aunt Dorothy Dugan puts Buddy in a pensive mood, and he embarks on a monologue about the time his cousin, "Louis the dog-faced boy," conducted a trouble-plagued campaign for the mayoralty of Blue Lake. The time came, Buddy remembers, when the pressures of politics grew overwhelming, and cousin Louis yielded to his canine nature: Gazing out the window onto the town, Louis began to howl—and kept on howling. "He howled," Buddy says, "until the roof rose and left its foundations and floated up into the night sky." If those howls had therapeutic, perhaps even magical, qualities, shouldn't their blessings fall on us as well?

Buddy invites the audience to howl along, to raise a communal howl, as a stream of white pin-lights, stretching from the stage outward into the newly fallen dusk, twinkles on. It's the simplest of low-tech effects, a switch thrown,

a minishift in spatial perspective—but the payoff, intensified by the participatory exultation of howling in tandem with some 250 others sharing this grassy hillside, is sudden enchantment. This might be the moment *Wild Card* was made for, the distillation into simple abstract forms (the wordless shout of the human voice, light coursing into darkness) of the play's themes of collective endeavor and hope for a viable future.

But quick...before such illuminations can do more than flicker at the corners of the audience's collective consciousness, onto the stage rush the energetic elders of the Blue Lake Grange and Museum Society, flipping pancakes and dancing like geriatric rejects from *Seven Brides for Seven Brothers*. Intermission.

> *"The big picture of this project is to encourage community discussion—to animate democracy."*
>
> —*Joan Schirle,* Wild Card *director, interview*

9:15 P.M.
Real darkness makes everything seem closer: the actors on stage, your companion on the grass, the strip of stars overhead. When the band takes the stage for Act 2, the projected image of a rough cityscape of lights and tall buildings appears behind them, a harbinger of the changes that might be in store for this quiet hamlet if all that *Wild Card* has imagined should come to pass. Time now for some points of view, Buddy announces, from the people to whom that future matters most: your friends and neighbors.

First up among these Blue Lake characters is Riccardo Milpedas (Oliver Steck), the self-appointed patrolman and protector of the levee along the Mad River southeast of town. Furiously custodial of this crucial swath of Blue Lake territory, Milpedas declares from his soapbox, with unequivocal fervor: "This levee is mine—it ain't for no hippies!" Not even city councilman Sherman Shapiro (who's here in the audience in person on opening night, laughing with great good humor at his own caricature) can escape Milpedas's wrath when he makes the mistake of choosing the levee as a congenial spot for a dog walk.

If the casino has generated prosperity, so has the promulgation in Blue Lake of an obscure Swedish religious sect, represented by locals Ann Bobansson and Bjorn Bendoverman (blond-bewigged Lisa Wiksten and David Ferney), who share a sketch that generates mild amusement with its Scandinavian caricatures. But when Buddy returns (armed with some good-natured jokes about another "sect" that's likely to be within hearing distance—Unitarians),

a question central to *Wild Card*'s underlying narrative rears its troublesome head: Why aren't there any Indians in this show?

"We did ask, but the cultural gap may be too wide," Buddy reasons. True, he concedes, there have been moments of bad blood between the Blue Lake city government and the area's Native Americans. But "it's the silence that bothers me," Buddy says, the absence of the Indian perspective—"a silence born of others not wanting to listen." He and the band offer a musical explanation in "Why There's No Indians In This Show," a twangy, honky-tonk anthem that once again takes the historical perspective:

> *"So after hundreds of years and millions of beers,/We're all getting kinda' the same./We all stomp on the land/And drive minivans/We all love to play that bingo game./But in some ways we differ/Makin' us a bit stiffer/Every time that we wanna know/Why there's no Indians in this show."*

Is it a genuine explanation? No, but it *is* a witty and calculated riff on *Wild Card*'s central paradox: How can you tell a story in which Native American initiative is the central action without incorporating a Native American point of view? That's precisely the conundrum that Dell'Arte has ended up wrestling with in *Wild Card*, despite the months of carefully planned preliminary meetings, the invitations to participate that were offered, the authentic good will that has been shared over time between the performance troupe and the Rancheria and its leaders. Once asked, the song's titular question persists, hovering at the edge of scenes and just beyond the reach of the dialogue, like an expected guest who's failed to show up for a party.

> *"I like political theater!"*
>
> —*Alex Ricca, city councilman, parodied as Albert Rixall in* Wild Card

But on the party goes, as the Blue Lake City Council—individually burlesqued, engendering hilarity among audience locals—is transformed into a finger-snapping, booty-shaking boy band, a precision-choreographed N-Sync of refugees from city hall, mouthing prerecorded harmonies about city budgets and election deals. Scarcely have the cheers for their unlikely athleticism begun to recede when the voice of another actual Blue Lake figure—the cranky and opinionated city councilman Albert Rixall—emerges from the noise.

Rixall, rendered bigger than life in a tour-de-force cameo appearance by Dell'Arte veteran Donald Forrest (who played the part in a wheelchair because

of recent back surgery), has vociferous complaints about the advent of Blue Lake Casino—"This town ain't a democracy! Why? Because everything is *delegated*... D, E, L, E, G, A, T, E, D!"—he descends into sputtering comic incoherence.

So what do other folks think? Buddy fields a telephone call-in, and on the line we hear the comments of actual Blue Lake citizens (more specifics gleaned from the dialogues and interviews): a school janitor who finds the casino congenial enough; Gino, a regular at the nearby Logger Bar, who voices some half-sober optimism; an edge-of-towner who's noticed that with the hills full of lights at night, you can't see the stars. Now Buddy's in the audience with a microphone, Letterman-style, giving a sampling of other folks a platform to talk about their biggest fears or greatest hopes for Blue Lake. A pair of very articulate youngsters (who are, in fact, actor Fields' own son and daughter, Sean and Maya) have their say, too: "Is it fair, no more skateboarding on side-walks?" the boy complains.

Clearly it's time for "a number for the next generation of this place," Buddy decides. Singer Dawn Felato, balancing dangerously on the edge of the building's roof as spot-lit smoke billows into the night sky, borrows a Kander and Ebb *Cabaret* tune for adolescent reflection: "What will I inherit apart from the wind,/That carries the scent of the sea?/What is the tale I can't wait to begin?/ Tomorrow belongs to me." Descending to stage level, she joins hands with the Fields siblings to note: "When the power goes out/I can still see the stars ..."

It's Buddy, in a funny but poignant closing monologue, who has the last word on Blue Lake's now-and-future conundrum, its crisis of identity and coexistence. The uniqueness of the place is his touchstone: "Blue Lake has always had its streak of difference—sometimes celebratory, sometimes nasty—but, oh, so necessary."

"In the long run, local people and the tribe are going to find the common ground they've been searching for, for years. Both governments are going to understand they have a symbiotic relationship, that they need to work together."
—Blue Lake city councilman Eric Ramos, Wild Card *video*

POSTCRIPT, JUNE 20, 2003
A new version of *Wild Card*—"It's called *Wild Card 1.5*, as it has about .5 worth of new material," declares Michael Fields—opens tonight in the Dell'Arte amphitheatre, almost exactly a year after the show's original debut. The new material Fields is talking about may be minimal, but it is critical.

"We are now working with a local Native American actress in the show, who is playing the role of Buddy's longtime lover," Fields explains. "They split 10 years ago, which is one of the reasons he left town. He runs into her by chance his first night back in 10 years. The difficulty of their relationship over time mirrors the relationship between the town and the Rancheria. The cultural divide only alluded to in the first version is personalized. As her character says, 'This is personal. It would be easier to go it alone. But deep down we know we can't.'"

The new Native American character also cracks a lot of "Indian jokes." As Fields notes in his final report to Animating Democracy, "My regret as a playwright, and a problem in the piece, was that I did not feel comfortable making fun of the native community the same way I felt comfortable making satire of all the other elements of the community. The fact that we could not find the appropriate humorous angle on that community was a drawback in the work and one that we hope to solve this year."

Much as postmortem critical discussions have engendered internal changes in the *Wild Card* script, community discussions around the project have led to a number of practical civic developments in Blue Lake. These include:

- A community group began to meet once a month to talk about the future of the town; it also meets with Arla Ramsey, tribal chair of the Rancheria, about the same topic.
- Based on the play, two people decided to run for Blue Lake City Council (one of whom won and created and filled the position of city council liaison with the Rancheria).
- Negotiations are under way for the Rancheria to provide a Native American scholarship to the Dell'Arte international professional training program each year.
- The local PBS affiliate broadcast the half-hour documentary on *The Dentalium Project*, in conjunction with the premiere of the new version of *Wild Card*.

The gambling hall stands tall for all to see, /And the river runs beside it, still wild and free.

—"The Ballad of Blue Lake" by Fred Neighbor and Joyce Hough

"To save paradise
they put up a parking lot"

DAVID ROOKS

INTRODUCTION

In summer 2002, a few blocks away from Dell'Arte International, a theater company and school for physical comedy in Blue Lake, CA, a small band of predominantly Wiyot Indians known corporately as the Blue Lake Rancheria completed construction of a casino. Among reasons given for building the casino was to fund efforts to reintroduce and re-educate tribal members in traditional tribal customs, mores, and language. Surrounding the casino was the largest parking lot in the county.

In anticipation of this development, Dell'Arte Company, a local community-based theater group, sought and received funding from Animating Democracy, a program of Americans for the Arts, to initiate a dialogue on community reaction to the casino. From this dialogue, material was drawn for the writing and performance of a play. After the play, video footage of interviews with dialogue participants was combined with scenes from the play and assembled into a documentary that comprised the third part of the overall *Dentalium Project*. To respond to all this, three writers of diverse backgrounds were commissioned by Animating Democracy: a theater writer, critic, and editor from New York; a playwright and arts writer with a special interest in community-based theater and cul-

tural planning from Los Angeles; and a Native American journalist from South Dakota. I was the third.

BACKGROUND, HISTORY, AND OPPORTUNITY

My name is David Rooks, tribal member of the Oglala Lakota Nation. I live in the sacred *He Sapa*, or Black Hills, a half-hour north of the Pine Ridge Indian Reservation in southwestern South Dakota. As a journalist, for some years I reported on indigenous issues affecting Plains tribes. Besides assaults on land and water treaty rights, expropriation of tribal cultures, severe joblessness, and high rates of physical and mental health problems in native populations, I also covered the proliferation of casino gaming and its consequences on native communities.

Over time, a pattern has emerged in the "casino-ization" of tribal economies. Wherever a tribal government considers construction of a casino, little if any formal dialogue is expended on the project's civic and social impact. The irony is that even with the negative effects of large-scale gambling on communities well catalogued, save for sporadic protest here and there the notion that casinos are intrinsically desirable receives little organized challenge. As tribal governments pursue them, tribal officials unfailingly frame the issue solely in terms of economic development. Consequently, casino construction is presented to the mass of tribal members as a *fait accompli* where the only difficulties identified are simple matters of material and regulatory detail. A particularly trenchant aspect of this pattern has been the later inability of these governments to render any admission of adverse social effects—minor speed bumps, apparently, on the road to sugar plum dreams.

Nationally, the golden goose of tribal gaming is under intense scrutiny, and with good reason. For some tribes, the fabulous amounts of money involved would make Croesus blush. In "Wheel of Misfortune," a special report in early December 2002, *Time Magazine* framed some of the crop of inequities surrounding Indian gaming:

> Imagine, if you will, Congress passing a bill to make Indian tribes more self-sufficient that gives billions of dollars to the white backers of Indian businesses—and nothing to hundreds of thousands of Native Americans living in poverty. Or a bill that gives hundreds of millions of dollars to one Indian tribe with a few dozen members—and not a penny to a tribe with hundreds of thousands of members. Or a bill that allows select Indian tribes to create businesses that reap millions of dollars in profits and pay no feder-

al income tax—at the same time that the tribes collect millions in aid from American Taxpayers. Can't imagine Congress passing such a bill? It did.

In a section entitled "Fraud, Corruption, Intimidation," *Time* encapsulated a pattern of the results of Indian gaming legislation:

> The tribe's secrecy about financial affairs—and the complicity of government oversight agencies—has guaranteed that abuses in Indian country growing out of the surge in gaming riches go undetected, unreported and unprosecuted. Tribal leaders sometimes rule with an iron fist. Dissent is crushed. Cronyism flourishes. Those who question how much the casinos really make, where the money goes, or even tribal operations in general may be banished. Indians who challenge the system are often intimidated, harassed and threatened with reprisals or physical harm. They risk the loss of their jobs, homes and income.

Time's investigative piece lent further credence to several allegations I had heard as a reporter. My conviction deepened that individual Native Americans, solely for the sake of historical victimization through tribal affiliations, were being handed the keys to the most nakedly blatant system of capitalist exploitation American society has to offer, as if part of some vast and mysterious trickster narrative. Over the graves of historical grief and broken treaties, twenty-first-century pleasure palaces were shape-shifting into audacious prominence. Over time, greed unfailingly amazes.

For the past few decades, I have watched the swift diminution of authentic Lakota culture through the passing of tribal elders in transitional generations, and as succeeding generations grew less and less able to resist the social torrents of a mass media society. Fewer and fewer Lakota speakers survive, and the practice of revered customs and community values have come to exist in ever smaller and more isolated pools. Will our people eventually dry into a powdered version

> Wherever a tribal government considers construction of a casino, little if any formal dialogue is expended on the project's civic and social impact.

of some corporate brand, existing only to further the financial interest of a bone-bleached legal entity? Will our casino, Prairie Winds, eventually come to own us? Since tribal casino expansion has been such a political juggernaut wherever it has taken root, I hoped to find some forum where other voices on

the subject could be heard. When informed of Dell'Arte's search for a native writer, and for what purpose, I eagerly sought involvement.

From the start, I felt strong mutual interests with Animating Democracy's support of Dell'Arte's *Dentalium Project* (dentalium is a local native word for beads used in traditional games of chance). At its heart it was, for me, a totally unfamiliar approach. Animating Democracy, funded with a Ford Foundation grant to Americans for the Arts, was exploring ways to use art to advance civic dialogue. *The Dentalium Project* was to commence a community dialogue on the impact a tribally owned casino would have on the small and, for the most part, non-Indian community of Blue Lake, California. I flew to northern California with a strong sense of anticipation, and drove into Blue Lake on the day the Rancheria planned the grand opening for its medium-scale, cookie-cutter-style casino. The gala would be concurrent with opening night for Dell'Arte's play called *Wild Card*.

From interviews, I learned that while a small number of tribal members had taken part in the dialogues, no Rancheria official had deemed it necessary to invite or consider non-Indian community opinion about their casino. Tribal chair Arla Ramsey said this practice of nondialogue was nearly traditional in Blue Lake. To her memory, no local white official had ever paused before the start of an endeavor to ask, "I wonder what the Indians think?"

POINT OF VIEW

Before relating a few of my experiences with *The Dentalium Project,* it might serve to unpack some of the mental and emotional baggage I brought to Blue Lake; not a private agenda so much as bundled preperceptions.

For a few years, with growing frequency my work took me into first one and then another tribally owned casino on various reservations. Received wisdom was if you needed to interview a tribal government official, the likeliest success could be had near the buffet table in that tribe's casino. From the Hunkpapa's Prairie Knights Casino near the west bank of the Missouri on Standing Rock reservation in North Dakota to the Oglala Lakota's Prairie Winds Casino nearer home, more than the names were similar. If you'd been to one you'd seen them all.

Every sight and sound heralds the rapid transfer of loot, from the incessant ringing of bells to the surreal neon and chrome glow of 24/7 light steadily sucked into shadow by plush-cut pile carpeting. From a tribal chair's point

of view, God bless the patrons padding silently through the maze of blaring video machines and over indeterminate carpets, strays of Alzheimer's ghosts: anemic seniors, some trailing aluminum oxygen carts like listless pets, shuffle from machine to machine, token buckets to chest; tribal employees, terse and purse-lipped, cash payroll checks at the teller windows (as rent or some equivalent waits); sucker buses, sometimes over a dozen, unloading herds of easy marks at the front entrance, men and women who often travel hundreds of miles for the opportunity to throw money into Tribe X's coffer. With this as regular backdrop for my interviews with tribal politicians, little wonder they often chose to be magnanimous: *noblesse oblige*, reelection dreams are made of this.

Tribal chair Arla Ramsey said this practice of nondialogue was nearly traditional in Blue Lake. To her memory, no local white official had ever paused before the start of an endeavor to ask, "I wonder what the Indians think?"

Depending on your point of view, you could call these casinos flotilla of greed or prairie islands of hope. I gained ambivalence toward these panaceas and wondered why. Without tugging a thread of the dismal tapestry that is many reservation economies, it is acknowledged that desperation is often an imbedded feature. My tribe's jobless rate is estimated at somewhere north of 70 percent, and Shannon County, which makes up the bulk of the Pine Ridge Reservation, has been repeatedly named the poorest county per capita in the United States. Poverty among any people denudes even the most vigorous cultures of hope in the social compact. Among the Oglala Lakota, economic destitution has gnawed at the cultural fabric to the point where cynicism, even toward the culture, sets in like mold. In such a climate, casino dreams can seem to descend like godsends.

But can financially successful tribal gaming, even when it brings with it plentiful versions of "McJob," provide an antidote to cultural disintegration? Or, does it speed the process? In casino tribe economies, how long can the tribe cling to cultural virtues formed in hunter-gatherer existences a few generations removed? From personal observation: not very long. Indigenous culture, or what is left of it, run through the acid vats of casino imperatives, is eventually stretched and tanned to museum quality artifact. To witness the process in embryo, see the decorative schemes and gift shop motifs of tribal casinos. There witness culture tagged, discounted, and reduced to kitsch.

But can financially successful tribal gaming, even when it brings with it plentiful versions of "McJob," provide an antidote to cultural disintegration?
Or, does it speed the process?

Another recurring question before arriving at Blue Lake was: How viable are the civic virtues and cultural customs of a tribal people whose main economic engine is a scheme that plays on their neighbor's baser urges: the idea that you can get something for relatively little, a haul beyond the dreams of avarice for a pittance. Especially when it is generally understood by these tribal people that that "little" will often be everything in their neighbor's bank account? When it comes to casino gaming and its well-refined allure—tribal, or otherwise—this postulation is miles from hyperbole. Add tribal gaming's potential for social destruction in cultures already struggling beneath high joblessness, alcoholism, drug addiction, and childhood neglect and abuse and you pour a flammable onto a blaze. Negative effects of casino gaming are not merely a tribal issue, they are a human problem.

These thoughts in mind, I sat down with tribal chair Arla Ramsey after the lights, figuratively speaking (we were outdoors), were turned down to start Dell'Arte's play.

DIALOGUE

Among opportunities in *The Dentalium Project,* I had looked forward to study of and experience with the community dialogues. When I arrived I learned these discourses were, practically speaking, inaccessible. Further, a list of the participants or even a partial text of the sessions was unavailable. Of the eight official dialogues, I am told six were documented, though none of my efforts to secure copies, or even summaries, of these documents bore any fruit. I was informed that an effort to place community participants at their ease and to promote more spontaneous participation rendered anything peripheral to this goal undesirable. Perhaps this extended to their recording. While there was no conscious exclusion of the project writers from the dialogues, save for one brief and truncated meeting (conducted by a local public television station) convened immediately after the first viewing of the play, this was the net effect. Being somewhat *ad hoc,* the postplay meeting was neither helpful nor spontaneous. Looking back, these problems now seem predictable.

None of the three writers were contracted earlier than May 2002, whereas the last dialogue was in April. It was certainly not Dell'Arte's design to exclude the

writers. My experience was they extended every reasonable courtesy to us, and then some. Later interviews with some dialogue participants found them of good assistance, yet subject to the normal aphasia of time-encumbered memory. While able to well present their own beliefs, this did not hold for articulating the concerns of others, nor was there much facility for representing the give, take, and blending of various points of view that all agreed took place during the dialogues. Still, the choice to at least partially insulate what were, after all, quite public sessions of give and take, slightly mystified, given every dialogue participant was well aware his or her input could be used later on stage. Because Americans for the Arts, the funding agency for the dialogues and the play, made provision to hire three writers whose purpose was to provide diverse responses to *The Dentalium Project* overall, not having the writers in place early on greatly limited my ability to contextualize the process. As much as anything, it was a source of needless mystery in conversations with the other writers. 20/20 hindsight, I suppose. What remained was to take in the play.

WILD CARD

Loosely drawn from the dialogues, playwright Michael Fields set *Wild Card* in an old-fashioned radio revue broadcast in the year 2012. The background theme was a celebration of the 10-year anniversary of Blue Lake Rancheria's casino opening. This artfully provided an unassuming context for presenting a broad range of views about the casino's effect on the community. A few weeks prior to the play's opening, Fields mailed me a copy of a nearly final version of the play's script with the proviso that it was a work in progress. In fairness, having read the play I came to its opening with a prior sense that it lacked something. A hasty judgment, I told myself, even as I hoped additions would be made.

> ...the choice to at least partially insulate what were, after all, quite public sessions of give and take, slightly mystified, given every dialogue participant was well aware his or her input could be used later on stage.

Inasmuch as a layperson can form a qualified judgment, I found *Wild Card* entertaining. The skills, timing, and talents of the actors energized the crowd, a testimony to Dell'Arte. That said, and with a nod to the theatrical experience and talents possessed by the other writers, I will confine comment on the play to a minor feature and a final overarching impression. That feature, a song, assumed some notoriety at a later Animating Democracy meeting of *Critical Perspectives* writers in San Francisco. First, some context.

Over the play's first act, a variety of community views about the casino were adroitly and comically aired. However, as the play went on its variety seemed increasingly superficial for lack of a certain community segment's points of view. The missing viewpoints were those of the Blue Lake Rancheria's native community. A year later, this still astonishes. Standing in, apparently, for a shred of native opinion, was a snappy country western tune that retailed various rationales for "Why There's No Indians In This show." Perhaps intended to be droll, tongue-in-cheek, or ironic, the song was none of these. Because much of the play involved light-hearted caricatures of actual community members—a longstanding and popular practice in many Dell'Arte productions—it seems probable that Fields and the play's director, Joan Schirle, felt the need for some form of explanation as to why there were "no Indians in this show."

Unfortunately, in calling attention to this absence no song could possibly explain it away. For Native Americans in attendance the question hovered like smoke over the rest of the performance. Was my discomfort merely an example of overly sensitive and essentially humorless politically correct cant? It's possible, but unlikely. There was a context: As is well established, most of the play was, by design, drawn from community dialogues. After the play, I remember thinking: "At least in the fifties, Victor Mature *played* Crazy Horse; he didn't just sing about him." I wondered if the old Latin phrase *res ipsa loquitur* —the thing speaks for itself—applied to the song. And was it emblematic of local facts on the ground? Had *Wild Card*, albeit unintentionally, reflected the larger truth about white/native nonrelations in the Blue Lake community?

The song aside, finally there was about *Wild Card* an overall timidity in relationship to its catalyst: tribal gaming come to a small community. After two readings of the play and attendance at two performances, I concluded that—as I understood the issues—*Wild Card* made no attempt to directly address any of the issues pertinent to Indian gaming, or even to gaming's potential dire effects on at least a portion of its community. Indeed, *Wild Card* seemed barely to consider gambling in any sense beyond its title.

WILD CARD: THE VIDEO

Two close viewings of the video produced by KEET, a local public television station, were valuable in providing the nearest thing to a peek at the dialogues. Unfortunately, the 95-minute video placed two-thirds of its running time in service to extended cuts taken from a live performance of *Wild Card*. So, too, the choice of play segments seemed, generally, to be the least relevant to any constructive analysis about the potential impact of casino gaming.

That said, several clips from interviews with tribal chair Ramsey, Blue Lake city councilman Brian Julian, community planning commissioner Kit Mann, and Dell'Arte's Schirle provided often concise commentary that spoke directly to these issues. Mann, Schirle, and Ramsey could be eloquent in their presentation of community concerns, both native and non-native. But, again unfortunately, civic dialogue here received short shrift. Forty minutes into the video there had been no reference to the concerns the casino raised in the community, and at 49 minutes the first reference to the dialogues surfaces. Since the highlighted segments of *Wild Card* bore no obvious relationship to casino realities, Native Americans past or present, or community members' fears and hopes concerning the advent of tribal gaming, it was not until the final third of the video that the expressed goals of *The Dentalium Project* seemed to come into any focus.

Had *Wild Card,* albeit unintentionally, reflected the larger truth about white/native nonrelations in the Blue Lake community?

The close viewing of the video did reveal Animating Democracy's promise at the margins. At times in the interviews, more was revealed about community attitudes than perhaps was intended. For example, near the video's end, community planner and nonnative Mann says, "The Rancheria can choose to contribute to the community; they can choose not to. And so the community doesn't really get a say." My first (and second) reaction on hearing this was: Isn't the Rancheria part of the Blue Lake community? So many assumptions seemed to be revealed in that statement, enough that I found myself posing several questions. In other words: I wanted to join the dialogue.

ART AND DIALOGUE

It may be that any form of political consideration is sorry motive for creativity and increases the likelihood for bad art. Still, what strikes the flint of imagination can be anything. I believe *The Dentalium Project*'s results were a mixed bag, perhaps due somewhat to a failure of nerve. Can art be considered effective or successful if it seems merely to safely parody and, finally, ratify an incomplete collection of civic attitudes? Given what I brought to the dance of *The Dentalium Project*, postproduction I found the general response to the play to be somewhat breezily self-congratulatory. Placed in light of realities that surround Indian gaming and their effects on numerous native and nonnative communities, the play is, finally, irrelevant. This is no measure of *Wild Card*'s artistic merit; actual theater critics who have seen the play assure me

Dell'Arte's production was first-rate. In fact, at times they seemed bemused by my hazy objections. I weakly related to them how I had watched *Wild Card* chagrined by a certain bulkiness of personal history. Or, maybe, I should just lighten up. After all, Michael Fields informs me that *Wild Card* is being rewritten, and will include a Native American as a key performer. That's progress.

Should "civic art" be more prepared to take a chance, to gamble on rejection or angering a constituency? Or does such a question betray a wrongheaded view about art and art's purposes?

So, should the creative purpose in aesthetic renderings meant to address vital civic concerns aim deeper than *Wild Card*? Should "civic art" be more prepared to take a chance, to gamble on rejection or angering a constituency? Or does such a question betray a wrongheaded view about art and art's purposes? Because *Wild Card* was the fruit of Dell'Arte's grant from Americans for the Arts, a grant specifically intended to promote community dialogue through civically engaged art, I admit I came to the play with presuppositions. Among these, I believed a distinguishing characteristic of the ensuing art would be a fearless clarity in its treatment of the issues involved. A central statement in the book *Animating Democracy: The Artistic Imagination as a Force in Civic Dialogue* is: "The ability for the public to draw meaning from the artistic experience is, in part, a measure of the success of civically engaged art." This strikes me as a worthy and laudatory measure. I hope, more and more frequently and in more and more places, this will become one of the goals of our art in the future. I continue to believe that, as an approach, art engaged in civic dialogue is a tremendous untapped resource for engagement with civic problems. Seen in that light, *The Dentalium Project* was certainly a worthy beginning.

The Arts and Development: An Essential Tension

FERDINAND LEWIS

PREFACE

There's a long-standing complaint from some quarters in America, perhaps drawn from our Puritan tradition, that the arts don't make good economic sense: If the arts can't stand on their own two feet in the marketplace without subsidies, like any other "business," it shows that the arts are something we can do without. For instance, in response to a poor economic climate, California is now taking decisive steps to essentially abolish its state arts council.

Meanwhile, new research shows that the arts are an economic- and community-planning tool that municipal development specialists cannot afford to ignore. Not only do the arts make an immediate and measurable economic contribution to local economies, the research says, but also the long-term presence of the arts tends to generate a kind of creative culture that helps to attract and nurture industrial innovation and market leadership among cities. With this new research, arts advocates can presumably argue that the arts are, at last, demonstrably useful.

Although evidence—and common sense—suggests that the arts ought to be integral to development, there is an underlying *tension* in that premise, since economic development is usually pragmatic, goal-oriented, and quantitatively evaluated, while the arts are idealistic, expressive, and qualitative in nature.

Because of that tension, positioning art in development may be more complex than simply demonstrating its contribution to economies.

This essay will describe a professional community-based theater project that ran up against such a tension in the context of local development, and found itself eyeball-deep in municipal complexities. How it attempted to navigate those complexities can demonstrate some of the opportunities and pitfalls of the relationship between professional community-based arts and local development.

A COMMON GOAL AND AN ESSENTIAL TENSION

Science historian Thomas Kuhn describes a necessary internal conflict that can be found in any truly important idea, which he calls an "essential tension." The inherent conflict in the relationship between the arts and development embodies such a tension. The tension persists even at the point where the two fields seem the least contradictory, as in their common goal of *community identity*.

The idea of community identity is a way to comprehensively describe the aims of development—identity is the thing that development develops. Ideally, development tries to get inside of the economic and social forces continually acting on our communities, and guide and shape and augment them in ways that make a place into, well, more of a place. Similarly, one of the subjects of professional community-based artmaking is community identity. Like development, community-based art operates from inside the forces that shape communities, framing them into local identity.

Yet, while development and the arts both seek to be on the *inside* of forces shaping a community, the arts must also stand *outside*, looking in, offering each audience member a chance to see his or her individual experience in a new or unusual way. While art involves its audience in a subjective experience, at its best it also liberates the individual's singular vision into a big-picture vision of what life could be. In other words, economic development focuses on the collective, while art simultaneously focuses on the collective and the individual. At their best, both help us see what our communities can be, while art also helps *me* imagine what *I* can be.

Although this essay cannot go deeply into the matter, it should also be pointed out that the inherent conflict between art and development can in some cases provide the only available field of expression for communities struggling against institutions of power. For that reason alone (although there are many

others) I hope that the case study presented below will suggest why the tension between art and development is indeed "essential."

EXAMPLES OF COMMUNITY TENSIONS

In 2002, Dell'Arte, a rural community-based ensemble theater that has been in residence in its hometown for more than 25 years, accepted a grant from Americans for the Arts' Animating Democracy to create a theater project using an "arts-based approach to civic dialogue." The project was to be about the controversy surrounding plans by Native Americans to build a casino in the community, and perceived threats of subsequent development in Blue Lake, California (population 1,300), a small town in Humboldt County.

From a development perspective, three tensions pop up right away. First, although the town and the reservation are separate communities—actually, technically they're separate *countries*—the town geographically surrounds the reservation on three sides. What happens in one inevitably impacts the other.

Although the need for cooperation between the town and the reservation is real, it is thwarted by the second tension: the cultural divide between the two communities is reinforced by the history of segregation and oppression of native communities by U.S. institutions nationwide. There is a further complication: Dell'Arte is a major player in the city of Blue Lake's economy and culture, and is therefore a political stakeholder in the community that *The Dentalium Project* was meant to represent.

…while development and the arts both seek to be on the *inside* of forces shaping a community, the arts must also stand *outside,* looking in…

Throughout this essay, the city of Blue Lake will be referred to as the "City," and the reservation, known as the Blue Lake Rancheria, will be called the "Rancheria." The combined City and Rancheria communities will be referred to as "Blue Lake." Except where otherwise indicated, the story of the City, the Rancheria, and *The Dentalium Project* are drawn from interviews with the people involved. I am grateful to them all for their patience and willingness to share their stories.

STAKEHOLDER: CITY OF BLUE LAKE

Although it is an incorporated municipality, the City in many ways embodies the image of "American small town," with its population of 1,300 and its

bucolic rural setting. The City was a northern California lumbering hub in the boom days of the timber industry at the turn of the last century, with working sawmills, saloons with batwing doors, houses with picket fences, and thousands upon thousands of trees sold down river for enormous sums of money.

The City's fortunes were tied almost exclusively to the lumber industry, so when that industry collapsed in the second half of the twentieth century, the fortunes of the City went with it. The City today is a quiet place along the untamed Mad River, home to a brewery; a bit of light industry; some truck farmers; and Dell'Arte, a professional theater and training conservatory of international reputation. Today, the number of saloons is reduced to one; the whitewash peels; and the City is mostly a bedroom community for its employed citizens, who tend to work in other parts of the county. With its dozen employees, Dell'Arte has been for years a major City employer.

> There is as yet no infrastructure for tourism, and little ability to develop the local economy. Dell'Arte is one of three businesses on the main street.

In interviews, City residents told me that their principal concerns were for preserving the City's small-town character; preventing an increase in crime; and protecting the lush surrounding countryside and the Mad River, which runs through town. The City Council understands that development is the best tool to shape the City's future, but volunteers sustain much of the efforts, making it difficult for projects to gain momentum. There is as yet no infrastructure for tourism, and little ability to develop the local economy. Dell'Arte is one of three businesses on the main street.

The City has made a variety of attempts at development over the past few decades. One such attempt—the case of Ultrapower—illustrates the depth of the cultural divide between the City and Rancheria.

THE CASE OF ULTRAPOWER
In the early 1980s, the City was nearly bankrupt, its resources so depleted that police protection was reduced to 45 minutes per day. The City Council at the time managed to attract one industry to town—a power generator called Ultrapower. It turned out that the Ultrapower smokestacks dropped ash on the City, but the taxes levied from the plant enabled the City to beef up police protection.

Today, Ultrapower is no longer operating, and the ash is gone, but the City residents that I interviewed remember well the decision to welcome the plant to town, despite its ash by-product. For City residents, the ash was a trade off. There was no such trade-off for the Rancheria, however.

STAKEHOLDER: RANCHERIA

The Rancheria is surrounded on three sides by the City. Walk across Chartin Street in one direction and you're in the City, in the other direction, you're on the Rancheria. Ultrapower's ash fell on the tribe's homes, but nobody on the City Council asked Rancheria residents if the trade off was acceptable to them. Nor did the tribe share in the benefits of the trade off.

The Rancheria is small (less than 40 acres), with few residents. It is situated on traditional Wiyot land, although the Rancheria is composed of the descendents of many tribes. The Rancheria was originally founded in 1908, but ownership was subsequently disputed, and the land was taken from the Indians for a time. Rancheria residents worked in the lumber industry until the bottom fell out of that economy, and then, like the local non-natives, they worked wherever they could.

The current residency began in the late 1950s. Few native speakers live on the Rancheria. Even though the Rancheria and the City are geographically the same community, the Rancheria has never been seen as an active stakeholder in City development, nor has City planning been considered in Rancheria development, until now. The most striking feature of the relationship between the City and the Rancheria is the invisible cultural divide between them, reflected in a historic lack of opportunity and political influence for the Rancheria, and in the City's current strategic economic development plan.

DEVELOPMENT PLANS

Drawn up as recently as 1997, the City's economic development plan mentions the Rancheria only in passing, as a potential magnet for cultural/heritage tourism. Truthfully, it would be hard to imagine the Rancheria as a cultural tourism site even today. The only tourist-oriented indigenous culture present is in the new casino's gift shop. The lobby of the tribal office is decorated with Navajo art. It is also impossible to overlook the fact that the Rancheria is located next to the City's sewage ponds.

The City has not included the Rancheria in its development plans, but then neither has the Rancheria included the City. Over the years, Rancheria residents

tried lots of ways to make a living, like chicken farming, raising horses, and other land-based enterprises.

According to tribal chairperson Arla Ramsey, the Rancheria's attempts at economic development were always land based, "That's just in the tribe's nature." This is borne out by research showing that a sophisticated property-based economy—a real estate system—in which land was bought and sold in exchange for symbolic dentalium shell money, was in place in what is now Humboldt County long before the first Europeans arrived. So, what little development there has been over the past 30 years in Blue Lake has proceeded along two separate trajectories, which has contributed to the current cultural divide. Although the Rancheria did not seek legal recourse in the Ultrapower matter, back in the 1970s a new road was proposed, and without consulting the Rancheria, City officials aimed the road right through tribal lands. The plan was nixed at the last minute by a lawsuit brought by the Rancheria.

INDIAN GAMING

Like many Native American tribes, the Indians of Humboldt County had an ancient tradition of sport gambling, playing for dentalium abalone shell money. But opening a casino on tribal lands was a project unlike anything the Rancheria residents had considered.

There were Indian gaming success stories in the state, though. Indian gaming had become an overnight economic success for many of California's tribes. Today, the Indian gaming lobby is the most well-heeled in the state. With no other immediate option for making money, the Rancheria found some out-of-state investors and announced that Blue Lake was going into the casino business.

Tensions between the Rancheria and City residents began to escalate almost immediately. The Rancheria's sovereignty meant that the City's input into casino planning was minimal, which only exacerbated the situation. It was into this situation that Dell'Arte inserted itself with *The Dentalium Project*.

ART AND TENSIONS

The role of art in the clash of cultural identities in not a new idea. "Beauty today can have no other measure except the depth to which a work resolves contradictions," wrote theorist Theodore Adorno in the twentieth century. Adorno and many writers after him argued that aesthetic considerations must be an

essential part of the social landscape, because only art gives us the opportunity to stand apart from the contexts in which we are caught up and *recontextualize* them in ways that are liberating. Recontextualizing can be understood as a resolution of tensions, or a productive use of them.

"Beauty is either the resultant of force vectors or it is nothing at all," he continues. It is the responsibility of artists to allow their work to be shaped by the very same "force vectors" that shape the lives and cultures in which the work is made. Indeed, it's interesting to note that in Adorno's phrase above, the word "beauty" could be interchanged with "community identity" or "a sustainable economic development plan" and lose none of its rhetorical power.

> The most striking feature of the relationship between the City and the Rancheria is the invisible cultural divide between them…

I draw out this conclusion to illustrate the parallels between professional, community-based art-making and local economic development. Given the force-vector premise, it stands to reason that in some cases development and community-based artworks ought to be working at resolving the same tensions. Since both are ultimately concerned with community identity, both must, as Adorno says of art, "…cut through the tensions and overcome them not by covering them up, but by pursuing them."

While both community-based art and development are focused on affecting the processes and forces operating inside a community, artists must also simultaneously stand outside of the context of those operations. It is therefore easy to imagine that the more contradictory the context, the more difficult it could become for artists to establish and maintain an outside perspective while remaining civically engaged.

STAKEHOLDER: DELL'ARTE

Dell'Arte is a professional theater company and school of physical theater that has been in residence in a sprawling two-story former Odd Fellows Hall in downtown Blue Lake for over a quarter century. Despite its touring and renown in places as far-flung as Uruguay and Denmark, a significant portion of Dell'Arte's work has always been thematically linked to the stories of the local communities and cultures, including not only the white communities, but also the communities on the Yurok and Kurok (though not the Rancheria) reservations.

Each summer Dell'Arte brings theaters from all over the world to perform at its Mad River Festival, which takes place in conjunction with the Humboldt County Folklife Festival, all of which draws a large audience from communities around the county. Indian storytellers are always a feature of the festival. Over the years, Dell'Arte's style has come to include all manner of theater traditions, including eighteenth-century American-style melodrama; text/movement deconstructions à la Robert Wilson; the Grand Guignol style, which was *fin-de-siecle* France's shock-theater; circus; storytelling; and the spectacle of Brazilian-style street theater.

Through all of Dell'Arte's work, though, runs humor. Dell'Arte's specialty is physical theater, and comedy in particular. The company's craft is based in the *commedia dell'arte* tradition of the Italian renaissance, which specialized in social critique through parody and rowdy physical comedy. Laughter is nearly always present, and this is never more true than in their locally oriented works, which are the pieces that return the company to its *commedia dell'arte* roots. Dell'Arte's School of Physical Theater is accredited to offer undergraduate and graduate degrees.

Given the fast changes under way in Blue Lake as a result of casino development, and the theater's history of artistic engagement with the community, the growing division between the City and the Rancheria seemed a good subject for a new Dell'Arte project. The playwright and director understood that history and tradition would be important to the project, and titled it with the ancient native word "dentalium."

The Dentalium Project would initiate civic dialogue between the Rancheria and City residents about the coming of the casino and what it meant to all of Blue Lake's residents. From the dialogues taking place over the course of one year, playwright Michael Fields would draw material upon which to base an original play describing current attitudes and feelings about the coming of the casino.

NEED FOR CULTURAL RECONCILIATION

What contribution could an arts-based civic dialogue theater project hope to contribute to the situation in Blue Lake? It is easier to describe what should not be done:

- **Repackaging** the situation into a feel-good example of diversity. The past cannot be ignored, overlooked, or overwritten.

- **Simplifying** Blue Lake's tensions by explaining them away with nostalgia. As theorist Michael Storper asserts in his paper, "Poverty of Radical Theory Today," while a "celebration of cultures" might assuage guilt, it would ultimately contribute little to the resolution of tensions.

- **Advocating for the identity of one group over the other.** Even though the Rancheria is a historically silenced group, it has chosen to use the economics of Indian gaming to assert its identity. Although the economies of the Rancheria and the City are both very much in flux, both have the means to be heard by the county and by the State of California. What they probably need most is the means to hear *each other*.

…art gives us the opportunity to stand apart from the contexts in which we are caught up and recontextualize them in ways that are liberating.

The advocacy model might be useful if it could be adapted to advocate for a future Blue Lake in which the two distinct communities have a common, shared life. As Storper says, "It is not enough to document difference and advocate the interests of particular group. It is also necessary to think about how these groups can fit together." Given Blue Lake's growing divisions, cultural reconciliation is a goal that makes sense.

Although achieving a goal as large as reconciliation between native and non-native communities would require much more effort than any single civically engaged art project could possibly deliver, making a contribution to that goal would be a reasonable aim. At the very least, the arts could help imagine what such a reconciliation might *look like*.

MULTIPLICITY

How does Storper's idea, "the construction of a public sphere composed of individuals with equal dignity," become realized in a small northern California town composed of conflicting cultures? Again, this sort of identity conflict is not new, nor is the idea of diversity. Imagining the necessary interrelating of multiple-yet-distinct cultural identities, early twentieth century philosopher Gianni Vattimo concludes that artists have a unique advantage in trying to imagine "multiplicities."

Vattimo suggests that one way to seek out resolutions for the tensions brought on by the collision of multiple cultures, languages, and beliefs can be found by

"the artist as one aware of the multiplicity of voices…" The artist is the one who is able, he says, to stand outside the situation and recontextualize it in a way that those inside cannot. Artists then reflect that recontextualized vision back to the community in a work of the imagination.

The task for the artist, then, "is one of seeing how to bring a conscious multiplicity into effect within the construction of the work." This requires artists not only to thoroughly understand the conflicting opinions, histories, and cultures in a situation but also to be able to imagine a unique and productive dynamic between them, with cultural identities interrelated yet distinct.

This is not to suggest that multiplicities are necessarily *pretty*. There will probably have to be a lot of water under the bridge before Blue Lake's two communities can find themselves sharing a common identity. The first thing they need to do, though, is *talk*.

ARTS-BASED CIVIC DIALOGUE

The first phase of *The Dentalium Project* was a year-long research process in which Dell'Arte hired the Cascadia Forum, a local leadership development organization, as a consultant to guide eight "community dialogues" between Rancheria and City residents, regarding the coming of the casino. Dell'Arte artists participated in most of the dialogues, and everyone understood that the dialogues were source material for a play that the theater would later create and perform in Dell'Arte's theater in Blue Lake.

My interviews with dialogue participants revealed that in the sessions, all the community residents, Indian and non-Indian, were quite willing to share their thoughts and feelings about the Rancheria's development plans. In an interview, tribal chair Arla Ramsey indicated to me that the dialogues had given the Rancheria the opportunity to present its case and speak its piece in a spirit of goodwill and cooperation.

City residents were also vocal in the dialogues, especially about their fears of how the presence of a casino might impact the City. (As City planner Bob Brown described it to me, the very scale of the casino building was intimidating to City residents: "You could have more people in the casino at one time than there are in the entire town of Blue Lake," he said.)

Meanwhile, at City Council meetings, Blue Lake residents blamed the Council and City Manager for not fighting hard enough, or for brokering deals that sold

the community's identity off cheap. But even those who were most incensed at the situation could see that the Rancheria was going to build its casino no matter what the City did, or didn't, do. The shoe of economic authority was for once on the other foot, and the Rancheria seemed to be making up for lost time.

Ramsey described in the dialogues how the profits from the casino would be used to finance a van service for the elderly, for the City and Rancheria alike. Also, a free breakfast program for children would be established, to be served at the tribal office each morning and available to all Blue Lake children. Finally, a retirement community would be built for the use of the City's and Rancheria's elderly. The Rancheria even pledged to any child who graduated from Blue Lake High School, regardless of heritage, a check for $500, no strings attached. The casino's architects would be careful to shield the parking lot lighting from the City neighborhood across the street, and the casino would build its own entrance road with a roundabout to keep casino traffic steered away from the City.

Although neither the State of California nor Humboldt County nor the City of Blue Lake can impose upon tribal sovereignty, California tribes are expected to make "good faith efforts" to mitigate the effects of gaming, based on their compact with the state. These remarkable contributions—community and retirement centers, $500 checks for graduates, social services, lighting adjustments, and roundabout—may be meant to fulfill that requirement. No official mechanism is in place to measure the effectiveness of good-faith mitigations or their continuance, however. Nor has the binding nature of such compacts yet been tested in California. Even those City residents who felt assured that Ramsey was looking for an honest exchange of good will and cooperation could see that the Rancheria in no way needed the City's permission, and hardly even needed its input, which was in time the most irksome thing to City residents.

OUTCOMES OF *THE DENTALIUM PROJECT*
At the end of the year-long community dialogue process, some City participants who were originally most vociferous in their objections to the casino reported a sense of acceptance regarding it, even an understanding of why it was important to the Rancheria. This was the first change that could be attributed to the dialogue process.

Other evidence of the project's impact would follow, including one City resident who was inspired to run for City Council (she won the seat), and another who was motivated to circulate a petition regarding traffic and parking. Clearly, the dialogues and play fulfilled some need for civic discourse lacking in Blue Lake.

With production of the play, *Wild Card*, the entire process reached its culmination. Despite the popularity that the play would have with audiences, its challenges were obvious, reflecting the complex relationship between community-based arts and development.

THERE WERE NO INDIANS IN THAT SHOW

Wild Card and the casino opened on the same weekend, and both had packed houses. The audience seemed engaged and entertained by the play. On the weekend I was there, I saw only two Rancheria representatives in the audience. Set 10 years in the future, *Wild Card* is cast in the form of a variety show. The play speculates on the demise of Blue Lake's small-town identity and emergence as a megalopolis as a result of the coming of the casino.

Although the play is set in the future, it is clearly about the present moment in Blue Lake. Audiences are led to understand that the play's setting is an exaggeration of City residents' fears, rather than an actual prediction of the future. (The backdrop for the outdoor stage presents Blue Lake's skyline in the year 2012 as jagged with skyscrapers, for instance.)

The substance of the show is a wonderfully relentless lampooning of local personalities and politicians in skits, songs, dialogues, monologues, and clown routines. Much of the dialogue was taken directly from the community dialogues. The play also has quite serious moments, and the opinions of the City's naysayers and yea-sayers were represented side by side. The opinions of children were represented. Even the opinions of the dead were represented. Only the opinions of the Native Americans went unrepresented.

I confess to being surprised that *Wild Card* was so focused on the present moment, and yet did not represent Indian voices. The script was self-conscious about the omission, going so far as to include a song, "Why There's No Indians In This Show." The song explained the omission as being due to the history of oppression of the native community by non-natives. Unfortunately, even that explanation was presented from the non-Indian perspective.

"WHY THERE'S NO INDIANS IN THIS SHOW"

Now I've been thinkin' about a long long time ago
In a galaxy not that far away
Before SUVs and pagers and keys
And playing cards down at the gamblin' hall
And those big bright lights and cigarettes and alcohol

Now for thousands of years they lived over here
Then the white people came along
Then we took all their land
And killed all their clan
Then we broke into a country song
So it gripes my butt
Every time some nut
Acts like he don't know
Why there's no Indians in this show

I'm tryin' to imagine what it must have been like for them
To have all these strangers movin' into their home
Now there's flight simulators and French fried potaters
And we all got cellular phones
And red or white
We all like barbequein' on the lawn

So after hundreds of years and millions of beers
We're all getting' kinda the same
We all stomp on the land
And drive minivans
We all love to play that bingo game
But in some ways we differ
Makin' us a bit stiffer
Every time that we wanna know
Why there's no Indians in this show

—Lyrics by Tim Gray

In this version of *Wild Card*—it was later rewritten and restaged for a second production—Blue Lake's identity was incompletely represented. The play was unable to recontextualize the historical tension between City and Rancheria. Although the show did present the current multiplicity of diverse opinions among City residents, it did not consider any sort of multiplicity in a future relationship between the City and Rancheria. The play in no way attempted to repackage or gloss over the community's tensions, nor did it overtly advocate for one group over another, but the Rancheria, which had been so well represented in the dialogues, was not represented in the play.

Dell'Arte's inability to use the dialogue process to unpack Blue Lake's history made it difficult for the first version of *Wild Card* to contain a vision of multiplicity.

Wild Card's playwright, Dell'Arte co-founder Michael Fields, states that as the play got closer to opening, he realized that he could not find a way to adequately represent the Rancheria in the depth and complexity called for in the situation. Nor did Fields feel he could make the necessary adjustments within the limitations of the production schedule. He chose to split the difference, and leave the issue for the play's subsequent rewrite, putting the song in as a sort of bookmark.

Granted, "Why There's No Indians In This Show" is a kind of historical red herring. Asserting that the Rancheria is unrepresented because of oppression deep in U.S. history implies that the Rancheria had the *means* to participate today and chose not to, which is not the case. It is rather more likely that the problem was a case of missing identity.

IDENTITY AS A STUMBLING BLOCK

Every attempt that he made to adjust the script to include the Rancheria's perspective was unsatisfactory to Fields. He was up against something that Dell'Arte had never encountered before, and Fields couldn't find a way to make it right. He even found it difficult to describe the problem.

The script process was caught up in three tensions. Dell'Arte artists had long grown accustomed to standing objectively outside of the community in order to recontextualize it, but here they were intensely *subject* to the situation that the play was describing. Maintaining objectivity was wrenching. In addition, the task of imagining the divided communities as a multiplicity was made more dif-

ficult by rancor between the City and the Rancheria, which had previously been suppressed in Blue Lake. Dell'Arte introduced the subject of history into the community dialogues from the beginning, but community animosity continually dragged the conversation back to current events. Therefore, Dell'Arte's inability to use the dialogue process to unpack Blue Lake's history made it difficult for the first version of *Wild Card* to contain a vision of multiplicity.

Finally, although Dell'Arte had done some "cultural bridge-building" with other tribes in the past (see Julian Lang, below), in this situation they couldn't find solid enough ground from which to represent the Indian perspective, and the Rancheria offered no help in that respect. The Rancheria had no reason to assume that Dell'Arte—an established City stakeholder—was trustworthy.

"APPROPRIATION"

Julian Lang is a member of the local Karuk tribe. (The Karuk are not affiliated with the Rancheria.) He is a cultural historian and storyteller who has annually participated in Dell'Arte's Mad River Festival. Lang is also a theater artist, and in that capacity has collaborated on Dell'Arte projects drawn from Karuk mythology, and he has performed in a Dell'Arte production.

Lang's perspective on Dell'Arte's artistic process is an interesting one, because along with his obvious respect and enthusiasm for the theater's work and commitment to the community, he also recognizes that its artistic process is contradictory with Karuk tradition. I do not suggest that this tension is something to be avoided, but rather that recognizing it is the first step in building the sort of multiplicity that can lead to cultural reconciliation.

In an interview conducted by the Community Arts Network for its *Performing Communities* research project, Lang described Dell'Arte's relationship to the community this way: "I think that they are committed to this place. That is kind of what it is all about. They have these strange personal histories that have connected them here and there with different native peoples."

At the same time, Lang acknowledged that Dell'Arte stands apart from the Native American community: "They seem to be insulated within their own world and we just occasionally drop in." Describing one aspect of a Dell'Arte collaboration, Lang said, "It seems to be a part of the nature of theater to appropriate and present views that may not necessarily be the views of the people doing...the acting." This was subsequently the cause for much discussion between Lang's tribe and Dell'Arte regarding the process for a particular

project. "We talked a lot about that appropriation of our culture and our cultural ideas and our responsibility. We don't just make a mistake by being over-generous with our stories...We are kind of leery of these relationships and collaborating and all of that."

In the end, the collaboration was ironed out to the satisfaction of Lang, the Karuk, and Dell'Arte, and the show was made and presented. "We ended up with a nice understanding. They agreed that we would do what we do and hope for the best. It was fortunate, because it was a good play and it was really impressive."

Various Karuk-Dell'Arte collaborations have been very successful over the years. Although Dell'Arte was "appropriating" stories from Karuk culture, they had the insights of the Karuk to help them fold those into an artistic process that was ultimately respectful and satisfying for all involved. Such a process would probably not be easy to transfer to a situation where there is a rapidly widening cultural divide and animosity, such as that sparked by the casino.

> Tensions are inescapable, and therefore multiplicities—of economy, ethnicity, culture, and politics—must be nurtured, because they refocus economic development toward human development.

Collaboration can be quite difficult if only one party stands to gain from the process. Lang indicated in the interview that the Karuk were getting *something out of* the collaboration from which they could ultimately benefit—theater experience and development of an artistic culture—which perhaps helped to smooth their collaboration with Dell'Arte. The Rancheria, on the other hand, needed nothing from Dell'Arte.

The Dentalium Project was born in fast water, forcing Dell'Arte to frame a course between two entrenched communities while attempting to renegotiate its own political and artistic position between them. The difficulties of *The Dentalium Project* were not solely the result of Dell'Arte's suddenly slippery position in the community, nor were they caused by the result of stonewalling from the Rancheria, or even by the fears of City residents. Rather, *The Dentalium Project* was shaped by a sudden collision of forces acting on Blue Lake's identity.

The City will change, the Rancheria has changed, and Dell'Arte's institutional and artistic evolution is inevitable, but the responsibility for bringing conscience and multiplicity to Blue Lake's future identity falls to all three institutions. It seems clear that taking no action at all could mean simply watching as two cultural camps drift to either side of a widening divide.

> The dialogues covered ground that would likely never have been discussed in any other sort of forum, and cracks appeared in cultural monoliths…

The success of *The Dentalium Project* is in the fact that it engaged community members in dialogue about the changes under way in the community and provided a forum for voicing a cultural rift that had divided the community for many years. The play not only held the attention of its audience but also inspired some to decisive civic action. The dialogues covered ground that would likely never have been discussed in any other sort of forum, and cracks appeared in cultural monoliths that would not have been there if the dialogues had not taken place. The play not only entertained its audience but also inspired some to action and challenged the artists who made it to consider their role in the community in a new way.

CONCLUSION: THE EVOLUTION OF ECONOMIC DEVELOPMENT

The possibility of cultural reconciliation calls for risk, multiplicity, and a willingness to live with essential tensions. Storper calls for "a new procedure of self-questioning, of self-doubt" that involves three questions which could be seen as a checklist for civically engaged artists attempting to maintain objectivity in an intensely subjective situation: "Where do our categories come from? Of what and of whom are we speaking? In whose name?" Those questions could be useful in clarifying the character of a particular multiplicity.

The need for diversity/multiplicity must be continually rediscovered. In the same way that one cannot point to the division between two cultures and ask, "When can we put this issue behind us?" the job of asking these questions is never done. In the same sense that no city ever finishes developing its economy, it also never finishes developing its identity. Separate cultures that share geography will never cease to need new ways to interrelate.

Tensions must be boldly acknowledged. An example of this can be seen in the way that ancient myths relate to modern sensibilities. "I am not so much into

entertaining, but just presenting a big fat myth and letting people think about it," says Julian Lang. "In order for you, a non-Indian, to understand my culture, you are going to have to walk away—not entertained, but I guess that helps. You are going to have to walk away thinking, 'Jesus Christ, what was that?' Not in a negative sense, but it is just like—there are too many things in there. You can understand it on the one hand, but on the other hand, it is too deep."

It is increasingly understood that rational solutions to community problems are simply too narrow and exclusionary, and so there is a need for more complex, comprehensive visions of what a community can be. In response to this, there is a growing movement today for "sustainable" economic growth, which calls for development to be led by a more culturally proscribed perspective of economics and planning. Vattimo and Adorno might say that the sustainability movement is an attempt to apply the aesthetic, objective vision of the artist to development. The sustainability movement reorients economic development toward *human* development. Tensions are inescapable, and therefore multiplicities—of economy, ethnicity, culture, and politics—must be nurtured, because they refocus economic development toward *human* development.

It may very well be that the arts can play a definite and significant role in economic development, but communities might stand to gain more if the argument were reframed. Rather than attempting to identify art with economic development, perhaps the stronger strategy for arts advocates would be to *champion* sustainable economic development for its potential contribution to human development. Now that would be a turnaround.

If community identity is a key factor in development, and if the arts make a real contribution to that identity, then it will behoove economic development to consider how the arts make communities viable, rather than merely prosperous. It is a more strenuous—though perhaps more attainable—challenge for artists and their advocates to reveal how economic development could make us all more human.

A Response to the Essays

MICHAEL FIELDS

IN READING THESE ESSAYS, it is clear they have a unique value as a prism that reflects and refracts a critical light on aspects of this work from specific entry points. They capture primary colors. They give us an essential separation into parts of what was a whole fabric. They provide new perspective, a distance, into what we (Dell'Arte) are so close to, so much a part of, so woven historically into, and so passionate about. And they will inform the future practice. And that, I believe, is the real value and the intent of these "critical essays," an intent that I think was well realized in these writers' work.

And yet a prism must, by its nature, split apart. And it is our work, our job, our art—to make a whole. A whole that may be composed of bits and pieces of understanding, history, context, relationship, craft—that by their nature refuse to be fractured into isolated pieces. And it is the consequence of that central fact that is at the center of my response.

We live here. We have lived here for 30 years. We don't talk, create, and go. We see all these people (or "stakeholders") daily. The future we address in the context of this project belongs to all of us in this community. We will live the consequences of our actions and this creation for years to come.

We have spent much of our lives as artists in this community creating and evolving a practice of work known as "theater of place." That is the fact behind the work. It is personal. It is community driven. It has high artistic ambition. And the complexity, nature, and culture of this place informs all that we do.

THE DIALOGUE

It is clear to us now that some of the essential choices we made during this project proved to be the right paths and others did not. What we found through this project's dialogues:

- Most of the people in town, especially those from the Rancheria and others who had lived in the community most of their lives, had never sat and talked in the same room together. There were deeply held suspicions about motives.

- Dell'Arte was certainly not perceived as either a neutral or a comfortable place to meet to talk about community issues. Everyone was leery of talking with a Dell'Arte person in the room, as they worried that their words would end up on stage.

- Everyone felt city leaders were not doing their job.

- Almost everyone was already resigned to the casino and was more concerned or fearful about what would happen next. And that this had less to do with historical native/white relationships than with economics and quality of life issues.

- Change was not comfortable, and there was great fear about where this change would lead and who would control it. And here we do get into native/white historical relationships and issues of a sovereign nation in the midst of a small community. But the real issue was what the future of this place would be, and who was driving that future. It was not primarily about gambling, casinos, or even native politics—it was clearly about the future. And that focus strongly emerged from dialogue.

- Taking a side in an agit-prop manner would be a negative provocation resulting in exacerbating divisions rather than giving them a true voice. And so we decided to give voice to many over the few.

Given what our dialogue facilitators had learned in their initial individual investigations, we decided to begin with a dialogue that would be by invitation only. It would have six members who were a cross section of the white community and six people from the Rancheria. No one from Dell'Arte would be present. It would not be recorded in any form. The participants would simply be asked to tell how they came to this community, what it was like to live

here, what they liked best, and what they feared most. This would be done in a story circle format, where one person talked and everyone else listened, prior to any cross talk. It took two months to set up this dialogue in a manner in which all the people agreed to be present together. It was held on the neutral turf of the Blue Lake Grange.

We projected a future that, while not apocalyptic, was certainly not ideal. But it was grounded in a comic perspective. And we included a multiplicity of voices

By all accounts this dialogue was very successful, and Cascadia (our dialogue group) saw it as an important building block in whatever would follow next, as an essential trust had been established among the participants. It was to allow an unpressured growth of trust that no audio or video documentation of this meeting was done.

This dialogue was for and about the community first. It was not designed to be just a resource tool or part of a public document. It was not designed to be written about. It was not for the writers' benefit or ours. It was for the community.

Cascadia held subsequent dialogues with the Dell'Arte staff, community business leaders, and the Rancheria. All were documented except the first two.

Several things have happened as a result of the dialogue effort. A community group now meets once a month to talk about the future of the town. This same group also meets with the tribal chairwoman of the Rancheria about the same topic. Many more stakeholders have become engaged in participation because they see the value and the possibility of impacting the changes happening within the community. Even the hairdressers have started a petition. And perhaps, most simply, an opening has been made in a wall that had been built up over a century of cultural and economic divide. As with any wall, this opening will take time and a constancy of effort to sustain.

THE ART

The dialogue certainly impacted the way the art was made and how it was presented to the community. The artists' role with the dialogue was primarily one of listening, although the perception in the community was that we were listening with the purpose of creating a play. Given our past history in the community with "theater of place" work, there was an understanding of what

we were doing and an expectation that real people and real issues would both find their way into the work. This is a sword that cuts two ways. It makes some folks reticent and some more forthcoming.

We made some critical artistic choices to make the work, in our estimation, accessible and engaging to the broadest possible audience—again with the intent to engage across divisions. These choices included:

- **To do it outside in our amphitheater.** Use of the amphitheater changes the atmosphere in which theater is perceived and engenders a less formal feeling of a "gathering." We believe it increases the comfort level for those not used to seeing theater. Some people feel the same way about going to theater as going to church, and we wanted to remove that barrier as much as possible. We wanted to create a "festive" atmosphere with as much celebration and laughter as possible.

- **To do it as a musical.** We hired the most popular local band and placed a lot of the content of the piece in the original music and songs. This simply made it less heavy and didactic. After all, theater is also about entertainment.

- **To do it as a radio show.** We worked with the local public radio station to do a live broadcast of the show, to use a different medium to reach many more people in the very large rural geographical region, who would not be able to see the play.

- **To do it as satire and utilize the comic skills we have developed over 30 years at Dell'Arte.** We set the play 10 years in the future. We projected a future that, while not apocalyptic, was certainly not ideal. But it was grounded in a comic perspective. And we included a multiplicity of voices, making fun of them all, in terms of where they stood about this future. The basic question posed was about the soul of the community and the simple fact that the only way to impact change is to get involved. Laughter is a biological response of recognition. If you can laugh at something, you are recognizing it in yourself. We wanted to provoke a lot of laughter.

- **To do it all at the highest level of professional artistic craft.** This is important to who we are and how we work. We have created a style over time. It takes craft. It is always our wish to advance this craft through each

work we do. This project presented challenges in this regard, as we do not usually do large-scale musicals that need to be staged around microphones for radio. I called the play I wrote a "physical radio play," and never have so many worked so hard to make a mic-stand come alive.

All of these choices were critical to our intent with this project. They shaped how the work would be perceived. They were strongly influenced by listening to the dialogues.

We had a vigorous internal debate within the company about style and aesthetics on this project. After participating in one of the Animating Democracy learning exchanges, we saw that many people were approaching the work almost from a biographical or political point of view, emphasizing content over artistic style, and placing a priority on the design of dialogue over the creation of art. After much discussion we chose to take the opposite tack. We made this decision because of our knowledge of our own community—how we are perceived as artists within this community and the community's expectation of our art—and because of our predilection to make sure that we entertain, not preach, to make the art provoke the questions. In the question of who leads the dance—the art or the dialogue—for us it was clearly the art.

Laughter is a biological response of recognition. If you can laugh at something, you are recognizing it in yourself.

Certainly the play, *Wild Card*, was successful by all measures. It nearly sold out each performance. It was the stated reason why two people chose to run for city council (one of whom won and has now created and filled the position of city council liaison with the Rancheria). It provoked a series of community visioning meetings, run through the county, which brought many new people (stakeholders) into discussion of the future. It brought a new audience together for the first time. And it worked so well we did it again this summer. And we made some essential choices in reaction to responses we had received from both the writers of the critical essays and the audience.

In the 2003 production, *Wild Card 1.5*, we involved a Native American actress. We wrote in a relationship with her and the central character that in its difficulty mirrored the relationship between the city and the Native American community. And we made it funny, but true, too. We made it personal. And that relationship was the central theme of this year's work.

THE CONTROVERSY

OK, now let's get to the native participation question that seemed to provoke more heat within the Animating Democracy world outside our community than from anyone in the community.

This project was premised on the involvement of the Blue Lake Rancheria as a partner in the work. It was clear from the outset that they were not comfortable with creative involvement in the theatrical part of the project. We sent Arla Ramsey, the tribal chairwoman, a precopy of the script, and I had several meetings with her about the project and the play. Their creative participation was invited. That invitation was not accepted. There is not a theatrical tradition in the local Native American culture, and native culture on the north coast is far from homogeneous. Nor are local Native Americans in agreement about casinos, or about who can speak about what to whom. So, our reaction to this response to our invitation was a muted caution. However, the Rancheria fully participated in all of the dialogues, and Arla is prominent in the documentary (where she also had editorial approval over how she appeared and what she said). She and several members of the Rancheria came to the opening of the play and were enthusiastically supportive (there are 50 members of the Rancheria).

I think we cannot assume that everyone's vision or comfort level with the art is the same, just as we cannot assume that all Native Americans are the same. And, as in the dialogue process, there needs to be time for trust to be established in all of these areas before full participation can occur. Trust takes time and, in some cases, a long time due to a long history of appropriation and betrayal.

> There is not a theatrical tradition in the local Native American culture, and native culture on the north coast is far from homogeneous.

There is a song in the play titled, "Why There's No Indians In This Show" It was mentioned in all three essays and seemed to be the touchstone for much of the response. The lyrics were even fully encapsulated in one of the essays.

Well it worried us, too. Our intent was to, in song, raise the issue that we could not solve in the most open way we could. That is the issue of full inclusion. And we wanted to provide, in song, the fact that this community has a long history of exclusionary, racist practices around the indigenous native

community that one cannot expect to disappear through niceness or political correctness. It was a country-style honky-tonk song. And in the context of the show itself, it was a powerful aspect of the performance. Inside the community it worked. Critically, it certainly provoked.

> My regret as a playwright, and a problem in the piece, was that I did not feel comfortable in creating satire of the native community the same way I felt comfortable utilizing satire of all the other elements of the community.

My regret as a playwright, and a problem in the piece, was that I did not feel comfortable in creating satire of the native community the same way I felt comfortable utilizing satire of all the other elements of the community. They mentioned this. And I agree. The fact that we could not find the appropriate humorous angle with that community was a drawback in the work and one that we addressed in this year's version. But, as David Rooks points out in his essay, this is the point where much work remains to be done to have a true dialogue of inclusion.

There is a specific craft to the theatrical work at Dell'Arte. It is not only practiced in the performing company but it is taught in our professional training program. In the past 10 years, we have rarely hired anyone into the company who has not gone through the training program. This is what gives the company its ensemble style and value. In this project, where we sought a Native American voice, ensemble experience became particularly problematic as we did not want a symbolic native spokesperson—which we felt would be more demeaning than valuable. It would make that point of view especially sacred, which it is not, especially around the casino issue. Ultimately, we could not find a resolution to this problem that worked. And that concerns us deeply. The solution, it seems to us, is to find a way to train Native American actors who wish to seriously go into this arena of theatrical work. We already work in the schools in this rural region the size of the state of Massachusetts. Many of these schools are on one of the six reservations in this region. In one of the new openings created through this project, we are talking with the Rancheria and others about supporting a Native American scholarship to the Dell'Arte international professional training program each year. Training would provide an equity of craft and could be employed to support multiple points of view. But it is our belief that this has to be addressed in an organic, comprehensive fashion, not a symbolic one. But it must be addressed, and, through the experience of this project, this has become a critical priority for us.

THE POINT

Our goal in this project, in essence, was to stimulate and provoke, via the art, new ways to talk about and imagine the future of this place. The casino was a catalyst, one that has turned the normal economic status quo on its head. The standard paradigm is that the minority culture is seeking equity either through economics or cultural validity, and that struggle becomes the basis of the conflict. Here, the culture that has been suppressed and depressed since the arrival of the white culture suddenly has superior economic power and is positioned, both through federal law and sheer resources, to determine the future of this place to a large extent. It can simply bypass the standard democratic process. There is irony here. There is also fear. This is where the dialogue component of this project was particularly valuable, and where we learned how to best employ it in our community.

The art was also an essential catalyst. It was successful because it was specific, it had multiple points of view, and it was as entertaining as hell. It used "popular theater" in the way it was meant to be used, to truly engage essential aspects of the life of the "populus." In the words of my Irish grandfather, "it didn't fart higher than its ass."

We remain invigorated and committed to continue to find the best and most integrated weave of our art, our organization, and our community. What we've learned from the experience of this project has been invaluable in that regard. Our own relationships with the communities within our community have deepened and grown because of this project. New levels of understanding have been reached. This has made a new place to begin to consider together the possibilities of what will come.

Much has changed. More will change. Our own role as an arts organization has changed in this place. As Ferdinand Lewis points out in his essay, there is an active leadership component that we are learning to acknowledge. With leadership comes accountability and responsibility, and perhaps a better understanding of what effects real change via art.

Peter Brook, the theater director, said it succinctly: "Only one thing is impor-
tant in the work of the theater; that is a group of people coming together
creating a climate that allows the recognition of the real problems of life and
the courage to tolerate them,
to face them, and to grow up
a little bit. Then the theater
becomes a useful action. All
the rest is chatter."

Wild Card...was the stated reason
why two people chose to run for
city council (one of whom won
and has now created and filled the
position of city council liaison
with the Rancheria).

What we do is theater. Yes,
we do "theater of place." Yes,
dialogue is central to our work
(more so now because of this
project). Yes, we are deeply involved in our community. But the source and
essence and perspective of our work is our art. Our investigations through this
project have led us to evolve the most useful actions we employ in our work.
And I think we have all grown up a little bit.

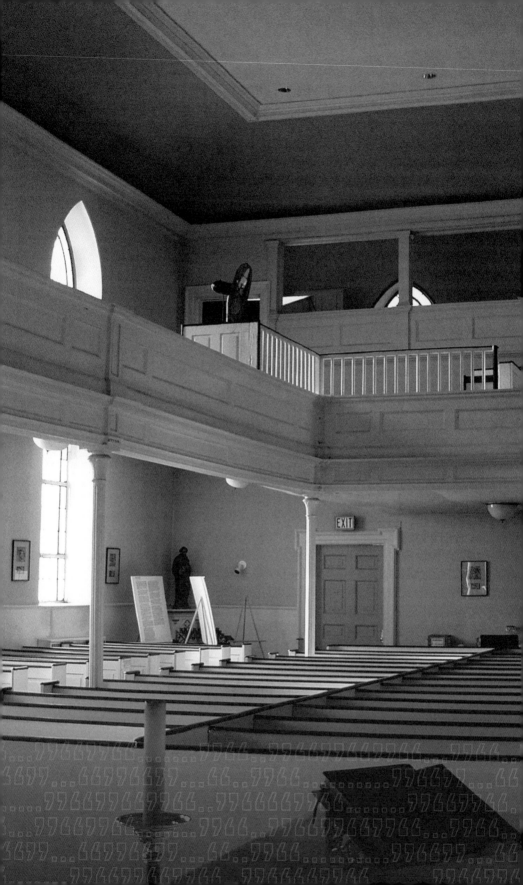

The Slave Galleries Project

::: **ST. AUGUSTINE'S EPISCOPAL
CHURCH AND THE LOWER EAST
SIDE TENEMENT MUSEUM**

This description of The Slave Galleries Project *is excerpted and
adapted from a report written by Lisa Chice and Liz Sevcenko
of the Lower East Side Tenement Museum and the Reverend
Deacon Edgar W. Hopper of St. Augustine's Episcopal Church.*

SLAVE GALLERIES: METAPHOR AND CATALYST
New York City's Lower East Side is one of the most ethnically diverse neigh-
borhoods in the country. New influxes of immigrants over time, alongside
the neighborhood's American-born racial minorities, have created constant
tension over the boundaries of inclusion and exclusion. At various times,
some groups gain access to the center of American life and power while oth-
ers remain at the margins. Conflicts among groups overrepresentation in the
neighborhood's history are intimately connected to material resources like
housing and schools. At the heart of these conflicts lies the question, "Whose
neighborhood is this?"

In this context, *The Slave Galleries Restoration and Preservation Project* is under way. St. Augustine's Episcopal Church was built in 1828 for the city's patrician elite. Today, it houses the largest African American congregation of any denomination on the Lower East Side. The congregation worships in the shadow of two slave galleries, haunting, box-like rooms above the balcony where African Americans were forced to sit for much of the nineteeth century. This rare artifact of racial segregation in New York stands as a stark, physical reminder of how and why boundaries of marginalization are drawn and contested.

Concerned that the African American population on the Lower East Side was diminishing as a result of gentrification, leaders of the church formed a committee, headed by the Reverend Deacon Edgar W. Hopper, to preserve and interpret the slave galleries. They wanted to show physical evidence that African Americans were present in the neighborhood as early as the 1820s, and to leave behind a testament to African American struggles and contributions for the future. "The cultural climate is such that the time is *now* to look at this project," said Deacon Hopper. "The whole question of being marginalized yet again is at issue."

In 1999, the Committee asked the Lower East Side Tenement Museum,[1] with which they already had a long relationship, to bring its extensive experience with research, preservation, and interpretation to the project. The museum agreed to conduct fundraising; develop and direct a team of preservation architects, consulting historians, and researchers; and commit its own interpretive staff. After years of successful educational programming of its own, the museum began to realize that historic sites had special power to move people to consider some of the most pressing issues of our day from a new perspective. The museum founded the Lower East Side Community Preservation Project (LESCPP), intended to bring together a coalition of diverse community leaders, called community preservationists, to identify, restore, and interpret local historic sites as focal points for dialogue on community experiences and issues. St. Augustine's Church volunteered to make *The Slave Galleries Project* LESCPP's first project.

The Slave Galleries Project brought together more than 30 community preservationists—leaders representing African American, Asian, Latino, Jewish, and other ethnic and religious groups—with scholars and preservationists in a collaborative learning process. The project included restoration, interpretation, and civic dialogue in a highly integrated and mutually informative process. The Tenement Museum referred preservation architect Roz Li of Li/Saltzman

Architects to work with *The Slave Galleries Project.* Through her work on the Tenement Museum, she had gained rich experience in uncovering the mysteries of marginalized peoples. Community preservationists agreed that the project could promote education about slavery and intolerance, empower people who are facing adversity, and act as a catalyst for dialogue within the community. Over a year's time, guided by Tammy Bormann and David Campt, two highly respected dialogue professionals experienced in intergroup relations, community preservationists talked first among themselves about issues of marginalization in the Lower East Side. They explored the meaning and use of the slave galleries, a powerful artifact of the history of segregation, as a space for dialogue for the larger Lower East Side community. Finally, they engaged people within their own communities in dialogue about the slave galleries and current issues they face.

RESEARCH AND INTERPRETATION INFORMED BY DIALOGUE

From the beginning, the idea that the slave galleries would serve as setting and metaphor for dialogue determined three priorities that are not found in traditional historic preservation projects:

- **Humanize the experience.** Organizers believed that the powerful experience of sitting in the slave galleries could move people to a different emotional place, dislodging or disorienting rigid beliefs and opening people to dialogue on difficult issues. This goal led to a focus on the individual human experience of the space in both research and preservation efforts. Research aimed to identify real people who sat in the space and introduce visitors to them.

- **Raise difficult, enduring questions.** The project sought to use the story of the slave galleries to raise questions that are as pressing and unresolved now as they were a century ago. For instance, a great debate arose about the use of the term "slave galleries" to describe the spaces hidden in the church. At the heart of the debate lay the fact that slavery in New York was officially abolished in 1827, one year before the church was constructed. Newspaper accounts from 1911 referred to the spaces as "slave galleries." But would they have been called slave galleries when they were built a century earlier? The real question is: Were there slaves sitting in the space? The arguments were intense. One historian suggested that referring to the space as slave galleries was irresponsible and inaccurate, while some Slave Galleries Committee members felt that *not* doing so was tantamount to denying the continuation of slavery after manumission. It was clear that

the story was more complex than a single truth. Church and museum staff and the preservationists worked to open this conflict as an opportunity to raise the larger questions that underlie the debate: What difference did it make when slavery was abolished? What difference do legal rights or legal changes make? What is the difference between legal and social freedom? What did "freedom" mean then? What does it mean today?

- **Tell the story from multiple perspectives.** It was very important to the congregation to preserve the slave galleries as a sacred site of African American people. But St. Augustine's and the Tenement Museum believed that there were multiple heirs to the slave galleries' difficult legacy. All along the way, they invited their diverse team of community preservationists to comment on the latest research and make suggestions about how the story told to visitors could be made most relevant to their constituencies. Community preservationists effectively drew parallels to the history of segregation in Chinatown, the segregated "galleries" of a local synagogue where women sat, and the experiences of countless illegal immigrants.

PREPARING TO ENGAGE THE LOWER EAST SIDE COMMUNITY

The Slave Galleries Project sought to shift what was commonly heated debate and competition around issues of marginalization to dialogue that would find common ground and deepen understanding among its various residents. Tammy Bormann and David Campt worked with community preservationists to empower and prepare them to use dialogic processes of communication, learning, and decision-making within and between their communities. Community preservationists committed to multiple training sessions with a specially designed curriculum to equip them for their work.

In the project's first phase, Bormann and Campt engaged community preservationists in dialogues around the process of interpreting the slave galleries. In subsequent meetings, community preservationists identified potential barriers to productive dialogue at the slave galleries and ways interpretation of the space could address them. For instance, for white people, there may be resistance to or denial of this history. Some people may want to know more but are afraid. The group suggested that a visit to the slave galleries always include opportunities for open reflection, dialogue, and debriefing—a space for people to come to terms with difficult emotions. Community preservationists also learned how to deal with confrontation, the clash of value systems, and hardened positions.

Each community preservationist selected a "learning partner" with whom he or she would facilitate community dialogues, pairing across gender, ethnicity, and organizational affiliation. Over three months, each team organized and co-facilitated two dialogues with members of their communities or organizations, including community seniors at the slave galleries, Chinatown teen volunteers at the Tenement Museum, Boys Club members, University Settlement staff at the Tenement Museum, and others. After each session, the learning partners debriefed with one another about process, content, and facilitation skills. They came to the next training session ready to share their insights and learning experiences with other training participants. In all, trainees conducted nine dialogues with groups of all ages and backgrounds.

HISTORIC PRESERVATION MAKING A DIFFERENCE TODAY

The Slave Galleries Project is building a capacity for dialogue that had not existed before in the neighborhoods of the Lower East Side. Community preservationists are identifying specific issues and places where dialogue may make a difference in getting people to talk about issues in the neighborhood. A historic high school building that is being converted into market-rate housing, for example, has been targeted as an opportunity to open up what has been largely private speculation to community dialogue between Asian renovators and community residents.

The Slave Galleries Project established the Lower East Side Community Preservation Project as an ongoing, organized, and recognized forum for developing community history initiatives that address shared neighborhood concerns. LESCPP has partnered with two other agencies to help develop innovative markers for neighborhood places with valued historic connections as well as importance in the lives of people today, and that can be focal points for community dialogues. A walking tour led by community preservationists will link many of these historic spaces and others identified through their work on *The Slave Galleries Project* with a tour and dialogue at the slave galleries. The tour will offer an extremely different portrait of the neighborhood than traditional interpretations of the neighborhood's history that focus on European immigration.

For project partners, *The Slave Galleries Project* has tested a model of how dialogue could be integrated into the development of a preservation project from its earliest beginnings as well as how it could be permanently embedded in a historic space. For St. Augustine's, *The Slave Galleries Project* laid the groundwork for the church to establish a cultural organization around the slave galleries. The project also trained almost half of the Slave Galleries Committee

as dialogue facilitators. The national attention that Animating Democracy brought to the project had a significant impact on how the church community viewed the slave galleries. Everyone in the congregation knew what those spaces were. But many congregants were not ready or willing to face the horror they represented. Many had never set foot in the space. As events were held around the space, several congregants were inspired to climb the stairs for the first time.

The potential of the slave galleries as powerful tools for civic dialogue is only beginning to be realized. As time goes on, the intent and hope remains that people from different communities and perspectives might form more substantial connections, and discover larger truths and new options for collaboration and action.

[1] The mission of the Lower East Side Tenement Museum is to promote tolerance and historical perspective through the presentation and interpretation of the variety of immigrant and migrant experiences on Manhattan's Lower East Side, a gateway to America. The heart of the museum is a tenement building at 97 Orchard Street, home to nearly 7,000 immigrants from 20 different nations between 1863 and 1935, when it was closed to residents.

The Colors of Soul

LORRAINE JOHNSON-COLEMAN

WHEREVER FOLKS HAVE LIVED, loved, hoped, dreamed, been happy, been sad, laughed, cried, been cherished or hated, have been lost, have been found, mourned or survived, there remains in that place a special something, kind of like a lingering spirit or a festering soul. And it is this spirit or this soul (multiple energies merging into a single reality) settled comfortably in the worn cracks and crevices of history to which we must pay homage and

attempt to give voice whenever we interpret places of the past.

"Tell the truth and shame the devil" my grandmama used to say. Well it's sad to say that it is apparent that a whole lot of folks weren't privy to grandmama's brand of wisdom, and, as a result, the interpretation of the African American story is sometimes so removed from reality that it is almost unrecognizable. The problem seems to be more and more of an issue as the popularity of heritage tourism reaches new heights. At least now there is a consensus that historic places have an obligation to mention the black folks whose lives were an important part of many significant spaces but there are still some failures in the system, especially in cases where the black history is particularly painful to hear. The solution for some has been to shy away from the harsher realities for fear of reducing the visitors' enjoyment. This is a frightening trend and it needs to stop. As a storyteller/interpreter, it

would be easy to tell only warm stories with happy endings. I know first hand that tough stories are both hard to tell and hard to hear, but we do folks an injustice when we don't tell it all. As children, we have all heard that if we can't say something nice, we shouldn't say anything at all, but I don't think our preschool teachers were referencing historic interpretation when they said it, and we need to make that distinction.

Tell the truth and shame the devil. Well, my grandmama was right. It's the only way to live and the only way to learn. But what my grandmama didn't tell me was how many devils there would be to contend with, and historic interpretation sure has more than its share.

Devil #1 – For the last six years I have been commissioned as a storyteller, an interpreter, and at times a unique blending of the two. Now, the storyteller and the interpreter come to the telling from two very different perspectives. The interpreter draws a direct and factual correlation between the site and the history of that place. The desired result is that the visitor make a profound connection to that space. Not too long ago, it was considered crucial that the interpreter maintain a distanced neutrality from themselves and the story. Now, many recognize that interpretive neutrality is not only impossible but an undesirable ideal.

The historical site tells stories, not a single tale, and sometimes these stories conflict with one another.

The storyteller, however, has an agenda from the beginning. He or she is using powers of persuasion to move you from where you are to a predetermined emotional place. They want you to feel. They want you to take something from the experience and chew on it for a while, and, believe me, they aren't trying to be objective. So how does one woman who is both a storyteller and an interpreter reconcile these differences? By understanding that there is a place for both historical fact and emotional response, and good judgment dictates which is emphasized when. If I am commissioned to create a piece about history that can be told by anyone, then interpretation rather than storytelling is in order. The very nature of its objectivity allows it to be appropriately shared by anyone. A story, however, that is personal, is limited in its telling to the people ethnically who own that story and to no one else. I consider the blending of interpretation and storytelling to be of course the ideal, and I consider that to be my specialty—but the combination poses its own unique challenges to say the least.

Devil #2 – We are all revisionist whenever we step into a historic place and look back. The story always reveals itself to us with the silent backdrop of how we live and how we believe at the moment. Often it takes time to grapple with interpretive complexity, particularly when that complexity calls into question cherished beliefs and ways of seeing oneself. Sometimes time and distance lead to a clearer view, but other times time and distance blur the view until nothing really is clear.

Devil #3 – The historical site tells stories, not a single tale, and sometimes these stories conflict with one another. The conflict may not be a problem since the ultimate goal is not just telling the story but creating an experience that allows the visitor to learn, to reflect, to dialogue critically, and to deepen their understanding of American history, our "civic glue," so to speak. In the case of slave galleries, there are conflicting possibilities as the interpretation/storytelling begins. One possibility is that many who were forced to sit in the segregated seating were outraged and rightly so. Another is that there were many who looked forward to the private fellowship with family and friends, away from folks who were other than their kind. By exploring both possibilities, we open up the discussion in two ways instead of just one. How do we feel when we are separated or marginalized? Isn't it also comforting at times to be around folks that are just like us? Is it necessary at times to separate ourselves in order to maintain our cultural connectiveness?

> The slave gallery at St. Augustine's has an untold story inside of it, and it is more than ready for the telling to begin.

Devil #4 – Interpreting African American history, we find more often than not that we simply don't have enough first-hand written accounts or documents to know the whole story. Memory and oral traditions represent the African practice of preserving the past in many instances. Black collective memory, vision, and "what somebody done told me" has to fill in the gaps. The slave galleries are no different. Once again there is very little data on the specifics of the folks who passed through that space but there are slave narratives available that can give us a sense of what it felt like to be relegated to separate seating. While there is no guarantee that the feelings expressed in these narratives are the same as the feelings of those who passed through the galleries, these resources are excellent places to begin. It is important to note that segregated seating existed in Southern places until the late 1960s. Many of the African

Americans who lived under those conditions are alive today, and the telling of their experiences can add to our understanding of the effects of segregated seating.

Devil #5 — Visitors to historic sites take in history through multisensory experiences, a combination of what they see and feel when they come to a place as well as what they hear. As I take my seat in the slave galleries, I am immediately aware that the space is small, cramped, uncomfortable, and has a limited view. It will be up to me to use my voice and some evocative telling to convey exactly how it feels to sit here.

Devil #6 — There are opening questions any good storyteller or interpreter asks before they even begin…

- Can I make a connection between history and the present? Should I just tell it like it was and trust my visitor to make the connection?
- Are we celebrating or memorializing the people who have passed through this space?
- If I leave this narrative as my legacy, can anyone of any age, any gender, or any color tell this story? And, if not, does that necessarily make it inappropriate?
- How can I empower the custodians of this space to understand that their role is not stagnant but as ever-changing as the interpretation and physicality of that space?

For me there is no better way to deal with a devil than to throw a measure of spiritual goodness his way—so I just shout my way through. In the story found in Joshua, Chapter Six of the Holy Bible, we find reference to the shut gates of Jericho and to a city locked down tight. But the Lord explains to Joshua that the city, no matter how formidable, can be his for the shouting and so it is with the shout of Joshua that the barriers come tumbling down. I guess that's why black folks connect so strongly to the power of the shout. It is because we have always known, even when the majority of us couldn't read or write, that there was strength in the utterance of the word. The shout for my people is song, praise, poetry, chant, dress down, word up, confirmation, and condemnation. It is a right that must not ever be denied.

And so I go into the slave galleries of St. Augustine's Episcopal Church with the words of Wole Soyinka, author of myth, literature, and the African word seared into my soul. "When you go into any culture, I don't care what culture

it is, you have to go with some humility. You have to understand the language and by that I do not mean what we speak. You've got to be able to understand the language, the interior language of the people. You've got to speak both the spoken language and the meta Language of the people." It is said that there is no greater agony than having an untold story inside you. The slave gallery at St. Augustine's has an untold story inside of it, and it is more than ready for the telling to begin.

The Slave Galleries Project is a collaboration between the Lower East Side Tenement Museum and St. Augustine's Episcopal Church, intended to showcase a rare example of segregated seating in the Northern United States and an invaluable part of black history in New York City. St. Augustine's Church was built between 1827 and 1829 as the All Saints' Free Church (Episcopal). In 1949 St. Augustine's Chapel moved into the building and became an independent parish in 1976. The slave galleries were constructed in 1827 at a time when slavery had been declared illegal in New York, yet the seating space has come to be known as the "slave galleries." It is supposed that one of the reasons for this name, legality or illegality aside, may have been because visiting parishioners from other states where slavery was still legal often visited with their slaves in tow. This is not certain, but for my purposes of storytelling/interpretation, it is inconsequential. Blacks, free or not, were segregated to those galleries relegating them to second-class citizenship or perhaps no citizenship at all, so slave galleries they were named, and, for me, slave galleries they will be.

Until the slave narrative, almost all public discussions of slavery were solely from the perspective of white. Now, for the first time, the enslaved had a voice.

The physicality of the slave galleries plays an important role in the storytelling. The galleries consist of two small rooms located at balcony level. There is one in the upper east corner and another in the upper west one. The east and west galleries have different histories of alterations, seeming as if they had different lives. (Does this mean there are two stories?) It appears that the window openings were originally built to be open without panels to block the view. (But we don't know if these were kept open to allow visibility between those seated in the galleries and those in the sanctuary, or if they were closed.) There are indications that there were pews used in the galleries at one time, as evidenced by the ghost marks in the east gallery. Physicality always affects interpretation. In this case, the interpretive

program should remind visitors that America was built on the backs of many, reflect that research is still in process, and be viable as a vehicle for dialogue about marginalization in contemporary America. Tough to do? You bet!

There is only one literary form that I would even consider to be appropriate for this program—the narrative, in tribute to the slave narrative and to Sojourner Truth, a woman enslaved in New York during the same period of time that the slave galleries were constructed. Her own published narrative became one of the most well-known and nationally respected works of its kind. A great orator, preacher, and defender of freedom, she also left us an important literary legacy. The slave narrative dates back to 1768 (Brittan Haman in Boston) with the majority being published between 1830 and 1860. Until the slave narrative, almost all public discussions of slavery were solely from the perspective of white. Now, for the first time, the enslaved had a voice. Of course these narratives are not without blemish. The stories were filtered through the white writers' sensibilities so that, in some cases, these writers may have placed their own agenda ahead of authenticity. Still, the narrative plays a pivotal role in our storytelling, and it is ideal in this setting.

Now we can finally move into the slave gallery as the historic space becomes story theater. Story theater is a wonderful concept made famous by Walter Dallas, an Emmy-nominated director who worked successfully in off-Broadway theater in New York City. According to Mr. Dallas, story theater layers complex character, narrative, improvisation, and motivation on top of each other, very much the way a building is constructed. The storyteller can construct, destruct, or at any given time step completely outside the action and bear witness to the significance or emotion of the moment, becoming both performer and commentator. Story theater grabs at the heart and never lets go. So now the slave gallery becomes theater and the narrative begins...

A STORYTELLER LOOKING FOR TRUTH

As I sit in this space and look down on this sacred place, I am conflicted in ways I didn't anticipate. The church has always been for me a sanctuary of peace and deliverance that separates me from the troubles of the secular world, but I have always been a member of a black church so color has never been an issue. I have always been welcome: kinship, fellowship, and worship always coming together in breathtaking spiritual experiences. God loved me they always said and so did the folks on the pews around me.

Here, however, things are different. Here I need the kind of inspiration that comes from on high. It is not my voice that needs to be heard, but the voices of those who sat here wondering what in the world God had to do with casting folks aside. But they are not here and nobody bothered to ask them how they felt when they were, so I can only hope that somehow I can feel and imagine just a little bit of their living.

It is no secret that the voices who speak to me are usually women, so I begin this the way I begin everything else—with prayer. I am looking for a wisdom woman to reach down and touch me and only God can send her to me. So I pray.

> Lord, how do you make 'em understand that sometimes a woman's got her back up against the wall and needs a silken strength to shoulder her and arms to hold her so she doesn't quite fall. And then when it seems like it's going to be you and me once again, you liberate me and consecrate me, Father. You send me one of your own who happens to be kin of my kind. You know the folks I mean—some of them soul-reaching, miracle-minded, way-making blessed ones. You know, one of them love-ladies, sister-friends, or one or two of them women kin. Then Lord, you throw in a few of them we-can-make-it-mamas, a couple of them I-know-where-you've-been, see-where-you're-headed, awe-inspiring-colored women.

> Lord, just now and again, every blues singing moon, I need to be the one who sees the stains on the inside, the scars that no longer show or the wounds that still fester. And when the grief finally comes, please let me recognize the desert teardrops of parched souls and dried up dreams.

> Lord, I'm just trying to get through the madness and this time it can't be about the me or the mine, the going it alone. No way. This time it's got to be about a Hagar, a Jezebel, a Sarah, or an Eve, so folks remember that we were never supposed to be a dark side of salvation or a casual reminder of redemption. I am calling on a sister so we can get down to business in order to get the job done. But we can do this, I know it. What I need is a wisdom

woman, that one who is always willing to sacrifice herself so I can see the better way. Let us connect now so we can take this thing sister to sister, make it ally to ally, and handle it woman to woman.
Amen Lord, Amen.

As always, the Lord delivers. And now, A wisdom woman remembers...

Oh, ain't it good to be faithful
'cause there sure been some times,
some of 'em pretty darn bad
when a little bit of faith was all we colored folks had.
But baby I can tell you, tell you how it's been true,
That it's good to be faithful,
so good Lord, let me tell you!

Bless Gracious! Ya 'll is finally here. It's been lonely up here for so long, I won-dered if I would ever have company again. 'Course being alone ain't always so bad. It's amazing how a pretty piece of quiet and the calming beauty of emp-tiness can set an old body still and put a good mind to recollectin'. You know I got me some rememberings that run so deep 'til they live in the pit of my stomach and touch the center of my soul. I didn't know if I'd ever get around to sharin' them either. I tell you, folks 'round here was getting downright frenzied that wouldn't nobody ever get to wonderin' 'bout this place, wantin' to see it or needin' to know about it. But I wouldn't hear none of that—no sir, not none of it. I tried to tell 'em that I wasn't 'bout to be hid away forever even if some folks do get to lookin' up here like I'm drippin' in shame. But I ain't the one that ought to feel disgraced. Nor sir, I ain't the one.

The way I figure it, if the Lord don't see color, ain't none of us supposed to. Bringin' folks to a place so they could praise the Lord and then go to stickin' em up here like they wasn't nothin' but trash you don't want nobody to see; it was a shame, I tell you. A shame! But sin will sure 'nough slow walk you down. Thank God for it too or this here story would still be stifled like a prison ache or a melancholy melody.

Ain't this place somethin?

Oh, I know at first there don't seem like there's a whole lot to see. It looks like somebody done come in and stole out all that was glorious, leavin' nothin' behind but this here scarred hard marker of rememberin'. It kinda'

reminds you of an old lady that got nothin' left but a little bit of dignity drag-gin' some where raggedly 'round her knees. But everything don't need to be shiny and pretty. Sometimes you got to bring your own measure of goodness and grace 'fore you can really see a place. 'Course I see it all, sometimes I see too much. Born on the wrong quarter of the moon folks used to say. Yes sir, I see it all.

I see the colors of soul splattered here, there, and everywhere, cradled in crevices we ain't even begun climbin' into. I see ghosts, too, leftovers and leavin's of folks who waited for their spirits to be lifted clear up to the Lord. Ishmael's tears may have moved God to goodness and mercy but my folks couldn't help but wonder if theirs didn't just make them old and ugly, and if mercy wasn't just a promise for yet another day, that reigned up in heaven a million miles away. But now they sit right at the feet of the Father. All of 'em—Nigger, Boot, Coon, Spook, Darkie, Auntie, Sambo, Pickaninny, and Colored Gal. All of 'em finally shining in glory.

You know every once in a while, you tell yourself that this time you ain't gonna say one word 'cause so much of what you've already shared ain't even been heard. You've already decided that you ain't going to tell 'em one more thing 'cause they probably wouldn't listen no way. But today I get to have me quite a say. And I'm going to tell it like the Lord would have me do, just like I'm supposed to.

Baby, I'm here to tell you that there is a God who hears you and who sees you. He's always listening and I know it 'cause I talk to Him all the time. I sure hope He's listening now.

Lord, when they said that the Black woman was the mule of the earth, did they say it 'cause they knew they had burdened us with something no other soul would dare try to carry? Did they know we was too strong to be crushed under the weight of affliction or did they finally just realize that we was too stubborn not to make it all the way through? Why couldn't they see that our headrags were not banners of surrender but our crowning glory and these scars were not whelps of weakness but punctuation marks for a well-fought war story. Why couldn't they see that we was woman too?

And Lord, we can't forget our men. They too need to be heard. But Lord, when our brothers speak, let not their voices sound raged from the lies told to us, the half truths uttered about us, or the blows that still sing. Let not their

67

meanings be mocked, misconstrued or mixed up like lost lyrics or mere mut-
tered cusses of misunderstanding. Listen now as they burst into a litany of
love, the song to stir the very soul and a unity laced rhapsody.

Allow a Black man this, his very serenade to float free,
for this is not a death song, some hopelessly sung hymn,
for they have silenced their voices too long
Now they must shout their strength until it
Echoes throughout the land and declare proudly
That which makes them a man.
And when they speak, let their darkness
Give verse to an African legacy, a rich Black history
And give rise to their courage, determination & pride
As they lift every voice and sing.

Lord for all of 'em, the sisters and the brothers whose souls reside in this place,
let them speak now. They shall no longer choke back the truth, disrespect
their discontentment or be seen as less than a human being.

And finally Lord, for the babies, 'cause when I was little, it sure was tough to
be somebody's colored baby in this here place. I only hope now, that things
done finally changed up their face.

Amen.

St Augustine's Church
Slave Galleries Project

RODGER TAYLOR

JANUARY 1, 2003

I watched 2003 arrive in church. New Year's Eve service has become a custom with me. Where better to catch that spiritual moment of change than on the Lower East Side, a couple of blocks from home, with my own family, and my church family, in the venerable rock gothic structure that is St. Augustine's Episcopal Church?

As Reverend Errol A. Harvey ascended to the pulpit to reflect on the passing year, I remember glancing at the old, white, brown-framed wooden pews. They look as if they could have been built in the early 1800s, as does the almost identical balcony. Above the rector, the church's high, clean ceiling and small, round, indented spotlights seem modern, almost art deco. I pondered the contrast of old and new. St. Augustine's is one of those

neighborhood institutions that feels like it's been around forever. It almost has. 2003 is St. Augustine's 175th anniversary.

Father Harvey, a tall, broad, distinguished man, appeared a little overcome as he reached for the words to grip the impending year. There had been several funerals recently at the church. Father Harvey lost his own father in 2002. When he spoke I had the feeling that his heart was wrapped somewhere around these events. As he concluded the sermon, I thought about the anniversary. In 175 years Reverend Harvey is

the church's second African American rector. I hadn't given it much thought before. But suddenly, at that moment, that thought, or a noise, caused me to turn my head to the back of the church. Maybe it was the spirits moving over the ushers who flanked the side doors, but my mind flew to two rooms hidden out of sight on each side of the organ, a short, skinny flight up from the balcony. Over time these two rooms have gone from being used, to being a novelty, to being forgotten, to being controversial and historically significant. They are St. Augustine's slave galleries.

Slave galleries, or "Negro pews"

Slavery extended into houses of worship throughout the nineteenth century and before. Forced into special sections customarily in white-run churches, African New Yorkers stood in the back or sat in the balconies, or in some places, in sparse and sometimes locked rooms called slave galleries.

As the clock struck midnight, we exchanged hugs and kisses. I found myself thinking about the folks who sat in those slave galleries at St. Augustine's. I wondered what they did on New Year's Eve. If they were in church, did they exchange hugs among themselves only? What if they were free and consigned to seating in that area, or were indentured servants? Were they happy, hopeful, angry? Were men in one room and women in the other? I wondered about the dynamics, social and otherwise, as those old African New Yorkers ushered in the New Year.

> Maybe it was the spirits moving over the ushers who flanked the side doors, but my mind flew to two rooms hidden out of sight on each side of the organ...

"In seminary I did a summer internship at St. Augustine's," Father Harvey told me. "I believe it was 1967. I heard about the slave galleries then, a passing remark. When I became rector in 1983, I realized there was nothing much written and not much general knowledge about them....What I find interesting about the slave galleries is that they're like an urban legend. The facts don't dispute, but stretch it some. It's a slave gallery, but really the dates are sort of curious. Slavery, as such, was supposed to end in 1827, the year before the building opened. So, why did you build slave galleries when you knew slavery was ending? You didn't believe it was going to happen?"

Yes, there was slavery on the Lower East Side.

Emancipation became New York State law in 1799. Due to the way the law was written, the vast majority of slaves in the city were not freed until 1827. But I'd argue that even after slavery ended, New York City continued to be the northern capital of the slave trade. They came to metropolitan ports from Africa or the West Indies, often as a transfer point on the way down South. The trade and products they generated made the city rich.

African New Yorkers were always very visible in the city. Many labored on the docks or at outdoor food markets. Others sold food on the streets. Some cleared them when it snowed. There were dance contests, prizefights, songs, and street performances. In early morning, an army of African New York sweeps moved about trying to keep the city clean. In the winter, sawyers providing firewood took over the sidewalks cutting logs and forcing pedestrians into the streets. Emptying the latrines or privies late at night, another army of blacks, the tubmen, swarmed over the city. These men often brought rum apparently to numb or anesthetize themselves. Inevitably tubs were sometimes dropped, leaving reminders of their work the following day. Their late-night singing, yelling, and fighting also generated a battery of complaints.

On Sunday evenings African Americans, dressed to the nines, would "stroll" down Broadway. In 1821 a New Yorker writing for the *New-York Columbian* that August counted 1,480 black New Yorkers in just under two hours. Two other observers noted, "They were all well dressed, and very many much better than whites." Further, they "usually walk four or five abreast, arm and arm, with cigars in their mouths, bid defiance to all opposition, and almost universally compel our most respectable citizens, returning from church with their families, to take the outside of the walk, and sometimes to leave the sidewalk altogether."

By the 1820s a noticeable number of African New Yorkers seemed to push the limits of their roles. Many demanded equal treatment and refused to be docile servants. But the New York establishment was in no way ready to acquiesce, share facilities, or compete on a level playing field. Excluded from most professions and many jobs, restricted to certain areas when allowed on trains, ships, and buses, African New Yorkers were also banned from libraries, theaters, and other public places. Danger met them on city streets. Women, children, and men, even those as prominent as Frederick Douglass and restaurateur Thomas Downing, were, on

...why did you build slave galleries when you knew slavery was ending?

occasion, attacked. Black churches, property, and businesses were also targets. The African Grove Theater was closed simply because many could not stomach the idea of African Americans performing Shakespeare.

Even whites who supported New York's African American population were often found wanting, as this article from the *Colored American* (an early New York African American newspaper) attests: "Progress would be made more rapidly, if teachers of schools, academies and colleges would receive and encourage the attendance of colored pupils, if professional men, merchants, artisans, etc., would hold out facilities for them to enter on new and useful employments; and if the friends of our cause, generally, would, in their intercourse with them, act more in consistency with their principles." The writer also declared, "If professedly Christian Churches would do away with the odious distinction of the 'Negro pew.'"

The ground beneath our feet
Bancker Street, where St. Augustine's Church now stands, was noted for its African American nightlife. For years, basement clubs, bars, and dance halls—many black-owned—pulsated with dancers and musicians. A writer described a soundscape on the block:

> …oyster stands and numerous tables of eatables that rendered passage along the sidewalks all but impossible. But the most visible, and audible, were the street peddlers, those smutty vendors who roll out the long words "Cha-a-a-a-r-r Co-a-a-le" in varying tones upon each syllable as long as the anaconda. From early in the morning until late at night—far too late by many accounts— their distinctive cries could be heard all over the city. Hollers such as "He-e-e-e-e-er's your find Rocka-a-way clams" and, most famously, in the autumn months, the ubiquitous "h-a-u-t corn, h-a-urt ca-irr-ne", formed a recurring and often disconcerting part of the city's soundscape.

The thing I remember most was that nobody made a big deal about the[m]. They were never talked about.

But the wealthy, "respectable" Bancker family, apparently embarrassed by the association with slums and black New York, demanded that the street be renamed. On October 23, 1826, two years before St. Augustine's was built on the street and 10 years before there was a Madison Avenue (in honor of the former president James Madison), Bancker Street became Madison Street.

St. A's and me

I began my relationship with St. Augustine's as a child in the 1960s. I didn't go every week. My attendance generally depended on what was going on in my family. However, I went to Sunday school for some time at St. A's. As a rebellious teen and 20 year old, I went to church less and less. As I got older, married, and moved back to the area, St. Augustine's evolved into my place. I still don't go every week, but I stay involved.

> I believed the development of a slave galleries historic project was essential for the church and for the community.

I can't remember when I first heard about the slave galleries. But I do know I believed the development of a slave galleries historic project was essential for the church and for the community. There were a few committees that attempted to initiate this task in the 1990s. I was on all of them. In 1997 I was asked to submit a report to the church's vestry about the need to begin a slave galleries project. In the report I requested a (nonpaying) position as lead researcher. I shot high but was willing to negotiate. For months I seethed when there was no response to my report, my request, and of course, no project.

The St. A's Slave Galleries Committee

Katherine Murray was involved in one of the earlier committees that focused on the slave galleries at St. Augustine's. "I don't think I heard much about slave galleries until Father Harvey came. He talked about them a lot. I was on the vestry and was chairperson of the program committee....About 1997 we came together to discuss what we wanted to do for the slave galleries. We were going to make decisions, do the research, and make it more a church project."

Hector Peña, a multimedia specialist, long-time leader of the St. Augustine's Gospel Choir, and former Slave Galleries Committee member, recalls, "I heard about the slave galleries before I actually came to the church in 1983. I used to work for Father Harvey in the Bronx. On the phone he described St. Augustine's and told me about them. The thing I remember most was that nobody made a big deal about the[m]. They were never talked about. It wasn't until Father Harvey started really pushing the history of the place that it became a point of interest."

This latest Slave Galleries Committee at St. Augustine's began in September 1999. Father Harvey is an active member. I'm a member. Usually meeting on a

monthly basis, we've promoted four annual events. We've worked with several organizations, including Americans for the Arts and Animating Democracy, the Lower East Side Tenement Museum, City Lore, and others. We've monitored grants and donations as they've come in, and generally directed and pushed the project.

> There are times when I don't want to go up there. I don't want to confront those personal and emotional feelings.

Deacon Edgar Hopper personifies the group. In many ways he is the slave galleries' gatekeeper. "There's nobody like him," says the Tenement Museum's Liz Sevcenko. "He's tough, that's for sure. But once you learn how to work with him, he's a total inspiration."

"It really piqued my curiosity, not that there was a slave gallery but that there was one in the church that I belonged to," says Hopper, a native New Yorker who was born 73 years ago and raised in Brooklyn. The deacon, like many African Americans, learned about his family's history through a sketchy, undocumented oral tradition. "It's always been part of the verbal law of my family that certain of my great-great-grandparents, aunts, and uncles were slaves on Staten Island. Several are buried there, in the Frederick Douglass Memorial Cemetery. All this gets tied into a funny kind of a ball of wax for me. My first visit to the slave galleries, and every one since, has been very emotional."

As gatekeeper, Deacon Hopper swings doors open and shut. "There are times when I don't want to go up there. I don't want to confront those personal and emotional feelings. I know it's not fair, but if your interest is intellectual, profes-sional, or educational I'm supportive of that. I won't show the slave galleries to everybody. I've had to work on it, but sometimes I feel, 'Hey, we're not letting any phonies up in here today.'"

> *"In the 1940s I was in the choir. We used to climb up those little stairs all the time to rehearse. It was right near the organ. We would sing up there on Sundays. I was really surprised to learn it was a slave gallery."*
>
> —*Evelyn Holloman*

175th anniversary flashback
When you consider the 175-year history of the slave galleries, you actually have to consider the history of *two* churches. What was All Saints' Free Church became St. Augustine's.

On May 27, 1824, Episcopal services began in a wooden building located on Grand and Pitt Streets. The spiritual leader was the Reverend William Atwater Clark. George Dominick and James P. Allaire were wardens. Allaire appears to have been one of the stars of the well-to-do mercantile group that founded and supported All Saints'. He built engines and worked closely with Robert Fulton, of steamboat fame. In 1816, Allaire constructed and ran a huge steam engine and brass foundry near the docks on Cherry Street.

The wood church on Pitt Street quickly became too small for the congregation. In 1827 they commenced, and in 1828, completed construction of a church nestled between Henry, Madison, and Scamel Streets. It stood

pretty much as it does today. On June 5, 1828, when All Saints' Free Church opened, at least Reverend Clark and James Allaire, dreamed of being a free church, meaning people would not have to pay for a seat when they came, "proclaim[ing] to all, high and low, rich and poor, one with another, that this is the House of God for *all* people," as Reverend Clark put it. But when All Saints' Free Church opened, the pews were for sale. Throughout Reverend Clark's tenure, though it infuriated him, All Saints' Church was never free. I wonder if they charged for the slave galleries. If so, who paid?

Lower East Side: We may not be sophisticated but we're real
In the old days, the church was known as the last outpost of Christianity before the river. In many ways it still is today. This part of the Lower East Side where Henry, East Broadway, and Grand Streets triangulate into a block that leads to the East River, remains remote and residential, against the throbbing metropolis of downtown Manhattan. There are no numbered streets in Loisiada, or the LES. If you're not familiar, you're lost.

Despite whatever mixture of well off, working class, and poor there's been in the area, tenement-type poverty has been the community's poster child. Though it was founded by wealthy businessmen, St. Augustine's, like much of the neighborhood, has been in financial trouble pretty steadily since the 1850s.

All Saints' becomes St. Augustine's

By the 1900s the Lower East Side had become predominantly Jewish. The two Episcopal churches in the area, St. Augustine's Chapel on East Houston Street near Second Avenue and All Saints', had been kept alive through the financial support of Trinity Church. On January 15, 1945, Father Berngen became the priest-in-charge at both institutions. He led a socially active ministry, with a clear mandate to work with the African Americans and Puerto Ricans in the area. By 1949 the old St. Augustine's closed, and the two churches were joined. All Saints' Church was renamed St. Augustine's, and the congregation quickly became African American.

> *"...they had told me that at that time for the organ to run well it had to be heated. They brought the slaves in and they would heat it. I'm not sure if it was logs and fire or there was some other heating mechanism involved. The slaves didn't just come up there to sit. They kept the organ going. I remember seeing the wooden benches up there in those rooms."*
>
> *—Bennett Dickerson*

Slave galleries rediscovered

In the 1920s several articles in books and newspapers celebrated the rediscovery of the uniqueness and importance of the church's slave galleries. A piece published in 1916 entitled *The Last Remaining Church Slave Gallery in New York* said: "The present day visitor at All Saints' may climb the same narrow stairs up which labored the asthmatic and body servants, put his finger in the slot of the bolt that locked in the slaves and sit on the benches on which played and trifled the pickaninnies. Lucky was the first rector, the Rev. Atwater Clark, for at least some of his congregation could not escape during the sermon!"

A less offensive reference appeared in 1927: "The slave galleries at All Saints' are believed to be the only ones to be found in New York today remaining in appearance quite as they were when in use a century ago. Hence, they are objects of keen interest to visitors and many come to the old church to see them." In 1923 a New York historical guidebook indicated that within the slave galleries was a "Lincoln Museum" and a "Netherland Antiquity Museum."

Pageants were a craze in the early twentieth century, as thousands of Americans celebrated their neighborhood history by acting it out in elaborate theatrical productions. All Saints' created a pageant for its centennial celebration in 1924. The following record of that celebration offers a reflection on the congregation's insight on church history, the slave galleries, and emancipation in New York.

All Saints': All Saints' was founded 1824 by Dr. Clark, who sold his library to rent a room to gather straying sheep into a church for Eastern settlement.

East Side: After the war of 1812, like now, our glorious Country had been left with overplus of ships which to employ. The merchants started an East Indian trade, whose clippers berthed on East Side shore creating docks and stores and factories and ship-yards, whose wealthy owners had to live near-by their business; so they settled fresh on East Broadway, that led unto Mt. Pitt, whose granite built the walls of our All Saints'.

All Saints': So then, East Side, you were not always poor?

East Side: Ah no! I was New York's Fifth Avenue. Here dwelt the traders who grew millionaires, importing sugars, spices, cotton, fruits and slaves!

(Enter, Negro Slave, followed by many Slave Children, all clanking chains from wrist to wrist, singing Sewanee River, which is joined in by all, during Slave Posture Drill of Imploration.)

Slave: O Massa, am I gwine to be forgot? Alone for me is there no room in Heav'n?

All Saints': Come in dear Negro Slave, you too may come; for you I build two special galleries, where you, locked in, may join in all the hymns and shout Amen! to what your Masters pray.

Another part of the pageant addresses the liberation of the enslaved in New York.

Uncle Tom: Black Tom am I, who guard my little Miss whose golden curls make me her willing slave. When she is sad, I wipe away her tears, when she is cheerful, in her laugh I join; she is my sun-shine and my oracle, who reads for me the blessed Word of God.

Little Eva: The little tyrant maiden I; a stamp of mine brings Tom unto his knees, a smile, and Tom springs up into a dance. If I should die, I want my Tom with me to pick me daisies in the heav'nly meads, and sing refrains unto my hymns on high; Please, please, St. Clair, release him for my sake!

(Imploration Slave Posture Drill, to Old Black Joe.)

Slave: In bondage still, will no one me release?
NY Governor: I will; 'tis time New York kill slavery!

(Draws his sword, and taps kneeling Slave)

Slave: Glory, glory, hallelujah, freedom!

The Slave Galleries Project partnership

In 1999 the Tenement Museum and St. Augustine's formed a partnership on *The Slave Galleries Project*. In some ways this seemed like the perfect marriage; in other ways it didn't. Father Harvey told me, "It wasn't until we gave an award to Ruth Abram, (the director of the Tenement Museum) that in my remarks I may have mentioned the slave galleries. Ruth said [she thought she could get us the] money to find out more about it. We talked. She came up with a proposal and we ran with it."

Deacon Hopper added, "Ruth Abram offered to become our fiscal conduit and to work with us." "It gave us immediate access to some expertise in how to restore [and] preserve, and [to] raise money." Liz Sevcenko was chosen to be the Tenement Museum's liaison on the project, and Lisa Chice her primary support person.

From this agreement both *The Slave Galleries Project* and the Tenement Museum gained prestige and money. The Slave Galleries Committee was given a budget for the over a quarter of a million dollars that was raised. Roz Li, a noted preservation architect, was hired to make a historical assessment of the condition of the slave galleries' paint and physical structure, and to determine the cost of restoration. A small team of graduate students did historical research. Father Harvey reminded me that "from its inception the partnership was designed to dissolve," and St. Augustine's partnership with the Tenement Museum ended in January 2003.

"I wish the relationship would last another year," Deacon Hopper added. "9/11 happened. The Tenement Museum lost budget and people, and money dried up for projects. If I had another six months, or a year, I would focus on some formalized instruction for our committee. That was all part of my vision about what would come out of this, and that's the only thing I'm not getting. [This is how

we do PR as soon as we know about a project. This is how we do fundraising, docent training.] The good thing is that I'm sure we will be able to work on most of these issues, because the Tenement Museum is still committed to helping and supporting *The Slave Galleries Project* in every way they conceivably can."

Hector Peña offered a different perspective. "I've always felt it was a relationship born out of necessity because of their connections. They've been good friends and have done a lot to help. I've always believed that we could do it ourselves. So the good thing is yeah…they helped, but [their] leaving is going to force the committee to stand on its own two feet."

> *"I…never before felt so much as I did when I was first introduced to the Slave Galleries. There is this screaming silence. It's amazing how you can feel the spirits of the people who were there. The wood is just soaked in it."*
>
> —Liz Sevcenko

JANUARY 14, 2003

I realize that for me *The Slave Galleries Project* is a ministry. It's part of what I do. Uncovering the hidden history of African New Yorkers is fun and exciting. I love participating in it. A little more than a decade ago my experience at the African Burial Ground transformed me. When the city's archeologist caught the construction company illegally scooping up and dumping the human remains from this historic site, I got my dream unpaid job. I became part of New York State Senator David Paterson's Task Force on the African Burial Ground. Being allowed to go down to the site at any time as a community observer, seeing those skeletal remains, feeling their presence, and working to help protect them made history real to me and cemented my love for this work.

Even so, as I sit in a Slave Galleries Committee meeting, discussing a youth jazz band that was appearing at a *Slave Galleries Project* annual event later this month and being lambasted for not being able to answer questions like how many band members are there, or how much is it going to cost, I think of something Deacon Hopper said: "Working on *The Slave Galleries Project* has been a…thankless task, from the point of view of having the satisfaction of people enjoying, or appreciating what you have done. People who get involved in historical sites have got to have this messianic feeling. Otherwise it doesn't work. It's just a bunch of old bricks."

Call him cantankerous, but he's right. No one ever gives you any credit for doing this work. I find myself going to meetings of the Scrapbook Society, a

group that is an amalgam of New York African American historical sites and groups, and Episcopal Church archivists. Of course I go to Slave Galleries Committee meetings to try to help plan events and work on organizing the mounting number of documents related to *The Slave Galleries Project.*

At the Slave Galleries Committee meeting, much to my relief, another committee member takes over the task of securing the youth jazz band. As I leave I have that familiar feeling of impending doom that I imagine many people who promote events feel. There seems to be a myriad of issues swirling around. Would our featured speaker show up? Would we have musicians? Our decision to go ahead with the event was rushed. Our promotion was lame. Would the public even come?

> *"They could have been indentured servants, enslaved or so-called free, but they were black and all lumped together. It is striking how much African American history is American history. Many people have had these experiences of being marginalized."*
>
> —Liz Sevcenko

The Slave Galleries' annual event

The youth jazz band was not coming. Father Harvey asked a Church friend and talented percussionist, Norman Riley, who had magnanimously kept the date clear, to perform. I was not thrilled to find out that Father Harvey indeed had arthroscopic surgery on his knee and was advised to stay off of it. Thankfully, he still planned to attend. I felt even better after talking to committee member Oland Saltes, who had opened the parish so that the musicians and folks from Savacou Gallery, who were going to be selling artwork downstairs after the program, could set up.

When I got to the church things continued to look up. Committee member Minnie Curry had done a wonderful job again with the food, and had help. I was thrilled when our keynote speaker, Lorraine Johnson-Coleman, arrived shortly after I did. I was soon mortified. The program was scheduled to begin at 1:00 and by 1:10 the church was still empty. However, as is so often the case with African American events, by 1:30, as Father Harvey limped up the block, we had a crowd. The program started. Norman Riley's band sounded great.

Soon it was Lorraine's turn. "I don't want to talk about those 12 people they bring up every February during Black History month. Y'all know those 12 people—Martin Luther King, Rosa Parks, Harriet Tubman...." Lorraine rattled

off some other names. She acknowledged their genius. She wasn't putting them down, but she wanted to talk about ordinary folks. "Because they're the ones who I think are *ingenious*. You know those *ingenious people*, who can take leftovers, add some water to it, make a big pot of rice, and feed everybody in this church." Lorraine kept us laughing and spoke to those spirits in the slave galleries.

Remembering Henry Nichols

On July 5, 1829, the second anniversary of the end of slavery in New York, a day of huge significance and celebration in the African American community, Henry Nichols; his wife Phebe; and their children William, Caesar, and Susan were baptized at All Saints'. According to the 1830 census, Henry Nichols and his family were black. They lived at 11 Lewis Street, only a few short blocks from the church. Henry was listed as a saddler (a maker of saddles) in 1829 and a year later as a harness maker. One wonders if the Nichols family was consigned to seating in one or both of the slave galleries. If they were, after the baptism did they climb back up to the galleries for the rest of the service, or did they leave perhaps to join the Emancipation Day festivities.

> People who get involved in historical sites have got to have this messianic feeling. Otherwise it doesn't work. It's just a bunch of old bricks.

Parting ceremonies

Whenever I think about the slave galleries—high up, small, rectangular, barren, with their unpainted wood, invisible fresh air, I always feel a comfort, a connection to the distant past, to horse drawn carts and scenic views of the river atop the hill that rose north and west from the shore.

On January 31, 2003, the day I was told the partnership between *The Slave Galleries Project* and the Tenement Museum officially ended, there were no parting ceremonies or tearful celebrations, no beginnings of renovation, fancy time lines, or concrete plans. There was, however, preservation architect Roz Li's Existing Conditions Report, as well her Preservation Plan, and Allan Ingraham's Historical Research Report. These documents are the essential building blocks that will allow and encourage foundations to further fund *The Slave Galleries Project*.

However, as Liz Sevcenko advises us, "There are some internal decisions that St. Augustine's needs to make." "How public do you want to be? Do you want

to have a separate 501(c)(3)? Do you want to be open all the time? We just tried to lay the groundwork, but some kind of infrastructure has to be built."

There was, I remember, a Sunday I snuck up to a slave gallery with two 9-year-olds, my son and his friend. We didn't stay up there long, but for a minute I felt like we were flying, being bathed in our history. Looking at it from a 175-year perspective, it's easy to feel hopeful about *The Slave Galleries Project*.

"The only thing that's ending is the Tenement Museum's direct financing of everything. Otherwise, we'll be there, Liz Sevcenko added, referring to the museum's continued involvement and support. "There's no other place that has the power that these spaces have."

Freedom's Perch: The Slave Galleries and the Importance of Historical Dialogue

JOHN KUO WEI TCHEN

I'M NOT A RELIGIOUS MAN. Yet, it's Sunday morning, and I'm in church services for the first time in my adult life. I'm perched on bleachers in a 14-by 22-foot room looking out at a 45 degree angle to the ceremonies a good 100 feet down at St. Augustine's Episcopal Church. It feels like the nosebleed

section of Yankee Stadium. But these are no ordinary bleachers. I'm in what the church has long called its "slave gallery"—a segregated, hidden, and inaccessible room lost in time and virtually forgotten.

Outside, we're at 290 Henry Street, Manhattan, in the urban heart of the United States, across from the chain-link fenced basketball courts. Nearby is the well-known original row house of Lillian Wald's 1895 Henry Street Settlement that pioneered the idea of public health nursing serving the immi-

grant and the poor. In contrast, this upscale granite church is not known. Why the historical amnesia?

All Saints' Church was completed in 1828 when the property was amidst open fields adjacent to the shipyards and docks extending to Dutch Corlear's Hook. That was before Loisaida; before the projects; before the social workers; before the tenements; before the large Jewish, Italian, Greek, and Irish migrations.

When All Saints' Church was organized in 1824 by Reverend William Atwater Clark, the American Revolution was still a living memory, the Constitution an untested document, and New York Harbor was the major slave port of the United States. With the beginning of German and Irish immigration, the city was growing rapidly, already the largest in the nation—boasting 200,000 residents (a tiny fraction of our city of over eight million). One in seven residents was of African descent. Manhattan's vessels traded throughout the Atlantic and at the ports of the Pacific and China. As the wealth of the area grew, Reverend Clark saw the opportunity to build a church with strong ties to British elite culture. Starting out in his house, the congregation grew rapidly. Within years they paid builder John Heath $13,554, a large sum, to construct a 90-foot-deep by 64-foot-wide by 32-foot-high gray granite structure with a bell tower. Completed in a year's time, the church seated up to 1,300 people and apparently filled up every Sunday.[1]

Within these walls a sacred part of the city's past is hidden. All Saints' dissolved in the 1940s and became part of St. Augustine's Church. Now this largely African American and Puerto Rican congregation is working to become the living link to the original Negro New York City settlements in lower Manhattan. And I've been asked by Deacon Edgar Hopper to help solve a problem.

THE FUTURE OF THE PAST
The deacon is not a man you can say "no" to. He's an intense, bald, slender man, in spirit and looks years younger than his chronological age. He retired from a high-powered corporate publishing career and is now looking to make a difference. This church is feeling the squeeze of changing times. With an aging congregation, gentrification, and the rapid increase of non-Episcopalian Chinese, the church is reaching out. His vision is to make New Yorkers care about the slave galleries and to create an African American heritage trail for the city. He is a man comfortable in his role of authority and now fully confident he is doing a Christian God's work. He wants me to figure out what the larger meanings of

these hidden galleries are for neighborhood resident New Yorkers today. Why should the recent Chinese immigrants care? And why should Loisaida campaneros/as or other New Yorkers? He stares me in the eyes: "Can you do this?"

The educator-activist in me jumps at the chance to make connections among Lower East Siders, present and past—my favorite part of what's left of old New York. With the latest flock of real estate speculators eager to sell tenement apartments for outrageous prices, hemming in immigrants and long-time residents, Chinese, Puerto Ricans, and Jews, the new hipsters, and the disenfranchised need to talk and come together. And most people don't even realize that, after the American Indians, it is the enslaved Africans, along with the Dutch and a handful of Sephardic Jews, who have been here the longest. The Dutch have long since become mainstream Americans; so have the Irish, Jews, Italians, and others become white.[2] But African Americans in the Lower East Side?

> Systemic amnesia needs to be replaced by a democratic, popular, living understanding of the past.

The historian in me knows this is a tricky problem. Scholars have yet to write a true history of New Yorkers living together. It's only been since the civil rights movement that the studies of women, separate ethnic groups, and racism have fought their way into the hallowed halls of academia. Furthermore, U.S. citizens largely don't know their own histories. And immigrants, Chinese or otherwise, are struggling to gain a foothold in this new country. What do they care about others? Most Americans imagine slavery ended with emancipation and freed African Americans became part of we, the people. Sure, the civil rights movement had to strike down remaining barriers in the South, but don't we now celebrate Dr. Martin Luther King's birthday? The typical narrative, from the victorious northern states' perspective, believes that once segregation was legally ended, everyone was free to compete in the marketplace. The complacent say: Look at all the successful individual African Americans on television and in sports! We all know life is not what free marketer tales would like us to believe, but few want to deal with the ongoing legacy of enslavement. Everyone wants to put food on the table, have some fun, make some money. This is in the past, just keep it there.

Our fixed notions of the past numb us from feeling and understanding the continuity of unresolved and contested issues into the present. Deacon Hopper

understands this dirty little secret. For most whites, it is easier to believe the American dream of freedom, hard work, and upward mobility. He understands nonblacks don't believe enslavement has anything to do with them. Do people want to learn about the slave galleries? What kind of history can be written that speaks to this broader public? Denial and forgetting are also part of the American past. And what is systematically *not* common public knowledge reveals much about the politics of our culture. Systemic amnesia needs to be replaced by a democratic, popular, living understanding of the past.

CLUES AND FRAGMENTS

The usual evidence for historical detective work is largely missing here. No original records of the building design have been found. Unlike many other New York City churches, All Saints' Church kept few archives. And the documentation on enslavement and slave ownership is scarce. The census, newspapers, and directories yield but tidbits of information, yet these clues are valuable. First, three questions must be answered:

Were slaves ever part of All Saints'?

Yes, probably. The 1820 census manuscripts show that at least two of Reverend Clark's founding 1824 vestrymen owned one slave each. William P. Rathbone, a merchant at 2 Fulton Slip, lived at 384 Bowery with a household of six members. He reported one female slave (between the ages of 14 and 26). John Rooke, a blockmaker at a lumberyard, worked at 270 Cherry and lived at 69 Rutgers with a household listed as 10 members. He reported one male slave (between 26 and 45), and one "free colored male" under 14. We also know U.S. Christian churches urged slave masters to convert their slaves. Their slaves, therefore, very likely joined the master's family in Reverend Clark's early services.

We also know James Peter Allaire, an original warden (officer) of All Saints' Church, apparently did not own slaves. Likely to be the most successful and wealthy of early congregants, Allaire (1765–1858) founded a brass foundry at 434 Cherry Street assisted by Robert Fulton. He constructed steam engines for Fulton and, after the entrepreneur's death, purchased his steamship factory in 1816 and moved it to Corlear's Hook—eventually becoming one of the largest such factories in the young nation. Allaire's financier and consultant, Joseph B. Curtis (1782–1856), supported the New York Manumission Society for the Freeing of Slaves. He helped to formulate the 1799 New York State manumission (emancipation) legislation and, with Reverend Samuel Cornish, founded the African Free School.[3] Did Allaire's artisan-workers own slaves? Did they attend the boss's church? Or did they all oppose slavery?

Historian Shane White has estimated that two of three merchants in New York owned slaves. Among retailers, ranging from peddlers to shopkeepers, one in four to one in three owned slaves. The largest group of slaveholders was the city's many artisans. One in eight possessed slaves. Most slaves in the city were women, and 13 percent of slaveholders were women heads of households.[4] Even if church members owned relatively few slaves, the debate about manumission must have swirled around all.

We have no records of enslaved African Americans before Freedom Day. Fortunately, All Saints' sacramental lists provide some insights into the lives of otherwise nameless "Free Colored" congregants. On July 5, 1829, for example, Henry and Phebe Nichols along with their three children, William, Caesar, and Susan, were baptized at All Saints' Church. In the 1830 Federal census, a Henry Nichols is listed as head of a household of 10, all of whom are listed as "Free." The 1828–1829 city directory lists him as a saddle maker living at 11 Lewis Street, a few blocks north of the church. On October 11, 1829, Samuel and Catherine Barber baptized their daughter at All Saints'. A Samuel Barber is listed as a mason who lived at 137 Orange Street (now Baxter) farther west in the Five Points neighborhood.[5]

In these scant historical fragments, we can glimpse the social and spatial dynamics surrounding the church. Lives were in the midst of dramatic changes. In 1830, New York City boasted a population of 202,589 and was already the largest city in the nation. New York Harbor's deep port, the Hudson River, and the completion of the Erie Canal enabled Manhattan Island to become the hub of a growing nation's internal and international shipping and manufacturing. From a modest population of 33,131 in 1790, migrants and immigrants tripled the population by 1820, when Episcopalians first sought to establish a church in Corlear's Hook. The population doubled a mere 10 years later. In 1790, one of five households in the city owned at least one slave. The slave population of New York was second only to Charlotte. Fully two of every three African Americans were enslaved. European American New Yorkers depended on enslaved labor to keep their work and households functioning and thriving.[6] After 30 years of struggle, New York State abolitionists, adopting the strategy of gradual manumission, achieved victory. On July 4, 1827, all African Americans in the state were free. Yet, due to limited opportunities and continued racism, many continued to work in subservient positions.

Research has revealed that a Mr. Henry Cotheal, a merchant at 49 Water Street, purchased two pews in 1845, 27 years after New York State manumis-

sion. In his household of 13, a "free colored male" (between ages 10 and 24) was listed.[7] I suspect this young man was a house servant or worker. Did he attend All Saints' Church?

Isn't the name "slave galleries" inaccurate?
If All Saints' Church opened its doors the year after manumission, why name these rooms slave galleries? If slavery technically was over, shouldn't we use another name? Couldn't we use the common, and equally offensive, term of the era, "Negro pews?" Indeed, "Jim Crow" segregation was alive and well in the North even before the phrase was coined. Yet, "slave galleries" is what generations of All Saints' priests and parishioners called it. This name, therefore, reveals something valuable about the attitudes of the church post-1827 Emancipation.

The 1924 pageant script, already quoted by Rodger Taylor, amply illustrates All Saints' own racial mythology. The poor immigrants of All Saints' acted out a revealing theatrical. "[F]or you I build two special galleries, where you, locked in, may join in all the hymns and shout Amen! To what your Masters pray." This same year anti-immigrant sentiment raged across the United States, culminating in immigration restriction laws cutting off the entry of "undesirable" (non-Protestant) Jews, Slovaks, Greeks, Italians, and others. Reverend Clark, it was told, locked the slaves in. But with the pleas of Little Eva and the undying loyalty of Uncle Tom, the New York Governor draws his sword and liberates the slaves. The prevailing practice of segregation never troubles this story telling. Rector William Nicholas Dunnell was christened in All Saints' in 1825 and even upon retiring in 1911 noted the "slave gallery" to reporters.

I believe the name was used in both a racist and a reaffirming sense for white parishioners. During enslavement and postenslavement segregation, both "slave gallery" and "Negro pews" were odious terms to African Americans. They smacked of white arrogance and affirmation of the status quo. One hundred years later, the attitude was still patronizing and racist. As time passed, what it meant to be a good Christian blunted historical complexities. Simpler tales were told. The story of the Governor's smiting of the chains of slavery effectively kept ongoing antiblack racism frozen as a problem of the past. New York public and private schools would also teach the simplified story of evil Southern proslavery and good Northern antislavery. During the xenophobic 1920s, immigrants became "100 percent Americans," in part by mimicking the Protestant-dominated secular narrative.

Rector Dunnell's retrospective stories to the press were also laced with nostalgia, decline, and Christian resolve. When he became rector in 1871, he claimed Irish Protestants filled the 1,300 seats. In contrast to Lillian Wald's concerns about aiding the poor, he framed his 40-year rectorship as one of decline and displacement. Then Jews came, the *New York Times* reporters reiterated, crowding the former residents uptown or over to Brooklyn. Novelty stories were retold of an era passed, notable to early-twentieth-century sensibilities, anecdotes about the Vestryman "Boss" Tweed, the congregation's slaves rowing masters across from Williamsburg, and, of course, the slave galleries. Slavery and the galleries were discussed in a narrative of the loss of a more prosperous, colorful, past community and the murky future. One article proclaimed, "Rector Retires, Church to Close."[8] In this sense, the uncritical tradition of All Saints' Church did not distinguish, or care to distinguish, if their slave galleries were actually used by slaves or not. From its founding in 1824 it was likely that slaves sat in segregated benches and the culture of segregated attitudes (and the active denial of ongoing racist practices) continued unabated.

Yet today St. Augustine's ministry has totally reappropriated the slave galleries—in name and in usage. Father Harvey, the head pastor, and Deacon Hopper are committed to promoting cross-cultural dialogues against racism and for broader human rights. At the services I attended, the parish prayed expansively, including for "the sick, the homebound, the homeless, the hungry, all prisoners, especially all inmates on death row, all victims of violence, war, domestic and child abuse, and police brutality; for all travelers, for all workers, for all people with AIDS, cancer, diabetes, heart disease, kidney disease, and lastly for our community."[9] The slave galleries are now used to promote critical historical awareness of past wrongs.

What's the physical evidence?
Evoking the "slave gallery" by tradition, and now for educational purposes, leaves an unanswered question: What was the actual experience of blacks—slave and free—in the church? That's why I'm here Sunday morning. I'm looking for any clues. I need to get a feel of the place as it is being used. Does the architecture offer any evidence that freedom changed the church's practices?

As I sit in on the wooden bleachers and visually search my surroundings, the organ begins. As an outsider, I'm pulled into the communal experience. The procession begins. A man is purifying the air with the censer. A silver encased Book of Gospels is carefully placed on the central altar. The spectacle is timeless. I realize this ritual in this building brings us back to how the building was used

when first opened. Or it could be centuries back, across the Atlantic in London. Yet, from my perch, I realize this collective experience was far from egalitarian.

I'll start with the obvious: a highly ordered, hierarchic relation to the altar stage was designed into the very architecture of the interior space. After the Anglican Church in England, pews were paid for and counted as a form of property. And as property values in Manhattan, the more central the location of the pews to the altar, and therefore to God, the higher the rent. The best seats, front and central, were charged 2 percent on the valuation added to the "ground rent." Lesser pews went from 1.5 percent to 1 percent, to free pews in "The Missionary Gallery" upstairs.[10] Were masters charged for their enslaved, indentured, or "free colored" workers' attendance in the slave galleries?

> Yet today St. Augustine's ministry has totally reappropriated the slave galleries—in name and in usage.

I realize that the very entryway from the street immediately signaled the status of the parishioner. Though the exterior three doors appear simple and the same, which door used was highly significant. The center door was the main entrance, in line with the best pews of the central ground floor. The two flanking doors led to the lesser ground floor pews, and the stairs to the lesser balcony pews. Once having climbed the steps to the balcony, a steep, narrow, and shallow set of stairs take you up to the slave galleries. My feet, not especially large, can only safely fit sideways. Six steep steps, three curved steps, another six steps—all ascended and descended at a near 45-degree angle. Once up in the bleachers I'm sitting in the very top corner of the building envelope, near the ceiling and at the top of the arched windows. The slave galleries are at the level of the crown molding. The stark, stripped-down simplicity of this interior is contrasted by the ornamentation of the balcony just outside the gallery.

John Heath, the builder, and the vestrymen clearly did not design these galleries for church members. As they planned the design, no changes were made for manumission day, a date that had been set since July 4, 1817. If any change was made from prior church designs, it was the further segregation of the "Negro pews" into specially designed closets even further removed from white attendees. Evidently, the church didn't think Emancipation should prompt them to rethink where blacks, enslaved or free, would sit. In this sense, their sense of proper design did not change, and their judgment of chattel status did not change either.

What happened to the slave galleries of All Saints' Church? The fact that they were built indicates that the architect, the rector, wardens, and the vestrymen expected the segregation of slaves serving white congregants to continue within the church. Yet, a baptism on a nontraditional day was held. Other changes were beginning to happen. The rector, the vestrymen, and the congregants could choose to change, but did they?

I suspect the church continued to be segregated, and African Americans left All Saints' Church, leaving the slave galleries empty, ignored, and soon to be mythologized by well-meaning but racist immigrant "pageants." The Nichols and the Barbers probably voted with their feet and left All Saints'. They may have joined an African American church west in the Five Points area, and they probably intermingled with the African-inflected port culture of lower Manhattan.

THE BIG PICTURE

How do the stories of various groups of Lower Eastsiders interrelate? Sociologist Benjamin Ringer offers a useful framework. The British, Spanish, and other European conquests of the Americas created a duality of colonizers and colonized—of whom would be included and whom would be excluded. For the United States, John Locke's ideas of property and citizenship, combined with the Eurocentric view of the hierarchy of the five races of mankind, deeply influenced who would be part of "we, the people."

Rebelling from British colonialism, colonial rebels sought a more egalitarian society. Yet, as an expanding culture based on private ownership and white, male citizenship, Indian tribes, Mexicans, African Americans, and Asians were deemed unworthy.[11] A place such as lower Manhattan was complicated by how even certain migrating European groups such as the Irish, Jews, and Italians were racialized as non-Protestant, nonwhite, and inferior. Each ethnic-racial group entering New York may have had a different language and history, but all encountered being excluded from the mainstream.

In secular Protestant Anglo-America, to own property conferred power and rights—the rights of a citizen and the power to vote. The promise of "life, liberty, and the pursuit of happiness" was a social contract meant for white men, who were the only ones thought capable of what C. B. MacPherson called "possessive individualism." The most important quality for a free citizenry was not simply owning property but owning oneself. Inferior races and women were not believed by many elite white Protestant men to be capable of making such rational, independent judgments. New York State legislators decided that

all white men, when properly acculturated, should be able to vote, whereas freed black citizens should first be required to own property.[12] This was not simply about whites and blacks but represented a systemic world view that regulated the thinking and practices of the United States' expansion into the continent and overseas.

All Saints' Church embodied the growth and wealth of the city, but also the deep conflicts and ongoing postslavery racism. After the British devastated lower Manhattan at the Revolutionary War's end in the 1780s, the slave system (and the servant system) were critical to digging out and rebuilding the city that created the platform for the port economy to take off. It may take a non-U.S. scholar to analyze these power dynamics most clearly.

To understand what happened here…is to understand how the dynamics of racialization affects us all in various ways.

Euro-Australian historian Shane White has demonstrated the correlation between wealth, occupation, and slave ownership in New York. Census records of 1790 indicate the wealthiest 10 percent of the city's population owned 55.6 percent of the total taxable wealth and owned 39.9 percent of the slaves. The top 20 percent owned 73.4 percent of the wealth and 60.9 percent of the slaves; the top 30 percent, 83.1 percent and 74.3 percent. But not just wealthy New Yorkers benefited from slavery. Even though the bottom 30 percent of the city's population owned 2 percent of the wealth, they still possessed 7.4 percent of the slaves. In contrast to the Southern plantation system, wealthy and poor New Yorkers ran modest-sized to small workplaces and households. Seventy-five percent of the slave households of this time owned only one or two slaves. Prominent households, not surprisingly, owned five or more slaves. For example, "the Beekmans and the Livingstons [and] Governor George Clinton owned eight slaves, Chief Justice Richard Morris six, and Aaron Burr five. John Jay, the president of the Manumission Society, also owned five slaves."[13]

White develops this point further. The growing city depended on the rural surround for foodstuffs and firewood. He calculates that four of every 10 white households within a 12-mile radius of Manhattan owned slaves. He unearths a startling insight. In Kings, Queens, and Richmond counties, 39.5 percent of the households had slaves. This meant "there were proportionately more households containing slaves in New York's hinterland than in the whole of any Southern state." In still-rural Kings County, an astounding 58.8 percent of the population owned slaves![14]

Ultimately manumission, and the Civil War, were not about African American freedom but about the future of white elites in an expanding Northern industrial economy. Gradual manumission enabled property owners, so deeply invested in slave labor, to squeeze out every bit of labor before freedom and to find other exploitable labor. How would wealth and economic growth be sustained?

The early-nineteenth-century slave system's decline in New York coincided with the decline of the apprenticeship system of skilled artisans. Steam power and the British industrial system inaugurated early mass production techniques. The pride of shoemakers controlling their own workshops and training young apprentices was soon to be displaced by less skilled workers assembling parts under factory discipline. The decades of the rise of the Port of New York renewed fundamental issues of labor and prosperity, life, liberty, and the pursuit of happiness (and property): Who would do it and at what cost? Could black servitude be continued? Who should qualify to be citizens? Voters?

Certainly the master of Sojourner Truth tried to extend her bondage illegally. Others tried to renegotiate work relations to keep slaves working for them after manumission.[15] British and Spanish plantation owners successfully experimented with Chinese and South Asian laborers to replace and supplement enslaved plantation workers. After fierce slave and indentured revolts, the British banned slavery in 1807. The profitable sugar plantation economy created a market for contract laborers from China and South Asia. From 1838 to 1870, over half a million laborers were brought on slave ships to plantations throughout the British West Indies and Latin America. These "coolie" itinerant port laborers were lured and kidnapped into eight-year contracts slaving on colonial plantations. Hotly protested by New York tradesmen, this type of coercive labor was correctly perceived as another form of brutal exploitation. Among the first Chinese and South Asians in New York City were escaped indentures.[16]

Another more powerful labor system was in the making. The market system of wage labor, exemplified by new entrepreneurs such as steam engine builder Allaire, were transforming the way people worked and lived in New York. The anti-slavery movement was driven by the ideology of the voluntary contract. Heralding a utopia, abolitionist leader William Lloyd Garrison believed all forms of human bondage would be destroyed with manumission and reconstruction. "Where are the slave auction-blocks...the slave-yokes and fetters....They are all gone! From chattels to human beings....Freedmen at work as independent laborers by voluntary contract!" European immigrants, however, were soon to suffer and fight a new form of bondage; wage slavery was to smash dreams of

worker independence. To a member of the Knights of Labor, Garrison's uto-pian claims made but 17 years earlier would already prove preposterous.

Garrison expressed a different viewpoint by 1886 in "Thoughts of a Workingman," "They say slavery is abolished in the United States now, but I say no. True, the colored people are free, but how many thousands of white slaves are there all over the country? What do you call men, women, and chil-dren that work in a mill or factory fourteen and fifteen hours a day....Are they not slaves?"[17] European American male workers, however, since 1821 in New York State, no matter how badly exploited, could become citizens and could vote. Voting property requirements were waived for white males, but simulta-neously imposed on African Americans. We know free African New Yorkers continued to be violated and marginalized after manumission and after recon-struction. And in 1882, Chinese laborers were also found to be not capable of acting on their own behalf, and officially excluded from U.S. citizenship and denied naturalization rights until 1952.

The European immigrant system effectively became the new engine for capitalist growth. Catholic and Jewish immigrants would soon inundate lower Manhattan workplaces and housing. Lower Manhattan African Americans would soon be forced uptown. Indeed, it was the Irish and immigrant-led 1863 draft riots that dislodged the African New York community from their original home, pushing them westward and uptown—ultimately to Harlem.[18] Among these immigrants were the new congregants of Dunnell's All Saints' Church. Their simplistic myths about black freedom and the American dream kept them ignorant of the shared problems they had with the church's segregated history.

WHERE IS HOME?
All Saints' Church embodies the historic battle of elites and various groups of "others." The Anglo-American elite norm of self-possessed, male citizens was the founding ethos of All Saints' Church. First African Americans, later other groups, and now Chinese immigrants battle and negotiate against and within these norms to survive and find their piece of the American dream. To understand what happened here, and what continues to happen to African American New Yorkers, is to understand how the dynamics of racialization affects us all in various ways.

What might freedom have meant for the newly baptized Nichols family? Where was home? It did not mean dramatic change of attitude or power. In 1821 it was decided by the New York State Legislature that African American

free men could not vote unless they owned property, whereas the property requirements were waived for white men. A resegregation of rights was under way, and white men, U.S. born and immigrant, would gain substantial power over African Americans. Henry Nichols could not vote, but his newly arriving Irish neighbors could. A Montreal visitor noted the segregation of public life: If "these 'Niggers' are on board a steam boat they dine together after the other passengers." If they attend church, "they are crammed into some corner like a proscribed body." "They are indiscriminately looked upon with aversion by the white population."[19]

Deacon Hopper provides two clues to the question "Where is home?" Henry and Phebe Nichols' baptism with their children indicates that they may have been recent converts. The Christian church expected slave owners to convert their human chattel. Clearly their postmanumission decision to baptize was their own decision. The baptism took place on July 5, manumission day for black New Yorkers. Conventionally, baptisms would be conducted a limited number of days of the year, and surely July 5 was not one of them. They somehow gained the support of Reverend Clark to conduct a special baptism. Deacon Hopper believes they must have been "infected by the celebration attitude" of that day of freedom.

This joyous moment within the church was linked to the massive, typically male street parade outside. James McCune Smith recalled, "That was a celebration! A real, full-souled, full-voiced shouting for joy, and marching through the crowded streets, with feet jubilant to songs of freedom!" Beginning at 9:00 a.m., Grand Marshall Samuel Hardenburgh carried a long staff and led four or five bands of many instruments and "played with much skill," with officers and members of charitable organizations wearing their special uniforms. The five-and-a-half hour street procession wended through all major and most minor streets.[20] Just as the city's African Americans jubilantly claimed the public streets, the Nichols family claimed the ritual altar of All Saints'. The personal was linked to the political: the private linked to the public. Freedom did not mean the end of racism, but it did mean there was more physical and spiritual space in which to wage the struggle.

Black New Yorkers have continued to struggle against the odds and enlarge what it means to be an American. As we reconstruct the slave galleries history, so too must we reconstruct the histories of the various groups who have lived and worked in lower Manhattan. All these paths intersect: all these groups lived a distinctive and intermingled history. The discoveries of St. Augustine's

reminds us how little we know. We have to keep asking questions and we have to keep doing more research.

"Life, liberty, and the pursuit of happiness" had a different meaning for African New Yorkers. In an elite, Episcopal church, trying to become a good Christian slave would only succeed so far. Racism, segregation, and at best patronizing treatment defined so many relationships. In sharp contrast the polyglot, ordinary people who traveled through and landed in this growing port created another culture—a popular people's culture. Making a living and living daily life meant transformation. In the streets, taverns, and public markets, Africans mixed with French-speaking West Indians; Protestant butchers with Bowery *boys* and *gals*; escaped Chinese-Cuban cigar wrappers created families with Irish women, taking on names such as John Thompson; and radical Germans talked international politics with abolitionists. As this port grew, so did the cross-cultural mass of people—all attempting to find their place in this island port of exchange.

Whether it was becoming regulars at an international diner or visiting with neighbors on Henry Street, those who stayed added their personal background to the amalgamation we still celebrate in the street life of New York. It wasn't fancy. It was a survivalist, aggressive, rough-and-tumble basic culture, but it was honest and it was less segregated. It was in this culture that people discovered their individuality by negotiating elements of the culture they came from with elements of the culture they were embracing. And it was in this culture that African American individuals discovered their affiliations with someone from County Cork, as a wage worker or as a street merchant, or as part of a youth culture.[21]

PUBLIC DIALOGUES
The slave galleries are a sacred historical site for all invested in continuing to press for more inclusion and more democracy. Part of Deacon Hopper's vision is to open up the slave galleries as a historic site. Members of St. Augustine's were trained with Tenement Museum staff and others with funds supported by Animating Democracy in a series of diversity communication workshops to get people talking.[22] In February 2000, more than 250 supporters from diverse communities and professions met at St. Augustine's to discuss the meaning of that space for them. Meeting on the same day the four officers tried for the shooting of Amadou Diallo were acquitted, a sense of injustices from the past and present collided. Since then, parishioners have been trained in leading cross-cultural dialogues with a range of individuals and organizations in the area. These face-to-face discussions push all parties to

compare personal stories and group histories. The more questions are asked, the more people realize how little history is known. The spirit has been infectious. Dialogues about the galleries open up new areas of research yet to be done. More fragments, more clues, now need to be pursued.

Perhaps soon the relations between the growing Chinese community, Jews, Puerto Ricans, and the congregants of St. Augustine's can be honestly explored. What are the perceptions of each other? What are the conflicts today? What

are the interrelated histories? Food can be shared; mutual recognition can be opened up. What is necessary for this to flourish? Honest, mutual, and informed recognition can become the basis of long term cross-cultural reconciliation and collaboration.[23]

More local historical research is desperately needed. The documentation of current residents is a great beginning point. Neighborhood youth, with good mentoring and tape recorders, can do wonders. Historians can be enlisted to pull together the best of what has been written and chart out research strategies. Organizations of the Lower East Side working on their own histories of place can join *The Slave Galleries Project* for the long haul. Annual cross-cultural story-telling and history conferences can be organized. True dialogues need this kind of support.

The history of this place matters. Hierarchy, inequity, and power are inscribed into all of what we take for granted today. Reclaiming these historical experiences and understanding their roots is powerful. And like all traditions, it can only be kept alive in the engaged retelling. What ongoing meanings does this past have for us today? And as we understand the diversity of struggles today, dialoguers can better ask the historical questions of where these issues originated and how they played out with earlier residents.

Now as before, the political culture of this historic neighborhood depends on the people knowing its own history and acting to extend its radical democratic traditions. I imagine us continuing in the footsteps of the Nichols family—of dreaming, pushing, and cajoling for bread (pasta, rice), but also roses.[24]

The slave gallery perch is a precarious, dangerous, but also a privileged position. If we truly understand the power of these humble confines, this sacred

place can generate profound insights and a community of conscience from which more freedom springs.

[1] All Saints' Church Vestry Minutes, December 13, 1827; Willam Nichols Dunnell, "Jubilee Sermon," All Saints' Church, New York, NY May 27, 1874; "Existing Conditions Report," Slave Galleries, St. Augustine's Episcopal Church, October 25, 2001.

[2] For more on these popular education questions, see: John Kuo Wei Tchen, "Back to Basics: Who Is Researching and Interpreting for Whom?," in "The Practice of American History," special issue, *Journal of American History* 81, no. 3 (December 1994): 1004–1011; Tchen, "Whose downtown?!" in *After the World Trade Center*, eds. Michael Sorkin and Sharon Zukin (New York: Routledge, 2002); Tchen, "Rethinking Who 'We' Are: A Basic Discussion of Basic Terms," in *Voices From the Battlefront, Achieving Cultural Equity*, eds. Marta Moreno Vega and Cheryll Y. Greene (Trenton, NJ: Africa World Press, 1993), 3–9; and Tchen, "Towards a Dialogic Museum," in *Museums and Communities*, eds. Ivan Karp and Steven Lavine (Washington, DC: Smithsonian Institution Press, 1992), 285–326.

[3] Here I rely on the research of Allen Ingraham in "Report of Research on Saint Augustine's Episcopal Church," conducted for the Tenement Museum and Saint Augustine's Church, 2001, 22–27; and the valuable contextual study of Lucien Sonder, "Interpreting Racially Segregated Seating in Antebellum Northern Churches," (master's thesis, Columbia University, 2001).

[4] Shane White, *Somewhat More Independent: The End of Slavery in New York City, 1770-1810* (Athens: University of Georgia Press, 1991), 8–9.

[5] Ingraham, 33.

[6] Ira Rosenwaike, *Population History of New York City* (New York: Syracuse University Press, 1972), 16–18; White, *Independent*, 5–9; id., 9–10.

[7] *1840 Federal Census*; cited from Slave Galleries Project research files, 1840/1860 Census Findings, St. Augustine's Project.

[8] "Old All Saints' Doomed," *New York Times*, March 20, 1911; "Dr. Dunnell Leaving All Saints' Church," *New York Times*, April 15, 1911; "Dr. Dunnell Says Farewell," *New York Times*, April 17, 1911; "Rector Retires, Church to Close," unidentified clipping, March 20, 1911, from Slave Gallery Project research files.

[9] "The Sixth Sunday of Easter" program, 25 May 2003, Saint Augustine's Church.

[10] All Saints' Church vestry minutes, n.d., Saint Augustine's Church.

[11] Tchen, *New York before Chinatown: Orientalism and the Shaping of American Culture, 1776-1882* (Baltimore: Johns Hopkins University Press, 1999), xv–xxiv; Benjamin B. Ringer, *'We the People' and Others: Duality and America's Treatment of Racial Minorities* (New York: Tavistock Publishers, 1983).

[12] C. B. MacPherson, *The Political Theory of Possessive Individualism* (Oxford: Oxford University Press, 1962); Amy Dru Stanley, *From Bondage to Contract: Wage Labor, Marriage, and the Market in the Age of Slave Emancipation* (Cambridge: Cambridge University Press, 1998).

[13] White, *Independent*, 5–9; id. 9–10.

[14] Ibid., 16.

[15] Sojourner Truth, *Narrative of Sojourner Truth*, eds. Nell I. Painter and Olive Gilbert (New York: Viking Penguin, 1998); Hodges, 191–93.

[16] Tchen, *Chinatown*, 49–51.

[17] Stanley, 4; id., 86.

[18] Iver Bernstein, *The New York City Draft Riots* (New York: Oxford University Press, 1990).

[19] *New York Evening Post*, July 22, 1829, quoted in Shane White, *Stories of Freedom in Black New York* (Cambridge: Harvard University Press, 2002), 60.

[20] White, *Freedom*, 65–6.

[21] For the idea of a port culture, see Tchen, *Chinatown*, 71–93. On cross-cultural popular culture stemming from the docks, see W. T. Lhamon, Jr., *Raising Cain: Blackface Performance from Jim Crow to Hip Hop* (Cambridge: Harvard University Press, 1998), 22–34; and Marcus Rediker, *The Many-Headed Hydra: Sailors, Slaves, Commoners, and the Hidden History of the Revolutionary Atlantic* (Boston: Beacon Press, 2000).

[22] The Lower East Side Tenement Museum has played a leadership role in organizing a network of "museums of conscience" and the Animating Democracy project has actively supported humanities dialogues projects in the U.S. To read more about the museums of conscience see: http://www.sitesofconscience.org. Also, see: Barbara Schaffer Bacon, Cheryl Yuen, and Pam Korza, *Animating Democracy: The Artistic Imagination as a Force in Civic Dialogue* (Washington, DC: Americans for the Arts, 1999).

[23] Eric K. Yamamoto, *Interracial Justice: Conflict and Reconciliation in Post-Civil Rights America* (New York: New York University Press, 1999), 10–11.

[24] For origins of the phrase "bread and roses," see Jim Zwick, "Bread and Roses: The Lost History of a Slogan and a Poem," http://www.boondocksnet.com/labor/history/bread_and_roses_history.html.

Building Upon a Strange and Startling Truth

LISA CHICE

SURFACING ASSUMPTIONS

When our consultants for *The Slave Galleries Project* introduced us to dialogue, facilitator Tammy Bormann said that dialogue is a way "to surface" the assumptions that inform our beliefs and actions. As community preservationists, we dutifully wrote this in our notes to help us understand how this was going to be qualitatively different than other forms of discourse. "How," we wondered then and ask ourselves now, "does civic dialogue serve as tool for forwarding the historic preservation and restoration of the slave galleries? How has it benefited the Lower East Side community as a whole? How does new awareness of old assumptions contribute to a community's sense of itself?"

If you enter St. Augustine's Church through the main entrance and then proceed to the pews in the sanctuary, you face the altar and pulpit with balconies overhead on either side of the church. Once seated in the main sanctuary, you have to turn 180 degrees in your pew and look up beyond the balconies and the organ over the entrance to see the windows of the slave galleries on either side of the organ. As St. Augustine's congregant and Slave Galleries Committee member Rodger Taylor wrote in his *Critical Perspectives* essay about the project, the congregants always knew that those rooms were there, but they were never talked about. You have to look for these spaces and whatever you know or assume you know about the spaces will dictate how you distinguish and

perceive them. On several occasions during our project, I learned that some long-time members of the church were entering the slave galleries for the first time. In contrast, visitors to the Lower East Side who have never set foot in the church but who have heard about the slave galleries through press or word of mouth will come to the church's doors, completely unsolicited, and demand to be shown them. The assumptions and expectations people have about seeing the galleries run the gamut.

Visitors come to the church with various assumptions about the existence of slavery in the North, the impact of manumission and how long enslavement persisted, the Christian church, freedom, choice, suffering, and the legacies of racism, to outline just a few. In his *Critical Perspectives* essay, historian Jack Tchen explores some of the most complicated assumptions, including ones that may make Americans disinclined to look at history: "Our fixed notions of the past numb us from feeling and understanding the continuity of unresolved and uncontested issues into the present." It would be impossible to map every participant's original assumptions, his or her interceding thoughts, and the final impact that *The Slave Galleries Project* dialogues may have had on him or her. However, for those members of St. Augustine's who had never been in the galleries, the communal effort to reveal the story and give voice to the ghosts behind it may have helped them move beyond internal barriers, or at least led them to a more direct relationship with this history.

THE SPACE THAT WRITES THE QUESTIONS:
SLAVE GALLERIES AS DIALOGUE STIMULUS

The role that the Slave Galleries Committee members took on as hosts to civic exchanges heightened their sense of how powerful this space could be to those beyond their own community, including to young people. The church members were riveted by two different youth performance pieces inspired by the galleries. One youth theater group researched, wrote, and produced a play. In another instance, poetry and spoken word pieces were composed by youth immediately following a visit. The space inspired questions that were expressed in these creative works, which made possible a different level of intergenerational dialogue than might arise in conventional dialogue. Following the poetry performances, youth and adults asked each other such questions as: Are older generations still too reluctant to confront their histories? Are youth too flagrant in their use of the N-word, a very hurtful and derogatory term to many, especially from previous generations? Do youth or young activists truly understand what their forbearers had to struggle against?

The honest, less guarded reactions of children and young people have shaped the way the tours of the slave galleries are delivered. Young recent immigrants or children who have not lived through civil rights struggles may need to be engaged through targeted questions to bring the experiences of those who lived so "long ago" to bear on their own life experiences. Children and adults alike may need help understanding the setting of the galleries: some have never been in a Christian church or may be uncertain about seating arrangements, baptismal rites, and other religious practices. Dialogue helped the Slave Galleries Committee and committee chair, the Reverend Deacon Edgar W. Hopper, to understand their own assumptions about bringing people into the space and how the space should be presented to resonate with different audiences, including youth.

> You have to look for these spaces and whatever you know or assume you know about the spaces will dictate how you distinguish and perceive them.

Deacon Hopper often recounts his experience with one impassive young visitor, a Hispanic teenager who had not spoken or reacted throughout his entire visit. Finally, Deacon Hopper asked the boy whether the story of the slave galleries would be interesting to his friends and how it could be presented to them. The boy became animated with ideas of how to create a multimedia environment that would be stimulating to younger people. The enthusiastic response strengthened Deacon Hopper's resolve to develop meaningful ways to connect specifically with young people as well as how to interpret the space for a wide range of visitors.

"Let the space write the questions," suggested one adviser to *The Slave Galleries Project*. The galleries, a physical artifact of a complicated history, allow visitors to construct knowledge through the experience of being in the space. You do not have to be told that African Americans were not considered an accepted part of the congregation when you feel how removed you are from the service in that enclosed space. You do not have to be told that you are not free to come and go when you experience the narrow winding steps up to the galleries.

In some dialogues, church members who had been in the galleries before said that they observed different physical aspects of the space in subsequent visits. As agents of this initiative and witnesses to the process of history being uncovered, they could begin to deal with a range of emotions and assumptions each time they entered the space or engaged in a dialogue about it. When

modern-day protective screens were removed from the windows during the architectural research, one committee member said, "There was more air. I felt more like a part of the parish—like it was less oppressive and somehow at odds with how I should feel."

The current structure of the slave galleries tours encourages visitors to ask questions and to balance known fact with what they see, hear, and feel—to come to their own understanding of the space.

FINDING EQUITY AND EMPATHY ACROSS MULTIPLE AGENDAS

Deacon Hopper expressed concern that at times the project was outer-directed. The Slave Galleries Committee knew that it had the option of pursuing this project without involving partners (the Lower East Side Tenement Museum and other members of the Lower East Side Community Preservation Project and Animating Democracy). Rodger Taylor's essay documents these sentiments and the fundamental passion and commitment within the congregation. Before the congregation agreed to host community dialogues, it needed to be convinced that the community dialogues would forward *The Slave Galleries Project*. In retrospect, the dialogue agenda took considerable time and energy that some believe might have been better spent on raising money for the physical restoration. How, in fact, have the dialogues helped or hindered the restoration process?

The dialogues provided a means of developing an audience and support base for the long-term project. The partnerships increased exposure and made it possible to invite audiences within a controlled format before formally accommodating public tours. Now, as a result of the dialogues, the committee has documented evidence that the space can serve as an educational and civic resource that will be valuable as it seeks support for preserving this historic space.

> The current structure of the slave galleries tours encourages visitors to ask questions and to balance known fact with what they see, hear, and feel...

Since the dialogues took place in the context of important ongoing civic issues in the neighborhood such as housing and education resource allocation, there were times I could look at a group of dialogue participants and identify those who were at odds in an outside issue. The results of *The Slave Galleries Project* dialogues may not have gone toward direct resolutions of the civic issues, but the opportunities to be exposed to

different views and consider multiple perspectives does seem to have opened communication channels within the community. This was even true with facilitation trainees from the different groups who applied the dialogue principles to relationships within their own organizations with noticeable results.

Both St. Augustine's Church and the Tenement Museum have had in mind that the project would have a ripple effect throughout the community: The Slave Galleries Committee has wanted to serve as a role model and inspire various communities on the Lower East Side to take ownership of their own history. Deacon Hopper has cautioned that people who do not take ownership of their history are in danger of being erased. He, in particular, very much wanted to see the direct intense collaborative approach used on *The Slave Galleries Project* replicated with an Asian American site and a Hispanic community site. As this has been a vision since the beginning of our collaboration, he has viewed it as an unfulfilled obligation to those who have participated from the Community Preservation Project. When the project organizers at St. Augustine's and the Tenement Museum organized the dialogues and decided to offer facilitation training, the idea was that participants would take their facilitation skills back to their own organizations and create dialogues around local sites of significance within their own communities.

> ...there were times I could look at a group of dialogue participants and identify those who were at odds in an outside issue.

In order for *The Slave Galleries Project* dialogues to be a role model for other community projects, it is useful to make a realistic assessment of the factors that have contributed to its success: The dialogues rode on the momentum of *The Slave Galleries Project,* based on interest in and commitment to preserving the slave galleries. The dialogues benefited from the structured time frame provided by the formal facilitation training. The process required time for planning and execution. It required access to a space. In the long term, *The Slave Galleries Project* dialogues have required ongoing financial support to organize and administer. With a more realistic assessment of the challenges in beginning and sustaining these types of dialogue or preservation projects, other projects may be more likely to succeed.

The success of the dialogues has finally relied on community participation, particularly the participation of the community preservationists. The dialogues

wouldn't have been as effective if there had been a great deal of attrition from meeting to meeting, as may often be the case in volunteer community committees. I have thought about why these very busy community members remained committed and kept coming back.

It seems that the community preservationists were motivated to a collective effort to counter misconceptions about slavery as well as other misconceptions about their own communities and the Lower East Side. Jack Tchen and Rodger

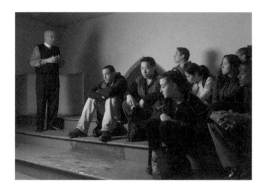

Taylor both devoted parts of their essays to address the public's lack of awareness about slavery in the North. Clearly, there is a need to look at race issues within our society and to identify how these issues divide us and plague our communities. And yet, unfortunately, civic exchange about race is too often precipitated by a negative incident or a confrontational situation. When St. Augustine's opened its preservation project to other groups, it was inherently an invitation to various groups to look together at the treatment of African Americans and the pervasiveness of racism. This dialogue wasn't driven by conflict. Instead it was part of an affirmative project that galvanized participants. As a dialogue participant and organizer, I was able to see many different ways that the slave galleries resonated with people of different backgrounds and how they allowed for exchanges that were different from any other forum.

Although the slave galleries have been the stimulus for what might be considered healing or cathartic dialogue across different backgrounds, I have been wary of overplaying the slave galleries as a metaphor for other instances of hidden oppression in history. I have feared that this might somehow be an unfair appropriation of the meaning the slave galleries have as a concrete artifact from one particular group's history—the experience of African Americans who were enslaved and subjugated. Ultimately, I think that this will be an ongoing issue for stakeholders. The dialogues have demonstrated how much other groups wanted to bring in their perspectives. At the same time, I can understand the person who advised the committee not to talk about other groups in a way that dilutes the African American experience.

A NEW HISTORY

Before he brings people into the space, Deacon Hopper prepares the visitors with a meditative moment. They are asked to close their eyes and imagine themselves as enslaved African Americans. Then they are told to enter the galleries in silence.

Often, we have started postvisit discussions by asking, "How did the space make you feel? Was there a time in your life that you felt similarly?" Storyteller Lorraine Johnson-Coleman wrote for *Critical Perspectives*, "The story always reveals itself to us with the silent backdrop of how we live and how we believe in the moment."

In their essays, Rodger Taylor and Jack Tchen reference the church's centennial celebration in 1924 and the pageant that was held depicting the freeing of the slave Uncle Tom from bondage. When we read the pageant script today we are disturbed by this unenlightened celebration of an emancipatory act that fails to deliver. It occurs to me that we have become a successive generation of community members trying to commemorate a history and deal with themes of racism, trying in different ways to put ourselves inside the story and the individual slave's experience. I wonder how our relationship to the space will be different from that of future generations and whether our efforts to preserve the story will have the anticipated results for future generations.

> *We, this people, on a small and lonely planet*
> *Traveling through casual space*
> *Past aloof stars, across the way of indifferent suns*
> *To a destination where all signs tell us*
> *It is possible and imperative that we learn*
> *A brave and startling truth*
>
> *—Maya Angelou*

Two hours into the first slave galleries dialogue, a Slave Galleries Committee member stands to leave. She says, "Normally I would just leave quietly, but after hearing what everyone had to say, I wanted to say good night to you all and also give everyone a copy of this poem that I had that reminds me of the things we have talked about tonight." The slave galleries have proved to be an unparalleled catalyst for discussions about a broad range of issues that affect us today. The history of the slave galleries and how they have been used is still unfolding as the community continues its pursuit of a strange and startling truth.

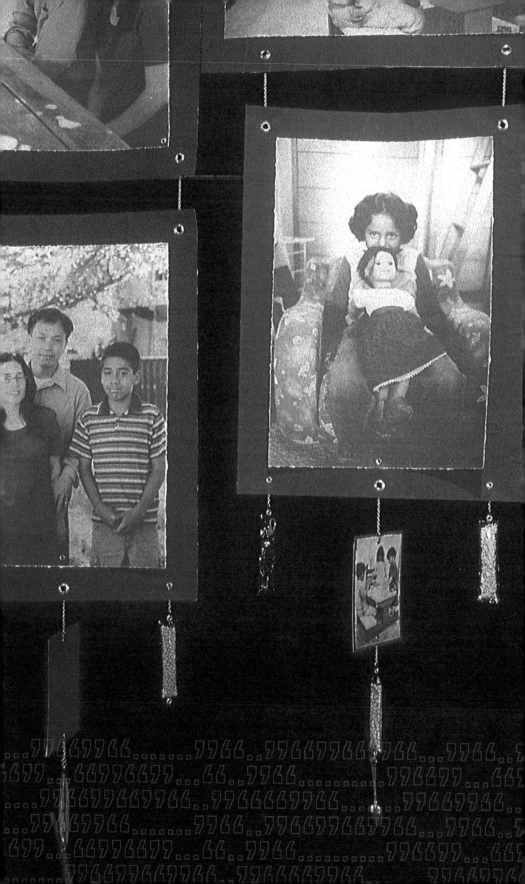

3 *Ties That Bind*

::: **MACLA (MOVIMIENTO DE ARTE Y
CULTURA LATINO AMERICANA)**

TIES THAT BIND was a photographic exhibit, oral history, and public dia-
logue project that reflected upon the history of intermarriage between Asians
and Latinos in the San Jose area to illuminate civic issues of intra- and inter-
ethnic relations in California today. MACLA was intrigued by major changes
in the California social and demographic landscape and disturbed by media
portrayal of Latinos and Asians at opposite ends of a civic-participation para-
digm—Asians are often singled out as "model minorities" while Latinos are
represented as a community facing serious social and economic deficiencies.
Through *Ties That Bind*, MACLA sought to dig deeper into the love stories,
cultural negotiations, and personal memories of people directly engaged in
expanding the definition of ethnic identity in California and to shed light on
these contradictions. Three questions guided the project:

- How were these tensions and desires experienced on the level of everyday life by mixed heritage Asian-Latinos themselves?
- How can artists represent these affective dimensions of "social facts"?
- What, if any, should be the role of community-based cultural organizations like MACLA in tackling these complex issues of civic life?

Fifteen families shared their personal stories with artists and scholars (writer and cultural anthropologist Renato Rosaldo among them) in order to create the work. The exhibition, a series of installations including new and old photographs, objects found in the homes, and created environments, reflected artists Lissa Jones's and Jennifer Ahn's interpretations of what they saw, heard, and learned through the process. As described in the MACLA exhibition catalogue, "The work creates metaphors of cleanliness and contamination (manifested in a bathroom scene); fragmentation and memory (embodied in cooking strainers); private meanings and public displays (suggested in a laundry line); the comfort of the familiar and the fear of the unknown (captured in shadow boxes); the opening and closing of ethnic identity manifested in mundane everyday routines (expressed through door frames)." Dialogue began with a core group of community leaders and advisors who helped frame the issues; it continued with Latino and Asian community participants whose photos and oral histories reveal the depth of the story of intermarriage, past and present; and concluded with a public forum. Dialogues challenged prevailing ideas about ethnicity that hold to separate histories and identities to consider instead how the reality of shared histories, bonds of affection, and common aspirations has contributed to the cultural and social landscape of the region.

Intermarriage and Public Life

MICHAEL J. ROSENFELD

INTRODUCTION

Interracial couples are inadvertent performance artists of a sort. Walking down the street together they attract attention, and they raise questions in the minds of strangers. Their body language is memorable because their faces are memorably different from each other. At the checkout line in the grocery store the clerk may assume the couple are separate; therefore to avoid the momentary awkwardness of explaining "we are together" the couple may hold hands as a matter of necessary pantomime. Some interracial couples are made uncomfortable by the extra attention; some pretend to ignore it; others relish it.

Love and mating are personal matters, of course, and some interracial couples will insist, at first, that their relationship is only a private matter between two people that does not affect, and is not affected by, anyone else. Yet the social ramifications of family and race are unavoidable. Most black-white intermarried couples in the United States have faced strong parental opposition to their union, usually from the white spouse's parents. Some of these parents have not spoken to their children in decades. Interracial couples are always on display; they always have some extra explaining to do; and their own children sometimes express confusion about mommy

and daddy's differences. Because the personal is political, and because race is the fundamental divide in American life, interracial families can't help but influence their communities.

Ties That Bind is a collaboration between Bay Area artists to open a dialogue about interracial marriages, specifically marriages between Hispanics[1] and Asians. The artistic exhibit, which debuted in September 2002, was designed to make visitors feel as though they were in a home—thereby making public the private. There were spices hanging from the wall; there were family photos everywhere; there was a sink with towels. The reception for the exhibit was food on a table in the middle of the dining room of the exhibition space, near the spices on the wall. The public were not only the viewers and the audience, but they were also living in the house and eating the food and therefore were themselves subjects of the artistic rendition of the intersection of Hispanic and Asian American-ness.

Many of the guests were also the actual subjects of the study. Families who had been interviewed and photographed saw their own family images hanging on the walls. For the children it seemed to be a delightful revelation, like being in the school play and having other children's parents applaud your performance. For the parents, it was intriguing but also seemed a bit disconcerting. Parents are naturally protective of familial privacy in ways that children are not. In this essay I'll compare some of the individual, private, and subjective perspectives on interracial unions with some presumably objective data from the U.S. Census. The *Ties That Bind* project made interesting claims about both the subjective and the objective realities of Hispanic-Asian intermarriage in San Jose, CA, and I'll try to explore some of the ways in which the subjective and objective realities were alike and different.

A FEW HISTORICAL POINTS OF REFERENCE
Racial intermarriage was illegal in many states of the United States until the Supreme Court struck down the anti-intermarriage laws in 1967 in the case *Loving v. Virginia*. A few state laws against intermarriage remained on the books, uninforced, until the late 1990s. Most of the state laws were specific in prohibiting intermarriage only between blacks and whites, but some also prohibited intermarriage between Asians and whites. In terms of U.S. law, Hispanics would have been considered white, and therefore would have been unable to marry Asians in a number of states including California prior to 1948.

In 1948 the California Supreme Court ruled that the state's anti-intermarriage law was unconstitutional, in the case of *Perez v. Sharp*. It took the U.S. Supreme Court 19 more years to catch up with the California Supreme Court and agree that laws against racial intermarriage were unconstitutional (Moran, 2001). The main reason that the U.S. Supreme Court waited until 1967 to undo the anti-intermarriage laws is that, apparently, they were afraid of the political backlash. It was one thing to force integration in the public schools, as the U.S. Supreme Court had tried to do in 1954 with *Brown v. Board of Education*. It was quite another thing to allow racial mixing within families.

The black political establishment in the pre-Civil Rights era was also wary of the intermarriage issue, seeing intermarriage as a personal matter and not a fundamental right. Among the early twentieth century black political figures, DuBois had a favorable view of intermarried couples, but certainly didn't make intermarriage a central political issue (DuBois 1995 [1899]). Booker T. Washington opposed intermarriage on the grounds that it would incite whites unnecessarily, and Marcus Garvey was ideologically opposed to the idea of racial intermarriage (Spickard 1989). By the mid-1960s the NAACP legal defense fund was willing to weigh in on the intermarriage issue, but did so gingerly.

> Because the personal is political, and because race is the fundamental divide in American life, interracial families can't help but influence their communities.

There were two reasons that black leaders and civil rights organizations were generally unwilling to fight the anti-intermarriage laws. The first reason was that mate selection was clearly a private matter, whose legality or illegality had public policy implications that were difficult to quantify. The second reason was that, for whites, the ban on racial intermarriage was of paramount importance. Gunnar Myrdal's 1944 influential midcentury research on race in the United States argued that the entire apparatus of racial segregation in schools and neighborhoods had as its primary intention the prevention of socializing, dating, and ultimately marriage between the races.

Although racial segregation in mate selection might seem to have less public policy relevance than segregation in public school classrooms, paradoxically the private and intimate nature of mating ensured that the ban on

racial intermarriage was the bulwark of the old racial segregation system. Without the effective social barrier between the races (as manifested in the intermarriage prohibition), large-scale segregation between the races in any social dimension would have been less feasible. The intermarriage ban is central to the larger system of racial segregation in the United States. In the aftermath of the Civil War, laws against racial intermarriage were the first kind of segregation laws to be enacted, and the marriage market was the last social arena in the United States to lose its barrier of legally enforced segregation.

THE ETYMOLOGY OF "MISCEGENATION"

The word "miscegenation" has Latinate roots, meaning "mixing between groups," so one might presume that this word for intermarriage is many centuries old, but that would be incorrect. The word "miscegenation" was invented during the U.S. presidential campaign of 1864 by proslavery newspaper editors in New York (Kaplan, 1949; Oxford English Dictionary 1989).

These editors perpetrated the following brilliant and insidious political hoax: They created a pamphlet that defined the word "miscegenation" for the first time, and purported to endorse "miscegenation" as a way to bring blacks and whites closer together after the Civil War. Then they sent the pamphlet to leading abolitionists in the North, some of whom responded in writing with guarded enthusiasm. Then the true authors published the incendiary pamphlet (along with selected endorsing quotes from famous abolitionists) claiming that the pamphlet had been written by the abolitionists, and that the true program of abolition and emancipation was the forced intermarriage of blacks and whites. The authors of the pamphlet correctly judged that Northern whites would be horrified by the idea of freed slaves marrying their daughters.

> The intermarriage ban is central to the larger system of racial segregation in the United States.

Indeed, the pamphlet played an important role in the summer of 1864 in turning Northern opinion against Lincoln. As a result, he was widely expected to lose the presidential election to General McClellan. It was only the Union victories on the battlefield in the fall that saved Lincoln's political fortunes and ensured his re-election. The great hoax of the "miscegenation" pamphlet was only discovered years after 1864.

INTERVIEWS WITH HISPANIC-ASIAN BICULTURAL FAMILIES

Unlike my own interviews with black-white couples, the Asian-Hispanic bicultural families interviewed for the MACLA project seem to feel less public, less noticed. For some of these families the idea of "bicultural" is a bit of a misnomer because both sides of the family are now irrevocably American, and little cultural memory remains of Japan or the Philippines or Mexico. For others, there were cultural and linguistic barriers at first but over the years the family has come to a sort of shared central culture, usually around English and American culture with symbolic reminders of the foods, religions, and customs of the land of their immigrant ancestors. The specter of race is more apparent to these families when they talk about the past.

> For some of these families the idea of "bicultural" is a bit of a misnomer... For others...over the years the family has come to a sort of shared central culture...

Don Shionozaki is a local elected politician in the Bay Area.[2] As an elected official his race and ethnicity is always open to examination and scrutiny because electoral politics have an unavoidable ethnic and racial component. Don Shionozaki's public life was not planned, however—his father, who was the natural politician, died in office, and Don inherited the position. He has done the best he can to fill his father's shoes. Don's surname is Japanese, but the Japanese grandfather was estranged from the family before Don was born, so his surname is by far the most Japanese part of Don. He notes that the Japanese American community is aware of him, but has not embraced him.

Don's paternal grandfather was a Japanese immigrant, and his paternal grandmother was an immigrant from Mexico. The two met in California in the 1930s. When they decided to marry, they had to go to Minnesota to get married, since interracial marriage was still illegal in California at that time.

In the aftermath of the bombing of Pearl Harbor in 1941, orders came down to remove all Japanese Americans from the West Coast to internment camps. Don's Japanese grandfather was exempted from this order because he was already an officer in the U.S. military, and his Japanese language skills made him valuable to the U.S. war effort. While Don's grandfather was not interned, Don's Mexican immigrant grandmother and her three Mexican-Japanese-American children (including Don's father) were interned. The

irony and bitterness of interning the entire family except for the only truly Japanese member of the family was difficult to accept, and Don's grandmother and grandfather were soon divorced.

Every family with Japanese ancestry that lived in the United States in 1941 was dramatically affected by World War II and internment. The policy of internment was of course not extended to German or Italian Americans, so the internment of the Japanese was clearly a racially motivated policy (Takaki 1989). German Americans and Italian Americans, and even German and Italian immigrants, were, by the legal definitions of the time, "white," whereas the Japanese were not. Don's father, though he was a U.S. citizen born in California, was interned because his father was Japanese. Other interviewees for the project, who were Asian but not Japanese, remember that they or their parents were forced to demonstrate, in all sorts of public ways, their non-Japanese-ness.

Growing up, Don had no contact with his Japanese cultural heritage, and only a very Americanized knowledge of Mexico and the Spanish language. Perhaps because of his mixed heritage, Don tried on a number of different ethnic identities growing up. In high school, he was Hawai'ian. It was a time that Hawai'ian music was popular, and some of the students thought Don was Hawai'ian, and he just "went with it." The girls in high school thought that Hawai'ians were exotic and interesting. In the army in the 1970s, someone thought Don might be Native American; they started calling him "Chief," and he just "went with it." In both cases Don's ambiguous ethnic heritage allowed him to become whatever the people around him wanted him to be or assumed that he was. He could pass for nearly anything.

> To my eyes, the most interesting things about the *Ties That Bind* project was how local, how intimate, and how concrete the exhibit felt.

Serving in the army, however, gave Don another kind of ethnic identity— American. Being of Japanese descent, or even just having a Japanese surname, still entitles one to crank calls and threats on December 7, the anniversary of the Pearl Harbor attack. When Don was canvassing the trailer homes of elderly whites in his district for his first political campaign, he found this audience was extremely suspicious of him—a young man with a Japanese surname. That suspicion melted away when he talked about his service in the

army. For the World War II generation, military service was a patriotic right of passage with which subsequent generations were insufficiently acquainted. As a working class kid raised in a fairly Americanized Mexican American household, Don needed the army both to pay for his college education, and to legitimize his American-ness.

THE CLAIM OF SINGULARITY: A LOOK AT THE NUMBERS

One of the central themes of MACLA's work on Hispanic-Asian intermarriage is that San Jose is a special nexus of Asian-Hispanic intermarriage. In order to unpack this interesting claim, I'd like to examine the important ideas that are explicit and implicit within it. First, there is the claim of singularity (that San Jose is different). Second, there is the claim of cosmopolitanism (that San Jose is the kind of place that nurtures subcultures that are excluded elsewhere). Third, there is the claim of heterogeneity (that San Jose is more racially diverse than other places). Fourth, there is the claim of alternativeness and transgression (that Asian-Hispanic intermarriage fundamentally transgresses against social norms that predominate in other, less cosmopolitan parts of the United States). I'll examine each of these claims, starting with singularity.

The reality of San Jose is that there is no more Asian-Hispanic intermarriage there than anywhere else. Intermarriage (between Asians and Hispanics and all other kinds of intermarriage as well) is increasing everywhere, so residents of San Jose can be forgiven for believing that the high rates of intermarriage that they see are somehow unique. It's a sign of the growing visibility of intermarriage in the United States in general that people in all kinds of specific places (like San Jose) think that they're in the middle of the action. As it turns out, intermarriage is going on everywhere in the United States at more or less the same kind of pace. Of course there's a bit more intermarriage between Latinos and Asians in California because that's where the Latinos and Asians are most prevalent. San Jose is part of a diffuse but powerful demographic change that is changing the public and private faces of the United States.

The following tables based on the micro-data from the 1980 and 1990 U.S. censuses (U.S. 2000 census micro-data was not yet available at the time of writing) shows the marital choices of Asian women in the United States. The same analysis could be done for Asian men, Hispanic women, or Hispanic men.

In 1990 there were 1,531,455 married women of Asian descent in the United States, and of these about 1.54 percent were married to Hispanic men. The largest group of Asian married women were married to Asian men (76.7 per-

cent), and the second-largest group were married to non-Hispanic white men (20 percent). Although the number of married Asian women in the United States nearly doubled from 1980 to 1990 (from 837,931 to 1.5 million), the percentage of those women who were married to Hispanic men declined slightly, from 1.8 percent to 1.5 percent.

In the censuses of 1980 and 1990, "Hispanic" and "Asian" are potentially overlapping definitions. That is, Asian identity is derived from a question about race, and Hispanic identity is derived from a separate question about Hispanicity, so there was no built-in barrier to respondents reporting themselves as Asian and Hispanic. Prior to 2000 the race and Hispanicity questions allowed respondents to choose only one response, so it was not possible to be Asian *and* white, or Asian *and* black.

Table 1: Husband's race for all married Asian women in the United States

HUSBAND'S RACE	CENSUS YEAR 1980	CENSUS YEAR 1990
Non-Hispanic white	195,859 (23.4)	305,953 (20.0)
Non-Hispanic black	15,811 (1.9)	22,814 (1.5)
Non-Hispanic Asian	608,213 (72.6)	1,174,899 (76.7)
Hispanic	14,968 (1.8)	23,632 (1.5)
Other	3,080 (0.4)	4,157 (0.3)
Total	837,931 (100)	1,531,455 (100)

Source: Weighted U.S. census data; percentages in parentheses are percentages of all married Asian women who are married to men from each category.

In these tables I have followed Census Bureau practices by putting all the Hispanics in one category, and leaving only non-Hispanics in the white, black, and Asian categories. Hispanics can, therefore, be of any race and some of them are Asians, either because their ancestors intermarried with Asians in the United States or because they are descended from Asians who immigrated to Latin America. There are substantial Chinese and Japanese populations in South America. Some of what is reported here as intermarriage between Asians and Hispanics might be more properly considered racial endogamy among Asians. The problem with statistics on intermarriage is that one must first have a definition of the races or ethnic groups, and such

definitions are problematic because the ethnic groups and races themselves resist definition.

In 1990 there were 23,632 Asian women married to Hispanic men in the whole United States, and of this number 10,047 lived in California and of those 726 lived in the San Jose metropolitan area. The key point to note in Table 2 is that the percentage of Asian women who are married to Hispanic men is not particularly high in San Jose. In fact, the percentage of Asians who are married to Hispanics in San Jose (1.4 percent) is a bit smaller than the equivalent percentages in California (1.7 percent) and in the United States as a whole (1.5 percent). That is, there is a high concentration of Asians in California, but California's Asians are no more likely to marry Hispanics than are the Asians of New Jersey or Illinois.

Tables 1 and 2 include married people of all ages and all places of birth. Whenever one looks at people of all ages, one is inevitably looking into the past, because a substantial portion of these married couples would have been married decades before the 1990 census. In order to get a better idea of what was going on recently before the 1990 census, it is useful to limit oneself to the younger married couples. In Table 3, I examine the marital choices of Asian women who were in their 20s at the time of the 1990 census (these women would have been married in the 1980s). In Tables 1 and 2, Asian women are included whether they were born in the United States or abroad. This can be misleading because foreign-born persons are frequently married before they come to the United States, so Table 3 includes only U.S.-born persons.

Table 2: Husband's race for all married Asian women at three levels of geography, 1990

HUSBAND'S RACE	ENTIRE U.S.	CALIFORNIA	SAN JOSE, CA
Non-Hispanic white	305,953 (20.0)	91,315 (15.6)	6,075 (11.4)
Non-Hispanic black	22,814 (1.5)	7,700 (1.3)	393 (0.7)
Non-Hispanic Asian	1,174,899 (76.7)	476,720 (81.2)	45,984 (86.3)
Hispanic	23,632 (1.5)	10,047 (1.7)	726 (1.4)
Other	4,157 (0.3)	1,360 (0.2)	122 (0.2)
Total	1,531,455 (100)	587,142 (100)	53,300 (100)

Source: Weighted U.S. census data; percentages in parentheses are percentages of all married Asian women who are married to men from each category.

Table 3: Husband's race for married U.S.-born Asian women age 20–29 in the United States and San Jose, California, 1990

HUSBAND'S RACE	ENTIRE U.S.	SAN JOSE, CA
Non-Hispanic white	15,253 (44.1)	322 (39.9)
Non-Hispanic black	729 (2.1)	18 (2.2)
Non-Hispanic Asian	15,661 (45.3)	398 (49.3)
Hispanic	2,622 (7.6)	70 (8.7)
Other	311 (0.9)	–
Total	34,576 (100)	808 (100)

Source: Weighted U.S. census data; percentages in parentheses are percentages of all married Asian women who are married to men from each category.

As Table 3 shows, if we limit ourselves to young U.S.-born Asian women, the percentage married to other Asians drops to less than 50 percent, the percentage married to non-Hispanic whites increases to 40 percent or more, and the percentage married to Hispanics hovers between 7 percent and 9 percent. Note again that the percentage of Asians married to Hispanics is not much different in the United States (7.6 percent) and in San Jose (8.7 percent). Given the fact that the racial and ethnic composition of San Jose is substantially different from the racial and ethnic composition of the United States as a whole, it is surprising how similar the United States and the San Jose data are.

So much for the claim of singularity. In another paper (Rosenfeld and Kim, eds.) I show that certain kinds of unions, specifically same sex unions and black-white intermarriages, are highly concentrated in the great cities of the United States, specifically in New York, Los Angeles, Chicago, and the San Francisco Bay Area. The more alternative and transgressive the union is, the more the couples are likely to be concentrated in these cities. Same-sex unions are the most alternative and transgressive type of union in the United States, and same-sex couples are also the most concentrated in great cities (especially San Francisco). Same sex couples and black-white intermarried couples frequently are rejected by their families, and so are forced to seek communities of solidarity and support elsewhere. The great cities are the places where subcultures thrive.

Compared to black-white intermarriage or same sex unions, Asian-Hispanic intermarriage is *not* particularly transgressive or alternative. Although Don

Shionozaki's family was persecuted (along with thousands of others) for having Japanese ancestry during World War II, none of the families interviewed in the *Ties That Bind* project told stories of familial rejection and disruption commonly heard when one interviews same sex or black-white couples. The implicit claims of alternativeness and transgression that are inherent within the public framing of the *Ties That Bind* project are not much reflected in the personal stories that the families tell.

How cosmopolitan and diverse is San Jose? The diversity question is fairly easy: San Jose is no more or less racially and ethnically diverse than California as a whole. Cosmopolitanism is a bit more difficult to assess. A place is cosmopolitan to the extent that it harbors and nurtures a diversity of ideas and subcultures that are not generally tolerated in other places. This definition of cosmopolitanism derives from classic sociological studies of urbanism (Wirth 1938; Fischer 1975), which celebrated the city as the place where immigrants, new music, radical ideas, and new customs thrive. In the context of interracial marriage, the cosmopolitan places are the places that are magnets for the most taboo and historically controversial kinds of unions: same sex unions and black-white intermarriages. Unlike San Francisco and New York, census data does not show the concentration of same sex and interracial unions to be especially high in San Jose. San Jose does not appear to be especially attractive as a living destination for alternative unions, and San Jose is therefore not as cosmopolitan as San Francisco or New York.

Art is an inherently cosmopolitan undertaking. San Jose itself has been transformed in the past few decades. Whereas San Jose used to be a quiet backwater halfway between San Francisco and the agricultural San Joaquin Valley, now San Jose is a major city in the midst of Silicon Valley, with a busy international airport and a global profile. San Jose has been transformed into a more urban and economically important city. During the brief internet boom of the late 1990s, commercial rents in San Jose were higher than in San Francisco or Manhattan, so residents can be forgiven for comparing their city to San Francisco or New York; that was the comparison the city fathers wanted them to make. Art projects like MACLA's *Ties That Bind* make San Jose more cosmopolitan, and this is unambiguously a good thing, but some may also imagine a San Jose that is more cosmopolitan than San Jose truly is.

To my eyes, the most interesting things about the *Ties That Bind* project was how local, how intimate, and how concrete the exhibit felt. This intimacy and geographic specificity is real, of course, just as the demographic phenomenon

of Hispanic-Asian intermarriage is geographically broad and nonspecific. Intermarried couples, the visible manifestation of a wider demographic trend, are local. One sees them at the grocery store, or at the park, or one knows them from church or work. In our subjective experience, intermarriage is always just around the corner, just down the street. It is natural, therefore, to assume that one's own neighborhood or city must be a hotbed of intermarriage activity. It's probably also natural for San Jose to assume that it's the center of every movement, just as it has been the center of the technology revolution. We want to assume that our lives and our art are special and singular and part of an important vanguard. Demographic and family changes, however, tend to be broadly distributed across geographical and social space.

We're all part of the frontier of changing family structure. Although the literature that was produced for the *Ties That Bind* project emphasized the peculiarity and singularity of Hispanic-Asian intermarriage in San Jose, the art exhibit itself had a different emphasis. The *Ties That Bind* exhibit was reflexive and general rather than singular and objectifying. The exhibit hall was set up as a home, in the same scale as a typical Bay Area home, with sinks and towels and pictures and spices, and real people eating multiethnic food and talking. The nature of the exhibit itself made all visitors part of the interethnic family. It emphasized the general public's participation and complicity in the changing roles of race and family in the United States.

[1] Although the term "Latino" is preferred over "Hispanic" in many academic and political circles, I use "Hispanic" throughout this paper because the U.S. Census Bureau uses "Hispanic," and because I use Census Bureau data.

[2] Although the MACLA project has permissions from its interviewees to use their real names in all written and artistic work, I have changed the names and blurred the identifying characteristics of interviewees for two reasons. The first reason is practical: in my own research I promise strict confidentiality to all subjects, and I felt it could be confusing to adopt separate standards. The second reason is that I believe in the privacy of personal lives, even for public figures like Mr. Shionozaki.

References:

Du Bois, W.E.B. [1899] 1995. *The Philadelphia Negro: A Social Study.* Philadelphia: University of Pennsylvania Press.

Fischer, Claude. 1975. Toward a subcultural theory of urbanism. *American Journal of Sociology* 80 (6): 1319–1341.

Kaplan, Sidney. 1949. The miscegenation issue in the election of 1864. *Journal of Negro History* 34 (3): 274–343.

Moran, Rachel. 2001. *Interracial Intimacy: The Regulation of Race and Romance.* Chicago: University of Chicago Press.

Myrdal, Gunnar, with Richard Sterner and Arnold Rose. 1944. *An American Dilemma The Negro Problem and Modern Democracy.* New York: Harper.

Oxford English Dictionary. 1989. Second Edition.

Rosenfeld, Michael J. and Byung-Soo Kim. 2003. Iternative unions and the independence of young adults in the U.S. Unpublished manuscript.

Spickard, Paul. 1989. *Mixed Blood: Intermarriage and Ethnic Identity in Twentieth-Century America.* Madison: University of Wisconsin Press.

Takaki, Ronald. 1989. *Strangers from a Different Shore: A History of Asian Americans.* Boston: Little Brown.

Wirth, Louis. 1938. Urbanism as a way of life. *American Journal of Sociology* 44 (1): 1–24.

Ties That Bind / Ties That Bond: A Community-Based Art Project in Silicon Valley

LYDIA MATTHEWS

IMAGINE THIS SCENARIO: it's 1999 in Silicon Valley, CA. Signs are beginning to appear that the inflated high-tech dot-com bubble is about to burst, catalyzing an economic downturn that will affect everyone in the region. Movimiento de Arte y Cultura Latino Americana (MACLA), a small, progressive community art center founded in 1989 as an advocacy organization to promote multicultural programs in downtown San José, is consider-

ing ways to build upon its mission despite the grim economic forecast. Through diverse curatorial strategies, MACLA has long established its reputation for encouraging socially engaged artists and fostering experimental cultural interventions that challenge mainstream art world practices. The quest is to continually invent new ways to connect civic culture and art in response to contemporary social conditions.

MACLA's visionary arts administrators, Executive Director Maribel Alvarez and Curator Anjee Helstrup, are brainstorming ways to widen their audience and increase the center's cultural impact in the area. Maribel proposes launching a project that challenges the way people typically categorize ethnic "communities": Why not address the changing demographics brought on

by an increasing number of intermarriages between Latinos and Asians, the two largest cultural groups in the region? They envision a MACLA project that would marry art and anthropology by commissioning visual artists and scholars—to gain insights into these hybridized families. They had already had great success with their "ethnographically" oriented low rider bicycle exhibition, a show that allowed one specific Silicon Valley subculture to display its wares and visually represent the character of its lifestyle. Perhaps now MACLA could commission artists to represent the life experiences of interracial families based on interviews and regular visits with them, encouraging everyone involved to learn through the creative process. Certainly artists would have the capacity to forward a vision to counter simplistic and offensive stereotypes—a loud, prison-bound gang member marrying the decorous, overachieving "model minority." Incubating such innovative visions was what MACLA had always been about—and so the idea for the *Ties That Bind* project came into being.

There is something enormously ambitious and delightfully ambiguous about the community-based art project that came to fruition at MACLA in September 2002. Its full title, *Ties That Bind: Exploring the Role of Intermarriage Between Latinos and Asians in the Making and Transformation of Silicon Valley*, conjures for me seemingly contradictory images that are at once erotically charged and traditionally acceptable. *Ties That Bind* brings to my mind transgressive sexual practices (from whips and stiletto heels to the history of "miscegenation" in America), alongside wholesome family heritages and proud cultural lineages. To be sure, such "bindings" suggest a source of pleasure and pain for their participants, with a shifting if not permeable line separating those two poles of experience. Particular notions of "cultural identity" can productively and creatively synthesize one's sense of self—or else they can become painfully constrictive or even wounding when operating within contemporary American society. This experiential range found visual expression by artists Lissa Jones and Jennifer Ahn in the MACLA gallery installation, which loosely mimicked a household full of nostalgic heirlooms, happy family portraits, ethnic culinary ingredients, bathroom towels embroidered with unpleasant cultural accusations, and unidentified stains on the bedroom sheets, hanging up for the viewer's close inspection.

> Critical writing about *Ties That Bind* must include a deeper analysis of the broad network of producers who comprise the labor force necessary to realize this work...

At the heart of this MACLA project was the exploration of a slippery power dynamic: how does cultural identity transform when people of different ethnic backgrounds and racial categories fall in love and raise families? How are these changes manifested in the visual environment of their homes and public spaces? And why has so little public dialogue been given over to

addressing these seductive but thorny questions, especially when interracial couplings are becoming prevalent not only in the Silicon Valley, but all across America and much of the world?

These questions are provocative enough in and of themselves, but they become even more textured when considered within the context of contemporary art practice. From my vantage point as a visual critic and art historian, what I find most compelling about *Ties That Bind* is how it relates to aesthetic precedents and critical debates within the history of community-based public art—especially those projects that aim to "give voice" to specific groups of people. When seen within this context, the project appears truly dialogic: its underlying assumptions, processes, and aesthetic forms are "in dialogue with" sanctioned practices within the art world and art historical antecedents. Critical writing about *Ties That Bind* must include a deeper analysis of the broad network of producers who comprise the labor force necessary to realize this work—from the funders, to MACLA's administrators, to the artists, to the Latino-Asian families, to the scholars and anthropology students who facilitated the interviews and public discussions, to myself as a writer as I grapple with why I am attracted to such projects in the first place. This is not a project that exists only between the artists Lissa Jones and Jennifer Ahn and the Latino-Asian family members with whom they interacted—such a characterization fetishizes the role of "the artist" and drastically reduces who is understood to constitute the "public" for the work.

During the past two decades, much public art has been collaborative in nature and dedicated to exploring issues of personal identity and collective experience. Since the extraordinary ruckus caused by Richard Serra's infamous

1981–89 *Tilted Arc* in New York's Federal Plaza—a staunchly minimalist work that so profoundly alienated its local constituents on a physical and psychological level that they sued the government to have it removed—public artists have developed practices that consult with local communities when making work. Thanks to directives mandated by the NEA, public artists today often aim to interact with people and stimulate public dialogue about a particular social condition. They don't wait for the dialogue to take place after the work has been completed, but rather make its dialogic component the stuff of their art.

In the late 1980s, Suzanne Lacy, a pioneering community-based artist, writer, and educator, dubbed collaborative, socially engaged aesthetic activities "new genre public art." She brought together other artists, cultural theorists, and curators for a three-day symposium that began at the California College of Arts and Crafts (CCAC), continued at the San Francisco Museum of Modern Art, and culminated in an intensive set of debates and dialogues in California's Napa Valley. Participants presented their work, debated its cultural significance, and collectively mapped out a critical language to articulate and legitimate process-oriented, often ephemeral public productions. Many of the conference members had already been engaging these aesthetic practices for more than 15 years and were determined to historicize and theorize their projects in what would become an influential anthology edited by Lacy and published in 1995.[1]

Developed in the 1970s on the margins of the art world, these collective public art practices were originally born of radical political ideologies, common among feminist artists and muralists of the La Raza and Black Art Movements. In their projects—which serve as the legacy of MACLA's undertaking—artists worked with community members to visually represent their personal and socio-historical experiences, which were underrepresented or invisible within dominant visual culture. Inside these otherwise marginalized communities, such aesthetic practices were the norm and proliferated with vitality "under the radar" of most museums and commercial art galleries. If these community-oriented works were noticed by art critics, they were typically dismissed as "naïve," "anachronistic," or merely "pedestrian"—yet most often they were simply ignored within the dominant art press. Since the 1990s, however, community-based art has appeared regularly within the mainstream international art world, and collaborative endeavors are now virtually required within the public realm to ensure that art has cultural relevance within its social context. Artists no longer only create objects; they are simultaneously involved in designing frameworks for social interaction.

Encouraging this relatively recent trend are a variety of private foundations and governmental grant opportunities that support artists who propose community-based projects in the public sphere (including Americans for the Arts' Animating Democracy program supported by the Ford Foundation, one of *Ties That Bind's* primary funding sources.) In this seemingly democratic cultural climate, it is important to note that art institutions like MACLA are merely sustaining their aim to promote socially engaged work, not opportunistically responding to a current cultural trend. They operate in this mode *in spite of* the fact that collaborative or community-based practice is currently in vogue—not *because* of the grant opportunities it affords.

The relatively rapid and thorough institutionalization of collaborative art practice resulted from a variety of factors. It was aided by the proliferation of postmodern critiques that flourished in academia during the 1980s and 1990s, effectively dismantling notions of "authorship," "originality," "individual genius," and "universality,"—all of which paved the way for a theoretical embrace of multicultural, collaborative art practices. But as cultural critic George Yudice astutely analyzed, perhaps the more poignant force at work at this time was the downsizing and elimination of many social service organizations. Responsibility for the welfare of the U.S. population increasingly shifted onto "civil society" during this period (think of the first President Bush's "Thousand Points of Light" program), and cultural organizations were quick to adopt these social agendas.[2] Artists, equipped with innate creative problem-solving skills that are often enhanced by art school training, responded by adopting the roles of educator or social activist. To work in this manner, they also became ethnographers of sorts, working closely with specific constituencies or addressing their particular social ills. Most public art projects funded during the last decade have emphasized otherness, marginalization, and oppression, with artists proposing inventive models to enhance public education and media literacy, salve racial strife, help reverse urban blight through cultural tourism, create jobs, reduce crime, salvage lost or repressed histories, and so on. To invent such public art proposals, artists typically attempt to have dialogue with their chosen communities, integrating with them while taking on the role of aesthetic anthropologists.

This "ethnographic" turn in public art can be characterized as a practice in which the artist spends time with a chosen community (sometimes over a period of weeks or even months), interviews its members, and then represents their stories, images, concerns, or desires within a work of art, one often produced through complex collective efforts. There are many precedents for this kind of practice:

- Suzanne Lacy's 1987 *Crystal Quilt,* a colossal performance spectacle held in Minneapolis's Crystal Court that featured the life stories of more than 400 elderly women and took over two and a half years and the efforts of over 500 volunteers, 20 staff members, and a team of 15 collaborating artists to produce;

- Larry and Kelly Sultan's 1996 spin on "missing children" milk carton advertisements entitled "Have You Seen Me?" which put into public circulation graphically designed brown paper grocery bags that revealed the photographs and life stories of immigrant children who attend Bahia Vista Elementary School and San Raphael High School in California's Marin county;

- Shimon Attie's 1998 *Between Dreams and History,* in which the artist enlisted Jewish, Latino, and Asian residents of New York's Lower East Side to share their life's dreams and immigration stories through laser projection of their handwritten words onto the sides of buildings in the neighborhood—a project that required the technical expertise of Disney Corporation's "Imagineers"; and

- Krystof Wodiczko's installation for inSITE 2000 (the binational, triennial art exposition along the Tijuana/San Diego corridor): a live video projection of the faces of women maquiladora workers testifying to abuse by men, managers, and officials within their factory environments—images so enlarged that they filled the huge dome at the Centro Cultural Tijuana, a public space that usually excludes these women because of their gender and class.

While well established in much contemporary aesthetic practice, this quasi-anthropological mode has not gone critically unquestioned. In his book, *The Return of the Real*, art historian Hal Foster argues that there is a "new ethnographer envy" consuming many artists and art writers based on the following set of shared beliefs:

First, anthropology is prized as the science of *alterity*;…Second, it is the discipline that takes *culture* as its object, and this expanded field of reference is the domain of postmodernist practice and theory;…Third, ethnography is considered *contextual*, the often automatic demand for which contemporary artists and critics share with other practitioners;…Fourth, anthropology is thought to arbitrate the *interdisciplinary*, another often rote value in contemporary art

and criticism. Fifth, the recent *self-critique* of anthropology renders it attractive, for it promises a reflexivity of the ethnographer at the center even as it preserves a romanticism of the other at the margins. For all these reasons rogue investigations of anthropology...possess vanguard status.[3]

For Foster, there are inherent dangers in these disciplinary assumptions. He argues that, unlike the most sophisticated anthropologists working today, many artist-ethnographers fail to critically acknowledge their own authority within the collaborative process when working with various social groups. They have the potential to unknowingly act as a kind of cultural colonizer rather than creative collaborator, and ultimately run the risk of functioning as a pawn to satisfy the multicultural political agenda of their institutional sponsors. In some cases, artists are asked to act as surrogate representatives for certain communities. At worst, curators may invite artists to participate in a public art project, predetermining which topics or disenfranchised groups the artist is presumed to "identify with" (e.g., an African American sculptor matched with inner city black youth, a lesbian photographer assigned to work with a group of gay parents, etc.)—despite the fact that such identification may be inaccurate or not in keeping with the artist's aesthetic interests.[4]

> ...many artist-ethnographers fail to critically acknowledge their own authority within the collaborative process when working with various social groups.

Foster's critique of the unconscious power dynamics at work in ethnographic, community-based art was an echo of the heated debate between critic Grant Kester and artist Martha Fleming that took place in 1995 in the pages of *Afterimage* magazine. Kester claimed that artists were now functioning as "aesthetic evangelists" who proposed a form of personal "art therapy" within communities rather than working to collectively transform the systemic, economic problems that caused their problems in the first place. Fleming, on the other hand, defended such public art practices, but located the problem in how these projects have been commodified by critics and curators "currently creating careers and fiefdoms for themselves."[5] She also insisted that each artist's success or failure be regarded on a case-by-case basis, rather than homogenizing the power dynamics within all "community-based" public art work, as Kester had done. It seems wise to heed Fleming's plea to consider the specific internal politics, cultural

contexts, processes, and visual languages of any public art case study when judging its merits.

MACLA's *Ties That Bind* is fascinating in relation to Foster's critique of "ethnographic envy"—particularly since the project was the brainchild of MACLA's executive director, Maribel Alvarez, who herself holds a doctorate in anthropology. From the onset, Alvarez aimed to marry art and anthropology as disciplinary modes. She commissioned one of the world's leading anthropologists, Renato Rosaldo, and his Stanford University colleague in sociology, Michael Rosenfeld, to join in the research and dialogic process for *Ties That Bind* by writing for this anthology. She also employed ethnographer Luz Guerra as the "Project Dialogue Consultant" and Wayne Maeda, an ethnic studies scholar from California State University, Sacramento, to serve as a "project scholar" and advisor in the development, research, and methodology used to implement the overall project.

> Reading between the lines of the transcribed interviews, I sensed their desire to participate in the MACLA project as a way to make sense of the complexity of their daily lives by having to publicly represent it.

All of these scholar-consultants had extensive ethnographic experience, and many worked alongside artists Lissa Jones and Jennifer Ahn to interview the 15 families who had been selected from the 40 applicants who responded to the project's website after reading about it in the local newspaper. Anthropology students from San Jose State University were invited to participate in the process by transcribing the interviews, and the artists continued visiting the families at least twice a week for the next three months after their initial meeting. Alvarez and curator Anjee Helstrup encouraged dialogue between the artists and scholars but also suggested that they not privilege either form of disciplinary authority while approaching the work. The point was to compare and contrast how each practitioner regarded and represented their subjects, not to seamlessly synthesize their unique professional perspectives.

MACLA chose the artists based on how well their personal experiences and professional interests complemented the project's interracial subject matter and collaborative goals. One criteria used by the curators was that the artists had to be from the Silicon Valley. They selected midcareer artist Lissa Jones because they were familiar with her hand-tinted silver gelatin prints of

Dia de los Muertos family altars from Oaxaca, Mexico, made collaboratively with artist Curtis Fukuda. Not only did Jones have experience with the process of artistic collaboration, she knew how to communicate with families in the making of her work and was herself the product of a complex interracial family. Her birth mother was Chinese and her birth father was Armenian, but her Irish-Spanish mother and Welsh father adopted her at a young age. Jennifer Ahn, on the other hand, was a first-generation American of Korean heritage; the MACLA curators had taken note of her recent San Jose State University Art Department graduate show in which she displayed photographic collages representing ethnic family histories. Originally a third artist was chosen to be part of the artistic team, a documentary photographer whose specialty was picturing daily life in Mexico. He soon dropped out of the project when he recognized the demanding challenges of collaborating with two other artists to create a unified sculptural installation rather than a more conventional three-person art exhibition. For someone accustomed to working independently and mounting framed photographs on a wall, the commission proved time consuming and alien to his cultural practice. It seems that a more experimental, interdisciplinary sensibility—including a willingness to experiment with untested forms and unfamiliar processes within a public arena—is often required to realize this kind of collaborative, community-based work.

Ties That Bind did not suffer from the kind of "aesthetic evangelism" that Kester warned against because it did not promise any therapeutic solutions to its participants. The couples had no idea what form the exhibition at MACLA would take. Reading between the lines of the transcribed interviews, I sensed their desire to participate in the MACLA project as a way to make sense of the complexity of their daily lives by having to publicly represent it. They acknowledged that their lives and this project could be seen as a social experiment for which no one yet had answers; perhaps the accumulation of others' stories might reveal a broader social or psychological pattern that they could see themselves reflected within. The fact that the artists would ultimately "picture" their condition clearly excited the participants, and they seemed more than willing to offer the artists any artifacts, family photo albums, or graphically detailed stories that might inspire their visual imaginations.

My participation in Ties That Bind is also worth critiquing. I was officially commissioned to write this piece well before the exhibition installation opening, and so my reading of the project description and the transcribed interviews

informed my expectations. Because I often work on topics involving visual manifestations of cross-cultural exchange, I had envisioned an installation that would help picture the *variety* of contradictory experiences within Latino-Asian American families. Certainly a Vietnamese-Mexican American couple would be struggling with different kinds of cultural tensions than, say, a Filipino-Guatemalan, Japanese-Panamanian, or Pakastani-Mexican American. And surely there would be huge differences if the couple worked in the tech industry or lived in the local ghettos, or married as a result of serving in the army together during World War II versus meeting at San Jose State University last year. I imagined some couples would approach an interracial union by fabricating hybrid rituals or creatively inventing common ground through other means…I arrived at the gallery eagerly expecting to see some of that diversity of experience represented.

> The materials spoke of permeability…as well as things that capture detritus… some things passing through seamlessly, others made present through their failed attempts at passing.

Instead, the artists had created a carefully crafted, unified visual environment in which all of the families were mixed together under the rubric of a relatively harmonious "Latino-Asian home life," with only hints of strife inscribed on the towels ("when I get mad at him, I'll blame it on his culture"). The gallery walls were painted in warm whites, tasteful pumpkins, and deep red hues that Martha Stewart would have approved of, complementing and echoing one another throughout the gallery space. An isolated image greeted viewers upon entry: it was a large black and white photograph of a mixed-race toddler attentively studying a toy dinosaur, as if to proclaim, "generic image of the next generation Californian grappling with something extinct." The spatial organization moved the viewer through a range of abstract, metaphoric domestic zones: there was the laundry room with its hanging bedroom sheets; the kitchen with its interethnic black beans, white rice, red chili peppers, and cooking tools; the front doors with their "welcome" mats spelling out *miscere* and *genus*; the dining room with its hanging food bonnets and family snapshots; the bedroom with its dainty collages of family photos and precious heirlooms; the pristine bathroom with its embroidered towels; and the living room with its large hanging photo gallery.

The materials spoke of permeability (strainers, food screens, doorways) as well as things that capture detritus (bathroom towels, soiled sheets)—some

things passing through seamlessly, others made present through their failed attempts at passing. High above these metaphoric materials and images a variety of statistical captions hovered on the walls, including: "Intermarriage is very high among Latinos and Asians: 35 percent of Latino men and women will marry outside of their racial or ethnic group; 45 percent of Asian men and 54 percent of Asian women will marry someone who is not Asian," and "A 20-something Anglo male living in the United States today is four times more likely than his father to marry a woman who is not white." This latter quotation suggests a clear message: the multicultural implications of this exhibition go well beyond Latino-Asian unions or the region of Silicon Valley.

My initial critical response was that while the visual experience of the installation was pleasing and made some poignant arguments, it seemed to assume that the primary border being crossed in marriage is an ethnic one. What was not revealed is how a more threatening border might instead be one of class, or generation, or religion, or gender role expectations within these couples' lives. I was also concerned that the installation had offered too many obvious ethnic signifiers (e.g., black beans and rice) and ultimately reinforced a *singular* notion of "Latino-Asian" hybridity.

Later that day the artists arrived at the gallery, and we discussed the show and their process at length. I remember being struck by Lissa Jones's answer when I asked her: What was the most significant conclusion she had made after spending time with these families? "How fragile and beautiful they are." The artists emphasized how much they wanted the families to feel comfortable within their formal choices and even honored by them. They developed the gallery installation recognizing it would serve as a community gathering space for the families during the opening and at the public dialogue.

> The artists emphasized how much they wanted the families to feel comfortable within their formal choices and even honored by them.

This recognition demonstrates what critic and curator Nicolas Bourriaud describes as "relational aesthetics." Championing works by gallery artists such as Felix Gonzales-Torres and Rirkrit Tiravanija (artists known for the aesthetic "gifts" they offer their viewers: of poetic phrases on paper to be taken for free or entire Thai meals to be enjoyed in the gallery space), Bourriaud proposes that contemporary art practice must be understood as an act of structuring social exchange:

Since the early 1990s, the artist sets his sights more and more clearly on the relations that his work will create among his public, and on the invention of models of sociability...Meetings, encounters, events, various types of collaboration between people, games, festivals and places of conviviality, in a word all manner of encounter and relational invention thus represent, today, aesthetic objects likely to be looked at as such, with pictures and sculptures regarded here merely as specific cases of production, of forms with something other than a simple aesthetic consumption in mind.[6]

> It is...free social exchange that the artists have offered through their creative gesture...

Bourriaud describes the contemporary art gallery as a potential "social *interstice*," borrowing Karl Marx's term for the type of trade that eludes a capitalist economic system's law of profit. If we regard the work of art more as a period of time to be *lived through* rather than merely a space to be *walked through* or an object to be collected, art practice becomes something like opening an unlimited discussion. From this perspective, the *Ties That Bind* installation enacts a free space; it creates a time span whose "rhythm contrasts with those structuring everyday life, and it encourages an interhuman commerce that differs from the *communication zones* that are imposed on us."[7] It is not economic, but rather free social exchange that the artists have offered through their creative gesture—something that defies the conventional logic of our capitalist system, with its fixation on spectacle and commerce. Jones and Ahn offer evidence that a viable form of labor exists beyond mere wage work: everyone involved has collaborated to produce a labor of love (or, perhaps more accurately, what George Yudice describes as "the immeasurable labor of love of art.")[8] The *Ties That Bind* artists—as well as the MACLA administrators—deliberately created such a social interstice, wherein the "community" (which normally identifies with one another only through an abstract racial category) was now able to come together to recognize each other's similarities and differences through public dialogue within an aesthetic format.

In her provocative new book *One Place After Another: Site-Specific Art and Locational Identity*, art historian Miwon Kwon challenges us to trade in our overused and undertheorized notion of "community-based art" for what she calls "collective artistic praxis." In Kwon's view, the most engaging projects involve so-called "communities" that are invented during the art process, not communities who already embody reified fixed identities. They consist of a provisional group that finds its bonds through the coordination of the

artwork itself; it *performs* its coming-together to create community where there was not one. If a work is to truly engage a democratic sensibility, Kwon argues, all parties involved in the complex network of collaborative labor—including the artist, the community, the curators, the institution, and the other participants—must be *uncertain* of their identities. For democracies to function, they must recognize that the goal is not a community identity that is coherent, unified, or certain. Rather, all parties who "animate democracy" (to borrow from the grant title that funded *Ties That Bind*) must continuously negotiate a sense of subjectivity through encounters with others who are different from them. In Kwon's words, "only a community that questions its own legitimacy is legitimate...Only those cultural practices that have this relational sensibility can turn local encounters into long-term commitments and transform passing intimacies into indelible, unretractable social marks."[9]

> ...all parties who "animate democracy"...must continuously negotiate a sense of subjectivity through encounters with others who are different from them.

The complexities of this dialogic dimension within *Ties That Bind* make it a particularly rich case study. Much more than any other project I've witnessed, this work aimed to make every participant involved—from the MACLA curators to the artists, to the students and scholars who collaborated in its production, to the interracial married couples whose life experience provided the work's content—reassess their definition of art practice, community, and personal cultural identity. While *Ties That Bind* continues the legacy of collaborative works that have become commonplace in the art world, it does so by redefining the social function of a community art space. To create *Ties That Bind,* MACLA shifted from functioning as an art space whose administrators curate and exhibit artists' projects to a site in which cultural labor relationships between curators, artists, scholars, and publics are actively renegotiated and *perpetually discovered* through human interactions. This is the best of what democratic, dialogic cultural activity can offer.

[1] See Suzanne Lacy, ed., *Mapping the Terrain: New Genre Public Art* (Seattle: Bay Press, 1995). This groundbreaking and influential book was itself a dialogic project, in that it arose from a 1989 program called "City Sites: Artists and Urban Strategies." As a young professor who was about to begin teaching at CCAC, I participated in these dialogues as a critic-in-residence during the symposium, which spawned my interest in this emerging field. Its participants included many of the pioneering practitioners of new genre practices, including artists Allan Kaprow, Mierle Laderman-Ukeles, Mel Chin; writers Lucy Lippard, Patricia Phillips and Jeff Kelly; and curator Mary Jane Jacobs, who proceeded to establish her reputation as the leading curator for collaborative art in controversial (and, in my view, problematic) public projects like "Culture in Action: Sculpture Chicago" from 1991–93.

[2] See two articles by George Yudice that fully address these issues: "The Privatization of Culture," in *Art Matters: How the Culture Wars Changed America* (New York: New York University Press, 1999). For his more recent analysis, see "The Collaborative Art of inSITE: Producing the Cultural Economy," in *The Expediency of Culture: The Uses of Culture in a Global Era* (Durham: Duke University Press, forthcoming) or online at: http://www.latinart.com/aiview.cfm?id=30.

[3] Hal Foster, *The Return of the Real: The Avant-Garde at the End of the Century* (Cambridge: The MIT Press, 1996), 182.

[4] Art historian Miwon Kwon thoroughly addresses the Kester–Fleming debate and Hal Foster's critique of the artist as ethnographer, describing how these power dynamics were at play in curator Mary Jane Jacob's "Culture in Action" program for Sculpture Chicago. Jacobs invited African American artist Renée Green to participate, yet assumed that she would want to address inner-city race conflicts as the center of her work, while Green was much more interested in pursuing the architectural history of the city, especially the legacy of Frank Lloyd Wright's Prairie Style. In this case, the artist's artistic and philosophical agenda did not match up with the curator's social and professional goals. See: Miwon Kwon, *One Place After Another: Site-Specific Art and Locational Identity* (Cambridge: The MIT Press, 2002), 138–148.

[5] Martha Fleming, letter to the editor, Afterimage (June 1995): 3.

[6] Nicolas Bourriaud, Relational Aesthetics, trans. Simon Pleasance and Fronza Woods with the participation of Mathieu Copeland (Dijon: Les Presses du Réel, 2002).

[7] Ibid., 16.

[8] Yudice, "The Collaborative Art of inSITE: Producing the Cultural Economy," http://www.latinart.com/aiview.cfm?id=30.

[9] Kwon, 166.

The Social Life of an Art Installation

RENATO ROSALDO

THE ART INSTALLATION, *TIES THAT BIND,* on intermarriage between Asians and Latinos in San Jose, CA, initially disappointed me. I found it a bland array of flowing sheets and pleasant pictures. I missed the grit, the tensions, and even the joys of any long-term relationship. I wanted to know about the particular life issues of intermarriages between people of different ethnic backgrounds. I thought that the artists had chosen to display pretty objects that were more generic than specific and thus had failed to evoke the particular character of Asian-Latino intermarriage.

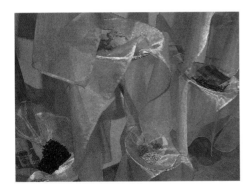

My expectations of the exhibit were similar to, if not shaped by, statements by the project director, Maribel Alvarez. In the exhibit catalogue, she said that Asians and Latinos were perceived as opposites in terms of civic participation, with Asians high and Latinos low in educational and economic attainment. She expected that the economic and educational differences would produce tensions between the two groups. Yet they have a high rate of intermarriage. The project, she said, was designed to explore "tensions and desires," the social distinctions of class and race as well as the feelings of love and romance. As director, she also asked about the role community-based cultural organizations can play in relation to such issues of civic life. I expected an exhibit brimming with difference and passion.

I'd like to tell the story of how I arrived at my initial negative judgment of the art installation. By the end, I'll say how and why I changed my mind about the value of the work of art.

The art installation was based on photographs and observations made during a series of interviews with 15 Asian-Latino married couples and their families. The interviews were conducted by scholars or activists who were accompanied by a visual artist. The couples were selected from among those who responded to online and newspaper requests for volunteers to be interviewed for oral histories about Asian-Latino intermarriage. The fact that the announcements used to recruit the subjects of the interviews were in English and posted on the internet or advertised in newspapers presupposed that the subjects were literate in English and that they had a relatively stable income, rather than being recent immigrants or financially impoverished or both.

The interviews, as I saw them, were shaped by what I call an "implicit contract" and that contract set the direction of the art installation. The interviews took place in the subjects' homes. The fact that the subjects were in their own homes and the interview team (including both the interviewers and the artists) were visitors set up a special relationship between the interview team and the interview subjects. The fact that two or more people were in the interview team and that a number of family members were present made the social situation a relatively formal visit. The subjects became the hosts and the interviewers became their guests. The interviewers could not, as good guests, violate their subjects' privacy. The interviewers, without saying a word, agreed to protect their hosts' secrets, not to embarrass them in public. They felt obliged to respect how their subjects wanted to appear in public.

The visual artists were even more constrained by the implicit contract than the scholars and activists who did the interviews. The interviewers did not have to see their subjects after the interviews ended, but the artists saw a number of the subjects after they were interviewed. All of the subjects were invited, and a number came to the opening of the exhibit. Later, at the civic dialogue, all of the interview subjects were invited and a number came. So, the artists were accountable to them. They were among the critics of the art installation. They could talk back to the artists.

At the beginning, the project was going to be ethnographic (a study in oral history and not yet an art installation). I was a consultant. I did one of the interviews along with a photographer who later dropped out of the project. At the time I

had no idea that I would become one of the writers; I didn't even know that writers were going to be part of the project. In the interview I did, the subjects asked us not to mention one topic. We honored their request. Even so, they were visibly nervous about having their lives exposed to public view. I sensed a concern about display and exposure, trust and violation, fear and assurance, silence and speech, power and inequality. They were afraid that we—their guests—might violate their hospitality by revealing their secrets and embarrassing them.

To reassure my hosts, I asked relatively open-ended questions about photographs on the living room walls. Who is this? How are you related to him or her? What is she or he doing? I thought of the pictures on the living room walls as conversation pieces. They were on display where a guest would first enter the host's home. When I asked about the photographs in the living room, I learned family history. One of the wife's grandparents, for example, was a Purepecha Indian from Michoacan, Mexico. The wife had returned to Mexico several times in her youth, spoke Spanish fluently, and had heard much of the Indian language as she grew up.

I was most moved by what was not said, by what I saw out of the corner of my eye. I made guesses about certain things the subjects did not choose to reveal, but I kept my silence, like a proper guest. I made notes about my guesses and called them hypotheses about tensions in the family. It's a habit from a lifetime of doing ethnographic study. Call it an occupational deformation, or some such.

The artists (as I came to understand their views from a later civic dialogue that I attended and reviewed on audiotape) went into the interviews expecting that the people interviewed would be very ethnic, that it would be visible in their dress, in how they walked and talked, in the objects and decorations in their houses. They imagined they would see immigrant homes. When they went with the interviewers, they found suburban American homes, like any other on the block. The interviews were all in English. They found pure assimilation. One person, for example, said, "Now that I'm American I don't have to do that [ethnic behavior] any more." What they expected wasn't there. They had to let go of their original idea and begin again. It was back to the drawing board.

I think that the artists were working (at the beginning of the project) with an out-of-date idea of culture. It seemed to me that they thought that cultures come whole, visible in objects and dress like badges of ethnic identity. If people didn't wear badges of ethnic identity, they seemed to see assimilation and loss of culture. But I think that different cultures often live in the same social space,

that they borrow from and lend to each other, and that the signs of cultural difference are subtle, more like the difference between a watery and a firm handshake than like a badge you either do or don't wear.

Maybe there should have been more than one kind of artist. Think, for a moment, about words, whether spoken or written. The artists were working in a visual medium and were less attuned to verbal language than, for example, a documentary filmmaker, a writer of prose fiction, or a poet. Perhaps the exhibit could have played tapes or videos from the interviews. Maybe the audience could have heard the other language of a bilingual speaker, either directly or through the subtleties of accent or diction in English. A Chicano, for example, may speak of a "dozen of eggs" instead of a "dozen eggs," revealing the hidden presence of the Spanish, "una docena de huevos." Certain speech inflections may reveal that the speaker is Mexican American even though she or he speaks no Spanish. Ways of treating people may make similar cultural statements. When Chicanos leave a party, they are often careful to say farewell to the hosts and the other guests at a gathering.

A Japanese-American anthropologist named Dorinne Kondo has written about a play concerning Asian Americans that she saw after it was panned by critics. It seemed so white-bread American that; like the critics, she hated it at first. She then realized it was about her generation of Japanese Americans who spoke only English and sounded like Val Gals. In the play, the sense of being Japanese American was subtle, yet powerfully present.

There were, however, certain words present in the exhibit: statistics, a statement from the project director, and a set of 10 dish towels with words from the interviews written on them. Here's what was written on five of the towels:

> "They didn't care if she was Mexican or...whatever. Was she Catholic?"
> "I think there would have been advantages for us if we had married within our culture."
> "When you raise a kid American, they really don't care about their heritage."
> "When I get mad at him I'll blame it on his culture."
> "I was trying to find out who I was all the time."

These brief statements were powerful partly because they were the only words from the interview subjects in the exhibit. I was grateful for them, but wish there had been more. The project decided to have different kinds of writers. Maybe different kinds of artists would have been a good idea too.

The artists didn't simply want to be nice to their interview hosts. In the exhibit they imitated the space where the interviews took place. They created intimate domestic spaces: a bathroom with towels; a laundry room with bedroom sheets hung to dry; a kitchen with cupboards of food; a dining room with food bonnets; a bedroom with heirlooms; and a living room. The bedroom and the dining room had family photos and the living room had a photo gallery. All these spaces were private, but they revealed nobody's personal secrets. They showed how they went into the inner sanctum of homes with their cameras.

They were looking for metaphors of their journey into the intimate spaces of an American home. Certain metaphors suggested how porous cultural boundaries can be (contrary to their views at the beginning of the project). They explored what does and does not pass through (doors, strainers, towels, and the wash). Strainers with cloth on them showed that everything is not filtered through assimilation. Each generation chooses what they will and will not retain from the generation before. Food came out of the walls, from the cupboards. One could almost smell it. Food symbolized cultural mixing—salsa with soy sauce, refried beans with rice.

Displaying bed sheets showed that intermarriage is about sexual intercourse. Asian-Latino couples have entered a borderland by loving someone different from themselves; they've taken the risk of marrying into another culture. Dirty laundry said just that: relationships have their dirty laundry, but the exhibit didn't tell exactly what it is.

The scholars and artists wanted to challenge the idea of culture as a bounded unit and allow multiple perspectives rather than stick to a single vision. After some discussion, they decided not to use slurs, not to insult their subjects by using the stereotypes they have to live with every day. They didn't want to close down communication with their subjects. Instead, they wanted to create something open ended and nonscripted. They wanted the exhibit to be welcoming, to open a conversation rather than to be authoritative. They wanted to invite people to a dialogue and not to give themselves the last word.

Their exhibit became a conversation piece and not a thing of beauty for its own sake. The civic dialogue that took place inside the art installation showed the wisdom of the choice not to offend and to create a welcoming space. I might go so far as to say that the suggestive blandness of the art was precisely what made it so effective as a vehicle for civic dialogue. I still wish the art had more

edge, though I'm not sure of how much edge would have enhanced the work of art without inhibiting the civic dialogue.

The exhibit's display of dirty laundry, saying that there was dirty laundry without saying what had soiled it or whose it was, raised a topic and at the same time made it safe for later discussion. The interviews and the work of art were part of a longer process that culminated in a civic dialogue where the interview subjects felt safe enough to speak relatively freely in front of their parents, their children, the artists, the writers, and media people.

Some people addressed the social and historical context of Asian-Latino intermarriage. One spoke about how the infamous Border Patrol was founded in 1924 to keep Chinese, not Mexicans, from crossing the U.S.–Mexico border. Another spoke of the Chinese in Baja California early in the twentieth century and how Mexican president Porfirio Diaz tried to send them back to China. Others spoke of Mexicans who worked in Japanese-owned orchards before the internment of Japanese during World War II, and of the Filipinos who worked alongside Mexicans in the agricultural fields of California. All this showed that the Asian-Latino relationship has been a long one.

What moved me most during the civic dialogue was how a woman—one of the interview subjects—spoke about tensions in her marriage. She did not name the sources of tension, but the fact that she was speaking made the tensions vividly present. At that point, the visual art became verbal, embodied in spoken words. I was moved and grateful that the art installation opened into a productive and moving civic dialogue.

The art exhibit thus became a conversation piece that built on the interviews and led to the main show, which was the civic dialogue. In other words, the interviews shaped the art installation, and the civic dialogue supplemented and completed the work of art. The work of art did not stand on its own, but provided the occasion for a later conversation. Perhaps this is as it should be in public art, or at least one way it productively can be.

Acknowledgments: I am pleased to thank Maribel Alvarez, Caron Atlas, and Pam Korza for insightful comments on what I have written. I remain responsible, of course, for the final version of the essay. After all, I did not take all the good advice I received.

Dialogic Gestures:
Doing Artistic Things with
Ethnographic Methods

MARIBEL ALVAREZ

IN A PUBLIC CULTURE like the one we live in, predicated upon mastery, rationality, order, originality, and efficiency, there's something to be said about the liberating potential of equivocation. The idea of getting things wrong, of not grasping all the dimensions of everything all the time regardless of the availability of technology or charisma, can breathe fresh air into many of our civic projects. It could be argued that the history of the United States paral-

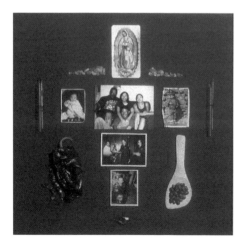

lels the history of art discourse in at least one way: no matter how narrowly self-contained an idea might be and regardless of how many people find it difficult to discern the alleged value at stake of a given masterful project, both pride themselves in "getting it right," often offering nothing less than history to prove their point. A wink, a nod, or a wry "I told you so" usually follows these moments of expert reassurance.

This is why I've always been in favor of creating spaces for artistic/intellectual production that can give artists and ordinary people a chance to test "uncooked" ideas, to borrow and stitch-up at random from a wide variety of approaches, and ultimately to fail and start anew. Something in the order of this phenomenon is present in the

paradoxical case of the *Ties That Bind* project that I directed in San Jose, CA, from 2000 to 2002.

Ties That Bind was conceived as a multilayered project that combined social science, art, and humanities and attempted to upset the rigid categories of personal and social identities that many people attributed to Asians and Latinos in Silicon Valley. By revealing through photos, artifacts, oral histories, and community dialogues the messiness and permeability that exchanges of love and desire had wreaked on people largely considered at odds with each other, *Ties That Bind* sought to reveal a story up to that point largely ignored within the officialist mythology of Silicon Valley. As the three writers invited to critique the project suggest in the previous essays, and I agree, there was something both moving and disconcerting about the results achieved by this effort.

> ...for some of the people involved in the project, in the end *Ties That Bind* fastened more secure than before the binaries that it had sought to destabilize.

Stretching perhaps too ambitiously to find a creative fusion between art and anthropology, the public and the private, the nuanced and the stereotypical, the sexual and the social, diversity and "Americanness," or ultimately, between happiness and anxiety, it is fair to say that, for some of the people involved in the project, in the end *Ties That Bind* fastened more secure than before the binaries that it had sought to destabilize. In this brief reflection, I intend to explore some of the methodological tensions that may account for this phenomenon.

It is quite possible, as Rosaldo suggests in his essay, that the disappointment felt by some of us about the *Ties* project may be a symptom of our own intellectual posturing and unexamined expectations about what art *should* do for "the people" and for social knowledge generally. The art community ("artworld" as some have called it) is known for its own excessive gushes of unqualified optimism about the "power of art" to change lives.[1] Ever since art became separated from other practical forms of labor in capitalist societies, there has been a great deal of enthusiasm among the educated classes for the value of artistic/imaginative skills to help people reach their "full potential." For those of us who are art lovers or art patrons, this belief runs even deeper. In some instances, deducing from the rhetoric that circulates widely in grant proposals, some of us expect art to do things for society that rather elaborate social policy initiatives have not been able to deliver. That being said, it

is possible to state, based on many formal and informal evaluations of the project offered by the people whose faces and stories became the public text of *Ties That Bind*, that the project touched a nerve and provoked many fruitful conversations in the local community. Most recently, the project traveled to Fresno, in central California, where a second phase of local documentation and dialogue complemented the Silicon Valley "findings."

The success of *Ties That Bind* in opening up a sustained dialogue on social identities cannot be attributed only to the fact that the art produced reflected people's stories in a personal way. Much of the project's significance, both in the local community and in the spectrum of community art practices more generally, derives from the fact that, as one participant told me, "we had never seen artists or a contemporary art gallery work so hard to understand what stands behind the obvious." As an anthropologist and curator, this was the best compliment I could ever hear.

Yet, for critics, curators, artists, and other connoisseurs, a lingering feeling that "something else" could have been captured seemed to have surfaced early on and stayed throughout the run of the exhibition. It wasn't necessarily that the aesthetics of the art installations conceived by the artists were off—as Matthews and Rosenfeld remark, MACLA managed to create a compelling visual environment. In addition, ethnographers and artists worked with the participating families in public and private interviews and facilitated dialogues for more than 10 months before the first piece of art for this show was ever sketched. The ethnographic methods employed throughout the "fact-gathering" phase of the project were sound and yielded tons of textured, seasoned insights into the dynamics of ethnicity, social identities, and intimacy in Silicon Valley. Most importantly, for the people whose lives were the subject of the oral histories and exhibition, *Ties* was a deeply meaningful and satisfactory experience.

Perhaps these multiple interrogations (and equivocations) reveal one of the most interesting lessons to emerge— the sobering recognition that, as a way of looking at "social facts," art is still more comfortable in the realm of the imagination.

The problem with *Ties*, it seems to me, was not so much one of production but rather of reception. Some observers of the process (myself included)

wanted to be blown out of our socks by the artists' interpretations of these heady and highly fruitful theoretical subjects we had stumbled upon. In one sense, those of us with these expectations were being rather conventional—calling upon art to unearth something magical that culture as an ordinary thing had rather obscured.

And yet, before I explore this underpinning ideology any further, I think that it is dangerous and misleading to suggest that the gap of perception here is merely one between the somber "deep" critic and the happy "shallow" informant. Perhaps what lies at the core of this dissonance are different degrees of *belief* in the power and capacity of representations, period. That is, the belief (or trust) in the ability of ethnographers, artists, and intellectuals to "get" what is important to get in any given situation and to represent their knowledge or insights not only more or less accurately but also in tantalizing terms than can ultimately provoke social effects through their products (texts, images, exhibits, symposia, books). Intellectuals and artists are for the most part sure of their ability to deliver these goods; ordinary people tend for the most part to be more skeptical. This belief in the transparency of meaning seems to hold steady regardless of whether one thinks of culture as bound and fixed or as fragmented and hybrid; the impulse to "capture" the drift of others' lives and to trust our communicative abilities to represent "it" remains the same. It is precisely there—in the intricacies of that belief system—that I think *Ties That Bind* offers a fascinating study on the politics and poetics of representation. With a large and diverse cadre of experts gazing invasively at 15 mixed-race families—sociologists, historians, anthropologists, art administrators, civic dialogue facilitators, artists, journalists, and philanthropists—the project materialized one of the oldest dilemmas in epistemology: what distinguishes "adequate" knowledge from "inadequate" knowledge? Furthermore, what business is it of artists to attempt to answer this question?

In my experience working with the participating families in the *Ties* project, many of them expected the project to shine *some* light on *some* aspect of their complex lives. Having made the decision to expose their intimate lives for thousands of people to see, they were quite aware that some of the representations would be "on target" and some would "miss the mark"—but in both instances the risk of telling *a* story (*their* story, not *the* story of all intermarriages) was worth taking. It was worth taking, partly, because no one else had bothered to inquire what it was like to be, as one participant put it "not ethnic all the time" (sic), or as another indicated "having to deal with the fact that when you embrace diversity, sometimes it can be painful."

For MACLA—a small, alternative, ethnic-centered arts space in an urban setting—blowing the cover off these questions on identity was a big deal. MACLA crafted itself carefully as a contemporary arts center rooted in communities of resistance but embracing an eclectic, inclusive, and often deconstructive ethic in its work and its role in the local community. Rather than engage in the kind of work that represented "heritage" and "tradition," MACLA set out to establish a new framework in Silicon Valley for questioning identities, all the while affirming their currency and the power dynamics that made them visible or invisible. Granted, at times this statement may have been nothing more than a philosophical stand articulated by an executive director who had read one too many books on cultural and political theory. But most of the time, felicitously, this stand translated into a programmatic agenda that engaged artists and approximately 18,000 people each year into exciting, inventive, and down-to-earth projects and conversations.

Ties That Bind was a project conceived in the context of these larger organizational concerns. In other words, before there was an Animating Democracy-funded project, there was MACLA and San Jose and the history of the politics of identity in Silicon Valley. These spaces and their dimensions—physical, cultural, and symbolic—were in themselves cultural productions of a sort. In many ways, the terms of the debate had been already set by social dynamics beyond the control of MACLA or the artists. In fact, from his vantage point as a sociologist, Rosenfeld

> MACLA set out to establish a new framework in Silicon Valley for questioning identities, all the while affirming their currency and the power dynamics that made them visible or invisible.

makes the observation that there was very little that was actually unique about intermarriage in Silicon Valley and takes a friendly jab at San Jose (at MACLA in particular) for imagining itself all too eagerly to be "in the middle of the action." If there was anything original about Silicon Valley Asian-Latino intermarriage as compared to his research on black-white intermarriage elsewhere, Rosenfeld tells us, it was in fact that the Silicon Valley couples and mixed-race folks here were "less public, less noticed" (and I venture to say that Rosenfeld is too polite and generous to say, actually, less interesting). When compared to other noticeably restless urban areas, ethnicity in Silicon Valley had demonstrated a tendency to morph with a certain ease and harmony into something "irrevocably American," says Rosenfeld.

This finding surprised artists Lissa Jones and Jennifer Ahn as soon as they began the first home visits. Jones confided in me early on her disappointment for not finding in many of the homes she was visiting "obvious signs of ethnic identity." The one place where these signs seemed to surface unmediated was in the kitchen—or in little, almost imperceptible rituals of everyday living in the bathroom, the bedroom, the entryways where some mixed-families adopted the tradition of taking off their shoes before entering the home. Rosaldo reacts negatively at first to the almost saccharine quality of the artwork produced after the ethnographic work, and Matthews takes MACLA to task for giving a safe and contained treatment to what cries out to be juicy, sexual material. But I have news for both of them: the artists *did* find sweetness and modesty among these mixed-race couples. Had the artists run away freely with their avant-garde imaginations (more so than they already did by utilizing stained sheets, washcloths embroidered with racial stereotypes, doors with welcome mats that spelled the word "miscegenation," or gauze-covered strainers full of faded memories), they would have represented a racy, wicked, and edgy sensibility that simply wasn't there in the ordinary lives of these folks.

Generally, artists do not bear the same burden of accuracy in representation that sociologists and anthropologists do. One of the goals of the *Ties* project was to test whether artists working with ethnographic methods can navigate through these two subjectivities—that of "researcher" and that of "interpreter"—to find a more balanced resolution to the gap between things as they "really are," things as people feel and live them, and things as social theorists see them. One of the most compelling arguments to support how effectively *Ties That Bind* tested this principle, indeed, is the fact that in the end the project left everyone equally restless. The artists asked repeatedly and sincerely: did we do right by these families? did we do right by MACLA? The writers and academics asked: what sordid tales lie behind this manicured and happy exercise? The MACLA staff asked itself: what power does a small arts organization have to illuminate social phenomena? Curiously, a sensation that we had barely touched the surface was perhaps the only feeling that the participating families shared with the rest of the stakeholders of this project. Perhaps these multiple interrogations (and equivocations) reveal one of the most interesting lessons to emerge from *Ties That Bind*—the sobering recognition that, as a way of looking at "social facts," art is still more comfortable in the realm of the imagination. Or put more blatantly, artists make lousy sociologists and sociologists make lousy art critics.

There is always a danger in any kind of cultural analysis to focus too much on the product at hand (in this case the exhibition) and too little on the process that framed the larger social/cultural project. Similarly, in the case of *Ties That Bind* it was all too easy to discuss the merits and shortcomings of the project itself while pushing to the background the contextual and structural dynamics that made *Ties* an intriguing and gutsy *intervention* by a small alternative arts center like MACLA. Matthews struggles to contextualize this important element, but she does not seem to be able to get beyond the fortuitous funding opportunity that made the project possible at this particular time and place. More to the point would be a recognition that MACLA had taken great pains to occupy a peculiar place in the ecology of the art-culture system in San Jose and had predicated much of this claim on its ability to workshop new interventions in the largely predictable field of visual representations in this city. *Ties That Bind* gave MACLA an opportunity to put its money where its mouth was—going beyond the circle of art patrons (or the predictable "outreach" programs to families in need) to people who lived and worked in Silicon Valley and had nothing to do with art and asking them: would you allow us to document your story and then make some artistic representation of it for others to see and discuss?

From our point of view at MACLA, we were not only mining stories for "content" but were also modeling a process that upset the balance of power between artist and subject, moving away from the archetype of the idiosyncratic/genius artist who sees and represents as he or she wishes, to one where listening and learning was more important than representing. We called upon ethnography (a methodology borrowed from the social sciences) to aid in this task. And yet, the paradox of it all was that in order to engage a broader community in the conversation, we chose the ways and means of visual representation in a gallery to manifest the things we had learned. In some ways, the project became a meditation on a question that many others have pondered—can ethnography "help" art or is it the other way around?[2]

The long and the short of this experiment was that neither medium of representation—artistic or ethnographic—can claim to be above the fray when representing intimacy or intimate matters. Unless one is willing—in either field—to uphold the representation (the text or the image or the installation) as the only product that really matters, then in every case we have to be prepared to deal with the consequences of representing live/engaged/smart subjects who will talk back and try their hand at shaping the modalities of what is being told about them. The fact that so many of the stories of intermarriage

dealt with intimate matters—and not always as happy, exciting stories—placed a certain burden on the artists to be, well, less artistic perhaps. It is one thing to make an enthralling statement about bedroom politics in general and in the abstract; it is an entirely different experience and responsibility when the two people involved in that bed and those politics are standing next to you, in front of your work, during the gallery reception. In this instance, as Rosaldo has eloquently stated, the exhibition had a "social life" that went beyond the art products. But what I find more intriguing (and troubling)

about these easy designations of cutting-edge art as "art-for-art's sake" versus "bland" art as "art with a purpose" is the fact the *Ties* project *did* mobilize and use the aesthetics of contemporary art to make its representations. *Ties* was far from being only an "educational" exhibit. In fact, and here the irony has got to make us laugh, the one thing that the participating family members said again and again that they loved about the exhibit was that it was not made up of "flat, boring pictures on the wall." Indeed it was the medium of the contemporary art installation that helped so many of the participating families feel respected and dignified as represented in the gallery. The story, one of them told me, was personal but not "too personal" (I think this was a code for saying not "exploited"). Perhaps the art medium became surprisingly reassuring to some of these "informants" because the other choices had already been discredited. I am aware that the only notion of an interpretative exhibition that some of these participants knew had come from anthropological exhibits and their infamous dioramas of frozen-in-time subjects or invasive techniques in search for "juicy" details. In a twist of fate, then, in *Ties That Bind* art redeemed anthropology. Curiously enough, when I conceived of the project, my assumption was that the reverse would happen, that anthropology would help us make better art.

Caught in the midst of this uncomfortable yet fascinating exercise were two artists who for the first time in their lives had dozens of people around them referring to them not simply as "artists" but as "artist-ethnographers." I am quite sure that neither Jones nor Ahn knew exactly what that meant when they signed up for this project. Although there are some wonderful examples of artists who have successfully used this approach—and we at MACLA had

previous experience working closely with one of the best in the field, Pepon Osorio—and in spite of the fact that I had used the ethnographic method to produce an interpretative exhibition on low rider bicycles a few years before, *Ties* stretched our abilities beyond what we expected. There was one simple reason for this and Rosaldo seems to have thought about it long and hard before he could remember that this is what often happens with ethnography: the subjects of the project requested that the best, juicier, racier, and more poignant stories be kept confidential. Jones and Ahn struggled with this issue. They were asked to serve, not two, but three masters: MACLA asked that they "respond to the community" but still deliver a compelling visual statement using the most transparent of all art media, photography; project participants asked that they not reveal the "painful" aspects of intermarriage: for example, some of the participants were the offspring of broken interracial marriages and had grown up all their lives hearing one or the other parent impute racial stereotypes to their former spouse, half of whose "heritage" these children also embodied); and the artworld in which they had developed and emerged as artists asked that they "be true to their vision" and create work that "pushes the envelope" if necessary.

No wonder it was hard to recruit artists to participate in this project. Some would have nothing to do with "ethnography." Others wanted to interview people but reserve the right to "interpret" the stories as they pleased—with full artistic license. I objected. I wanted something weird: an interpretative exhibit that utilized the tools of contemporary art (installations and so forth) but that did not serve an artist's idiosyncratic taste but rather the communal vision of the participants/informants. I asked the artists to create new works with what they learned from the subjects of the project, not from what they *thought* the subjects should learn from their "great" art. This made for some tense moments between the artists and me. After all, I was asking that they suspend the very same thing that many would argue made them artists in the first place—an original nonfunctional representation that would puncture reality—not one necessarily bound to serve any social-welfare purpose.

> In a twist of fate, then, in *Ties That Bind* art redeemed anthropology.

In the end, my own problems with the project had little to do with either the process or the product, but much more to do with the structural semiotics that seemed to predetermine what was possible to achieve in a project of this nature at a core level. Sure, maybe there were too many references to

ginger and chiles in the visual materials. Or maybe the anthropology of it all was lost somewhere in the array of repetitive black and white images with no context other than some questionable metaphors. I can live with those short-comings. After all, when a project like Animating Democracy comes along invoking the metacategories of "community" and "civic dialogue," the danger for platitudes taking over really good critical work is extremely high. I count MACLA and me lucky that we had a real gritty project, with real people, and real issues to debate.

I do have one regret about the exhibit and that is that the works created were not in themselves more dialogic. I think the participants would have taken more risk with the art—or endorsed the artists taking more risks—if they had been more involved in the design of the exhibition and the installations. If, instead of being an audience to their own stories, they too would have been empowered as artists/creators, somehow. But I have a hard time imagining how I could have given Jones and Ahn that directive on top of all the other demands I placed on them. Nonetheless, there were things in this ambitious, wonderful project that went missing. Rosaldo is right in wishing that sounds and voices could have been heard. Maybe video is a better-suited medium than photography for a project of this nature. Matthews is right in urging for more explicit disclosure of the subtexts in the project that remained obscure to the gallery visitor. Rosenfeld is right in desiring that more public dialogues about the sociological differences between intermarriage in Silicon Valley and other areas could have taken place.

Rosenfeld also introduced in his essay a notion that I now find extremely fruitful for further investigation but that did not occur to me until I read his essay: mixed-race people and couples are "inadvertent performance art-ists of a sort." From a conceptual point of view, the analytical framework of "performativity" could be extremely interesting to examine intermarriage and mixed-race subjects. The literature and theory on performance is so well developed, especially in the context of themes of dissident sexualities and desire: how come I did not think of it before? In a practical, programmatic sense, many things could have been done through performance in the *Ties* project to explore the dynamics of intermarriage—from story circles to spo-ken word poets to plays, symposia, dance, testimonies, etc.

I am reminded, however, that whatever this ethnography and this exhibit cap-tured in this moment in time, in this cross-section of space and culture in San Jose, is what this project yielded and nothing more. With all of its flaws, it was

still far from being insignificant. The meaningfulness of this intervention resides precisely in the paradox of its promise and its limitations—in writing its own text and submitting it for scrutiny. In that sense, I am reminded that no matter how crafty and astute anthropologists, artists, and writers become at the art of representing or subverting "reality," the interventions of art/cultural scribes manipulate reality as much as deconstruct it.

[1] For a good treatment of this topic see Joli Jensen, *Is Art Good for Us? Beliefs about High Culture in American Life* (Lanham, MD: Rowman & Littlefield, 2002).

[2] An interesting meditation on this question can be found in: Arnd Schneider, "Uneasy Relationships: Contemporary Artists and Anthropology," in *Journal of Material Culture* 1, no. 2 (1996): 183–210.

Reflections on
Critical Perspectives

FROM WRITERS

Rodger Taylor My approach to writing about this project was different from most writing I've done. I wanted to and was asked to write a story about the project from my point of view, but I quickly realized that my involvement and my interest was totally related to the people in the community and the church. So I had to include other individuals because that's what the project means to me. I often find myself writing what I thought and experienced through my interpretations of what other people were saying to me. I also wanted to shape my experience through the prism of love for the history that the project represents because that's what makes it valid and interesting to me. That was the key to my involvement and motivation.

Lydia Matthews The lively exchange between all the participants in the *Ties That Bind* project has been eye opening, intellectually challenging, and creatively inspiring. I greatly appreciated the insightful critique offered by MACLA Executive Director Maribel Alvarez, who challenged me to think more precisely about the political position of community-based art spaces vis-à-vis mainstream institutions now eager to appropriate their collaborative, community-based practices in the name of an enlightened public art. Similarly, the stimulating discussion between artists and scholars who participated in the *Critical Perspectives* conference introduced me to a range of interdisciplinary approaches for exploring the nature of art in public space. However, there was one aspect of the project that most engaged me: in encountering such diverse ideas and sensibilities, I felt compelled to re-evaluate not only my own disciplinary assumptions, but the very reasons why I was attracted to the project in the first place. In other words,

the dialogic exchange inspired me to examine my ethical "stake" in writing about this very topic in new ways.

As part of the *Ties That Bind* project, MACLA provided me with 13 transcripts of the initial interviews between the artists, the Latino-Asian couples, and the anthropology/sociology scholars who participated in the process. During the interview process, all the participants sought common ground with one another by telling their biographical narratives: it was an "equalizing" device and the means of gaining insights and trust in one another. These stories were rich, textured, and diverse, sometimes filled with intimate and contra-dictory details about what it meant to be in a "mixed marriage" today. Each family member told his or her story as a proud but struggling agent of social change—each seemed extraordinarily self-conscious of being a witness to [his or her] own situation within contemporary history.

The experience of reading these transcripts inspired me to move beyond the role of socio-aesthetic voyeur—to consider how these "cross-cultural" and "inter-racial" identity issues have operated within my own life...to locate myself historically within this dialogue. I wanted to drive the project from MACLA's gallery in San Jose back to my home in San Francisco's Mission/Castro district, where I live within my own interethnic Greek-Jamaican/mixed race partnership. Working as a professor of visual cultural criticism at a local art college has made me acutely aware of how these cross-cultural dynamics operate in the contem-porary visual arena, as well as within my own life experience.

Jim O'Quinn I've had some varied and interesting writing assignments over the years—follow Clint Eastwood around a decaying mansion in the Louisiana swamp for an afternoon, describe a timber-cutters' strike against the International Paper Company without taking sides, talk a dozen opera divas into confessing their unfulfilled aspirations. But I've never taken on a more carefully structured or thoroughly thought-out writing task than that presented by the *Critical Perspectives* project. Certainly I've never had the benefit (or the challenge) of taking part in an organized, multiperspective, large-group discussion about the topic prior to the writing experience; nei-ther have I been part of a writing team whose mission is to reflect in depth upon a topic at hand from three different but interconnected perspectives.

Is this different from other critical writing I have done? Yes, in that I was hyper-aware throughout the process that the interface between art and community was of paramount importance to both the artists involved and those who had com-

missioned the essay. In fact, though, the only writerly techniques [my] essay uses to valorize that interface are straightforward reportage of it and the juxtaposition of meaningful quotations and related narrative—not particularly distinctive or innovative devices, an observation that leads me to suspect I have a great deal to learn about writing effectively in this mode. Surveying the notes from the San Francisco meeting, I can spot a dozen questions that I still don't know how to answer: How does a writer's voice create an implicit or explicit relationship with the reader? How to define this historic moment? Too many cooks?

Still, humanistic values and social issues have always been important in my writing—in that old Clint Eastwood feature, I remember a feisty sound bite about whether the movie he's filming will accurately depict the vagaries of Reconstruction; the strike story wore its leanings toward labor on a well-stitched sleeve of sympathetic adjectives; I even got some of the opera divas to wax political. The point is, I value and aspire to writing that is multidimensional, politically informed, and rooted in a principled point of view—which has made this assignment a rich and thought-provoking one.

David Rooks Here, near the end of this assignment, comes a light sense of accomplishment. Elsewhere, I have likened my attempts to write about civic dialogue and *The Dentalium Project* to mud wrestling with mad hens: a thousand urgent themes that cackled anarchy against all nests. So much to write about—but what to include? There came a time when, in conversation with Jim O'Quinn and Ferdinand Lewis, the two other writers involved, I quite confessed my utter sense of inadequacy to the task.

My reasons were three: (1) Inexperience. I had never written about art or civic-based dialogue, even peripherally, before. (2) Competing priorities. Dell'Arte's very existence was and is a wonderful revelation to me. Everyone I met, from Joan Schirle to Michael Fields to Julie Thompson, was generous and professional. My admiration for Dell'Arte was only deepened by my expressed dream of realizing some theatrical equivalent to Dell'Arte composed of and dedicated to Native Americans. Unfortunately, this deep desire incessantly impinged on my thinking about *The Dentalium Project*. Even now, I fear I was less than fair to the necessary efforts produced by the dialogues, play, and video that were *The Dentalium Project*'s substantial first fruits.

Reason three needs its own paragraph. Partly, it's a "why I became a writer" clause. I spent six years of my childhood in an Indian boarding school. Among the several emotional and psychological results was a fundamental antipathy to listening to

non-natives discounting and ignoring native experiences and, especially, native responses to their own experiences. Oddly, the most loathsome of these cultural imperialists were not the bordertown rednecks. Bedrock ignorance, however pernicious, can be written off. Rather, the more egregious and deepest cuts came from liberal patronizers who would inevitably paper over the innate dignity of Oglala Lakotas with an overweening sense of their own empathy and compassion. It continues to revolt. I became determined to speak for myself. So, too, I have long desired that authentic native voices everywhere retain custody of their lived history. In firm possession of that, they will own their present and future, too.

Unfortunately, *Wild Card*'s lack of a native voice made reason three the drooling uncle at the reunion during my writerly considerations.

Ferdinand Lewis All art in some sense talks about the time and place in which it was made, but in the case of arts-based civic dialogue, time and place talk back. The writer covering such work must listen in both directions at once, which is a painstaking process, to say the least. All art may be about what it means to live in the world, but civically engaged art is about what it means to live in a particular time and place in the world, and so as a writer I must begin by extending my research out into the community, both backward in time through local history and forward to its most pressing implications.

Writing about arts-based civic dialogue, I am listening to the very local voice of Blue Lake or Blue Gap or Brooklyn or Van Nuys, but also to where those places might echo out into the universe. Put another way, the challenge to the writer covering this work is to strategically deploy the specifics of the place-world out into the ether, giving particular human experiences a universal habitation and a name.

Civically engaged artists, whose subject matter is the place-world, take on civic responsibilities that other types of artists can, frankly, afford to ignore. Writing about arts-based civic dialogue, the writer wades almost as deeply as the artists into the civic and specific human concerns represented by the project. Those concerns are no less important than the project's aesthetics.

In a sense, while all art *includes* its audience (and critics) in a subjective experience, civically engaged art also *implicates* them. Patience is required. For the writer, covering arts-based civic dialogue may mean persistently listening, long after the actual project has ended, to those returning echoes of small events that shape the lives of a community, and its remarkable works of art.

FROM ANIMATING DEMOCRACY

Suzanne Lacy writes: "It's an imperfect art, this working in public, and its aesthetic hallmarks, when we learn to see them clearly, will be based on vulnerability and transparency and complexity."[1] As a writing experiment, *Critical Perspectives* seeks to expand the ideas of what criticism is. It poses questions about the relationship of the critic to the artist, and about the relationship of the artist and the critic to the community. It sees the critic more as a participant-observer—not just a consumer advocate or arbiter of quality, but, rather, someone who is involved in the process of cultural production, and who participates by bringing the work into the public's imagination. The *Critical Perspectives* experiment looks to jump-start new approaches to writing about civically engaged art, in an environment in which things can be tried, mistakes can be made, and learning can take place. Here are some of the lessons learned, questions raised, and implications surfaced through the *Critical Perspectives* process.

Of paramount interest is expanding who can and should be invited to write. Artists and project directors have critical insights into their own process and final work that can deepen the understanding of the work and yet they are rarely engaged to write. The contributions of the project leaders, almost overlooked in the *Critical Perspectives* plan, have turned out to be an essential part of the dialogue about the work.

A future direction suggested by the experience of the *Critical Perspectives* project is including more local community voices among the writers. As it turns out, with one exception, neither project directors nor Animating Democracy pressed in this direction. For the most part, the inclusion of local voices is an ideal that has been identified, but not fully realized. Future writing endeavors might push the envelope further by pursuing community participants as writers about the work.

Critical Perspectives also suggests a value in affording opportunity for writers to be in dialogue with each other. The extensive amount of interaction in the *Critical Perspectives* model promoted connection to the projects and to fellow writers, with the possibility of informing and enhancing the writing. But for a few writers used to working more independently, the collaborative exchange around writing drafts with project directors, fellow writers, and *Critical Perspectives* coordinators has not always been met with enthusiasm. In addition, the luxury of time, access, and resource that has made such a layered

process possible may not be easily replicable without the kind of time and money that has supported this effort.

"Who is the writing for?" The fundamental question of for whom the writing is intended remains unresolved. As Caron Atlas describes in her introduction, *Critical Perspectives* is concerned on the one hand that the writings have value for the project participants. *The Slave Galleries Project* writings, for example, have been used by the church to inform preservation advisors and will be drawn upon even more once the galleries are restored. On the other hand, the *Critical Perspectives* book is meant to advance field discourse about arts-based civic dialogue among readers such as artists, cultural organization leaders, arts critics, writers, journalists, and scholars in the disciplines represented by the writers. MACLA and Dell'Arte project directors envision that, in addition to potential community value, their writings are for artistic and scholarly fields. For whom is the writing intended remains an important question for future writing endeavors, affecting choice of writers and defining the purpose of the writing.

Who should curate such a writing process? *Critical Perspectives* provided funding to both the projects and the writers. Despite bending over backward to assure writers of their independence in what they write, the question has remained whether this independence is possible given the dynamics of relationships with the projects and the organization sponsoring or funding the opportunity. What might it look like if artists and communities created this process on their own behalf? What other approaches (i.e., curating by a magazine or other publication) might work?

Finally, the imperfections of the *Critical Perspectives* experiment reflect an aspiration toward new territory. The strength of the *Critical Perspectives* writing project, observes art critic and writer Patricia Phillips, is "its interdisciplinarity and attempts to make connections in meaningful ways between different fields and ideas." Exchange between writers from diverse backgrounds and perspectives has offered an invigorating experience. Being a part of *Critical Perspectives* has crystallized issues of accountability and raised questions for the writers about what might need to change in their writing; it has provided glimpses of possible new roles for critical writers—and elements of a possible new framework for critical writing.

Exploring a New Critical Framework
What would be the possible elements of an expanded critical framework for arts-based civic dialogue and other civically engaged art? As the field has

pursued this question in recent years, the fundamentals of critical practice: description (what does it look like?), analysis (how does it work?), interpretation (what does it mean?), and evaluation (does it succeed?) still hold true. What else is needed, however, to take into account the multidimensional nature of the work and its civic intents? To add to the discourse on this question, the experience of *Critical Perspectives* and the broader Animating Democracy initiative suggest the possibility that an expanded critical framework would:

Consider the civic/social dimensions of the work along with the aesthetic dimensions; and consider artistic process as well as the product as integral to civically engaged art. Those working in civically engaged art advocate for an integrative aesthetic language that considers the social dimensions and the public engagement processes that are fundamental to the concept, activity, intent, and form of this work. Rather than coming in at the end of a project, critical writers might be engaged early on and throughout the project in order to get a full view of its complexities and evolution.

Reconsider who can function in a critical role. The complexity of civically engaged art projects suggests the value of multiple perspectives by various writers rather than a single central authority. Critics are part of the larger discourse about civically engaged art but not the only ones who can contribute to its analysis. Artists, cultural essayists, anthropologists, community partners, and dialogue practitioners can all contribute to understanding of the work. Project participants, including artists and community members, are voices of reflection and critique, valued for their perspectives on the meaning and impact of the whole.

Expand the critic's relationship to a project. This might include the role of collaborator or advocate, as well as documenter, witness, or critic. Depending on the goals of critical writing, a writer might assume one or more roles. In a collaborative role, writer and project/artistic director might define a mutually beneficial relationship. Ferdinand Lewis proposes that writers consider the role of "advocate," balancing critique with an "asset oriented" approach to writing. Instead of looking for what's lacking, Lewis offers that writers reveal positive lessons and progress points even within the struggles or shortcomings of a civically engaged art endeavor.

These different roles of critical practice would require the writer to be in closer relationship to the work and its various players, rather than keeping the

expected critical distance. This more intimate relationship raises questions, however, regarding the subjective versus objective position of the critic in the interpretation of the work. Journalist David Rooks asks, "How much participation should writers have, and at what point does it interfere? Are there observational biases in the writers that *should* be welcomed into the dialogue?" As some experienced, the closer to the inside a critic gets, the more difficult it becomes to be objective.

Finally, while the writer's inside perspective offers an intimate and detailed account that can be useful to others—a kind of witnessing as Lydia Matthews suggests—it is also subject to potential pressure from internal relationships and power dynamics. Participants may be either less or more inclined to disclose things to someone who is "inside" the project. The writer may feel a more direct sense of accountability, which arguably all writers should embrace, but may also feel limited by knowing that he or she will have to live with the repercussions of what is made public.

Shift the language of evaluation from notions of "success" and "failure" to a more complex view of what is important: "value," "accountability," "effectiveness," and "risk taking," in addition to aesthetics. There are many other ways to approach the question of assessment, particularly of community-based or civically engaged art. Ben Cameron, executive director of Theatre Communications Group, suggests that, in reflecting on community-based work, critics should consider not only the aesthetic "quality" of artistic work, but the *value* of the overall project within its social context. In two 1998 editorials, Cameron emphasizes the need for artists to articulate their value to society, as opposed to focusing only on determinants of artistic quality.[2] The "value" of a project is understood as the extent to which it benefits a community. His emphasis on "project" also expands the critic's field of view beyond the product to include artistic/community *process*.

Critical Perspectives writers have been averse to the word "failure" when assessing the efficacy of civically engaged art efforts. The various aesthetic and civic intents embraced by projects and by a range of creators, organizers, partners, and participants means that efforts are likely to be more effective on some terms and less so on others. In addition, a single project may need to be considered in relation to the long-term efforts of an organization—what has happened before and what will happen after. Particularly for cultural organizations that are deeply a part of a community, the ability to present programs over months or years can mitigate against the individual

success or failure of a particular effort. Where one project may be more effective than another, the long view gives perspective on the cumulative effect of the work.

Assessing the impact a project has on community or civic life is one of the key challenges of writing about this work. Both artists and cultural organizations become keenly aware of the ethical and political issues that a project raises and the repercussions of their artistic process and product. Accountability to those civic interests is seen as a key evaluative criterion.

An expanded critical framework would consider effectiveness in relation to original intent and planning, but also in relation to what actually happened. The essays by Renato Rosaldo and Maribel Alvarez about *Ties That Bind* get at the complex negotiation of artistic and civic expectations and realities. According to Alvarez, respectful restraint on the part of the artists in the treatment of personal information—that on the one hand limited the intensity of the artistic statement—also contributed to the success of the artwork in opening up a lively dialogue about social identity.

Consider the degree to which artists, organizers, and even community partici-pants take risk to advance civic and aesthetic goals, and how responsibly they do so. Risk is inherent in developing art with civic intent; some degree of risk taking is necessary to realize social, civic, and/or artistic goals. Artists and cultural organizations take risks sometimes by virtue of taking on a civic issue in the first place, by reframing it, or by forming challenging partner-ships. They take risks in terms of aesthetic choices, content, and form. In different contexts, artistic provocation or artistic restraint could each be considered a risky approach.

Because civically engaged art efforts touch real people who are affected by issues, some actions may jeopardize trust, destabilize relationships, or exac-erbate issues as much as they may lead to new and exciting artistic forms or increased understanding about an issue. Therefore, *Critical Perspectives* writ-ers view risk taking as a factor to consider when assessing effectiveness of the work; weighing outcomes against the desire to break through aesthetic and/or civic boundaries in some way. Just as artists and organizations antici-pate and weigh the potential for positive or negative effects, it is crucial for writers to understand these risks as well in order to fairly assess the efficacy of civically engaged art and to produce writing that is at once generous, gen-erative, and challenging.

EFFICACY AND EXCELLENCE

Artists, cultural organizers, and critics versed in civically engaged art argue that it is possible to articulate standards of excellence for this work and the integrity of aesthetic assessment relies on an understanding of the forms and meaning of that work. The experience of *Critical Perspectives* and Animating Democracy suggests some ways to think about efficacy and excellence.

Civically engaged art that is effective on *aesthetic* terms:

> *Offers a compelling artistic/cultural vision.* There is clarity of artistic intent and a philosophical basis for the work. The choice of creative process and/or form is well suited to aesthetic and civic goals. Program design is responsive to the needs of the community while also advancing the artist's own aesthetic investigation. The work is engaging, imaginative, innovative, and culturally relevant.

> *Reflects rigor according to standards relevant to the artistic or cultural form.* The work demonstrates excellence in skill and craft. Cultural work is authentically grounded in tradition and/or contemporary artists' work as appropriate to the effort.

> *Embraces risk taking in creation, programming, and/or connecting art/culture with audiences that allows new possibilities to develop and advances artistic/cultural vision.* Artists, cultural leaders, and project partners embrace tensions inherent in the relationship between fostering meaningful dialogue/civic engagement and maintaining the integrity of the creative work (i.e., what's the best way to present the art and the dialogue?).

> *Stimulates audiences, the public, stakeholders, and/or participants to draw meaning from the artistic experience.* Civic intent may enhance appreciation for the artistic work, and deepen its meaning.

Civically engaged art that is effective on *civic* terms:

> *Demonstrates integrity of intent and accountability in execution to partners, participants, and others involved.* The work effectively considers relevant historical/social/civic contexts. It operates from intimate knowledge of the community(ies) affected by the project. The organization or artist is able to identify and work with partners toward authentic mutual benefit and is sensitive to issues of authority, ownership, and power.

> *Engages the intended publics or participants in meaningful civic dialogue and/or other forms of civic participation.* Artistic choices in terms of form, content, and presentation of the work deepen meaning around the civic issue. The effects of civic engagement may be at a personal level or systemic level.

> *Is valued by the people for whom the project is most intended.* Stakeholders, participants, and public(s) find meaning in the work, value it, and see it as relevant to and reflective of their interests and concerns.

Consider the power issues embedded in the writer-practitioner relationship and emphasize the critic's own accountability in relation to the impact of his or her work. Writers call upon themselves to be conscious of the impact of their writing, particularly when projects may be less than effective. Jack Tchen asks, "How comfortable do we feel airing out complicated issues that fix the way in which the artists and other players are characterized?" Renato Rosaldo agrees that it's not about jumping on a group for what went wrong, but trying to look ahead to what could be done in the future—taking the larger view without diminishing standards or rigor.

We look forward to continued learning from the *Critical Perspectives* experiment and from the experiments of others in order to go beyond present limitations—to continue to expand the framework for writing about civically engaged arts and humanities.

[1] Suzanne Lacy, "Seeking an American Identity (Working Inward from the Margins)," essay commissioned by Animating Democracy (Washington, DC: Americans for the Arts, 2003). http://www.AmericansForTheArts.org/AnimatingDemocracy

[2] Ben Cameron, "The Missing Link," *American Theatre* (November 1998): 6. Idem, "Essential Values," *American Theatre* (December 1998): 6.

Contributors

Maribel Alvarez co-founded and was executive director of MACLA—an alternative contemporary Latino arts space in San Jose, California—from 1996 to 2001. Under her leadership, MACLA achieved national recognition by The Andy Warhol Foundation as one of the most effective alternative art spaces in the nation. She is also an anthropologist, folklorist, and curator who holds a dual appointment as assistant research professor at both the University of Arizona's Southwest Center and English Department. She was born in Cuba, grew up in Puerto Rico, has done ethnographic fieldwork in northern Mexico, and has been involved in the Chicano arts movement for more than 20 years. Maribel serves on the Board of Borderlands Theater in Tucson and on the board of the more than 30-year-old folklife festival, "Tucson Meet Yourself." She is on the faculty of the annual Leadership Institute of the National Association of Latino Arts and Culture (NALAC). In 2005, she completed a study for Cultural Initiatives Silicon Valley, assessing the relationship between the nonprofit arts sector and the informal, amateur, and avocational arts practiced in the Silicon Valley region. Her book, *Mexican Curios: Performing Folklore at the U.S.–Mexico Border*, is forthcoming from the University of Arizona Press.

Caron Atlas is a Brooklyn-based freelance consultant working to strengthen connections between community-based arts, policy, and social change. Caron was the founding director of the American Festival Project and worked for several years with Appalshop, an Appalachian multidisciplinary arts and education center. She was the Animating Democracy liaison with Cornerstone Theater Company, Intermedia Arts, Social and Public Art Resource Center (SPARC), and Urban Bush Women, and coordinated Animating Democracy's *Critical Perspectives* reflective writing program. She is co-editor of *Critical Perspectives: Writings on Art and Civic Dialogue*. Caron has recently been a consultant for the Ford Foundation; Creative Capital Foundation; 651 Arts: A Cultural Blueprint for New York City; and National Voice, a civic participa-

tion coalition. Caron writes frequently about cultural policy and is an adjunct faculty member at New York University's Tisch School of the Arts. She has a master's degree from the University of Chicago and was a Warren Weaver fellow at the Rockefeller Foundation.

Barbara Schaffer Bacon co-directs Animating Democracy, a program of Americans for the Arts that fosters civic engagement through art and culture. Barbara has worked as a consultant since 1990, prior to which she served as executive director of the Arts Extension Service at the University of Massachusetts at Amherst. Her work includes program design and evaluation for state and local arts agencies and private foundations nationally. Barbara has written, edited, and contributed to several publications, including *Civic Dialogue, Arts & Culture: Findings from Animating Democracy, Animating Democracy: The Artistic Imagination as a Force for Civic Dialogue, Fundamentals of Local Arts Management,* and *The Cultural Planning Work Kit.* Barbara has served as a panelist and adviser for many state and national arts agencies. She is president of the Arts Extension Institute, Inc., a board member of the Fund for Women Artists, and an elected member of her local school committee.

Lisa Chice is director of public programs at the Brooklyn Historical Society. As interpretation associate at the Lower East Side Tenement Museum (LESTM), she coordinated and performed outreach for the Lower East Side Community Preservation Project. At LESTM, Lisa also managed research for the *NY Times Guide for Immigrants in New York City* (2004) and administered a website for the International Coalition of Historic Site Museums of Conscience. As a program assistant for the National Trust for Historic Preservation, Lisa coordinated the Northeast Region's Emerging Preservation Leaders Program, an effort to provide scholarships and training to community leaders in order to help them work to preserve local places. She reviewed and processed applications to the National Trust grant programs, Save America's Treasures designation program, and J. Paul Getty grants. Her involvement in the membership-based Asian American Resource Workshop (AARW) included organizing the first annual meeting of the Asian Pacific American Agenda Coalition and Campaign to Protect Parcel C, the last parcel of community space in Boston's Chinatown. She served on the AARW board in 2000. Lisa received her B.A. and B.F.A. from Tufts University and the School of the Museum of Fine Arts, Boston, in 1994.

Michael Fields is a founding member and the producing artistic director of Dell'Arte, as well as the producing director for the Dell'Arte Mad River Festival. He is currently the director of the California State Summer School

for the Arts Theatre Program, the president of the American Center of the International Theatre Institute, and a member of the board of directors of Theatre Communications Group. He is a former resident director of Het Vervolg Theatre of Holland. Michael has taught at the American Conservatory Theatre, the California Institute for the Arts, the Dutch National Theatre School, and the Danish Dramaturg Institute. He has directed productions nationally and internationally, including a new adaptation of *A Clockwork Orange* in Aarhus, Denmark. He received Dramalogue awards in 1984 and 1986, and a 1984 San Francisco Bay Area Critics award. He holds a B.A. in communication arts from the University of San Francisco and an M.F.A in directing from Humboldt State University.

John Sophiea Fiscella is a community artist and teacher. He recently co-curated the photo exhibit *Looking for Palestine: Historical Images by Hanna Safieh* with Anna Sloan. Presently, he is working on a program of performance pieces in association with writers Adania Shibli, Amani Elkassabani, and writer-filmmaker Mahmoud Kaabour. An editor in the fields of cultural and performance studies, he has been an editor of Animating Democracy publications since its inception.

Lorraine Johnson-Coleman is a nationally respected consultant in the areas of cultural preservation and community programming who counts the Kellogg Foundation, National Parks Service, and National Trust for Historic Preservation among her clients. Known for her "down home wisdom," Lorraine is a regular contributor to NPR's *Morning Edition*. In addition to her consulting work, Lorraine is a sought-after speaker in the field of heritage preservation and the best-selling author of three books on Southern culture. Lorraine's first book, *Just Plain Folks*, was a November 1998 featured selection of the Literary Guild. The audio book edition, in which she performed the stories, won a 1998 *Publishers Weekly* Listen Up Award. The "Tale Tellin' Blues" episode of the nationally aired *Just Plain Folks* public radio series won a 1999 Crystal Jade Award of Excellence from the Communicator Awards. Her most recent literary work, *Larissa's Breadbook*, is a celebration of the diversity of American culture through two of its staples—storytelling and food. Journeys Home™: An African American Heritage and Cultural Arts Initiative, developed by Lorraine, has been recognized as a national model for cultural preservation and heritage tourism development. Implemented in Battle Creek, MI, Lorraine is working on the initiative with 15 counties in the states of Louisiana, Mississippi, and Arkansas as part of the Kellogg Foundation Mid-south Delta Initiative. Lorraine also tours nationally in a one-woman show of comedy, storytelling, and poetic narrative based on her work.

Pam Korza co-directs Animating Democracy, a program of Americans for the Arts that fosters civic engagement through art and culture. In addition to coediting *Critical Perspectives: Writings on Art and Civic Dialogue,* she is co-writer of *Civic Dialogue, Arts & Culture: Findings from Animating Democracy.* She provided research for and co-wrote—with Barbara Schaffer Bacon and Cheryl Yuen—the launching study, *Animating Democracy: The Artistic Imagination as a Force in Civic Dialogue.* Pam worked with the Arts Extension Service at the University of Massachusetts at Amherst (AES) for 17 years. There she coordinated the National Public Art Policy Project in cooperation with the Visual Arts Program of the National Endowment for the Arts, which culminated in the book *Going Public: A Field Guide to Developments in Art in Public Places,* which she co-wrote and edited. She was co-editor and contributing writer to *Fundamentals of Local Arts Management,* also published by AES. She directed the Boston-based New England Film and Video Festival, a regional independent film festival.

Ferdinand Lewis is an Irvine Doctoral Fellow at the University of Southern California's School of Policy, Planning and Development, where he studies urban planning and lectures in methods of inquiry. Ferdinand is a member of the adjunct faculty at USC's School of Fine Arts Public Art Studies Program, where he teaches art as community development. He served on the faculty at California Institute of the Arts for 10 years, during which time he also worked as a freelance consultant and writer on various projects. Ferdinand is the author of the forthcoming book, *Ensemble Works: An Anthology,* from TCG Publishers. As a journalist, his writing has appeared in the *Los Angeles Times* and *Daily Variety,* as well as in the magazines *American Theatre, Animation, Logik,* and *Audio Media,* and on websites for Discreet and the Community Arts Network. Ferdinand was a founding member of the Los Angeles-based theater company Ghost Road, and is the author of three plays, including *Note From the Bottom of a Well* which he developed for Cornerstone Theater Company's Festival of Faith.

Lucy R. Lippard is a writer, activist, and author of 20 books on contemporary art and cultural criticism, including one novel. Her books include: *The Lure of the Local; On the Beaten Track: Tourism, Art, and Place; Mixed Blessings;* and *Overlay: Contemporary Art and the Art of Prehistory.* She has been a columnist for the *Village Voice, In These Times,* and *Z Magazine.* For 30 years she has worked with artists' groups such as the Artworkers' Coalition, Ad Hoc Women Artists Meeting for Cultural Change, and the Alliance for Cultural Democracy. She was co-founder of Heresies, Printed Matter, PADD (Political Art Documentation/ Distribution), and Artists Call Against U.S. Intervention in Central America. Lucy has done political comics, performances, street theater, and has curated

some 50 exhibitions in the United States, Europe, and Latin America. Lucy graduated from Smith College (B.A., 1958) and the New York University Institute of Fine Arts (M.A. in Art History, 1962), and has received Honorary Doctorates in Fine Arts from the Moore College of Art, the San Francisco Art Institute, the Maine College of Art, and the Massachusetts College of Art, as well as a Guggenheim Fellowship, the Frank Jewett Mather Award for Criticism from the College Art Association, and two National Endowments for the Arts grants in criticism, among other distinctions. She is a research associate at the Museum of Indian Arts and Culture/Laboratory of Anthropology in Sante Fe, NM. At home in Galisteo, NM, she has served as member of the Santa Fe County Open Land and Trails Planning and Advisory Committee and edits her community newsletter. She received a Lannan Foundation Completion Grant for a book on the Galisteo Basin.

Lydia Matthews is an educator, writer, curator, and arts activist based in San Francisco. She received a B.A. in interdisciplinary studies at The Colorado College in 1981 and completed her graduate studies in art history at the Courtauld Institute of Art in London, England and the University of California, Berkeley. In 1994, Lydia was Public Programs Director at Headlands Center for the Arts, where she curated programs that brought together artists, scholars, and political activists to discuss community-based interdisciplinary art projects flourishing in urban areas. As associate professor of art history at California College of the Arts (CCA), she co-founded and currently directs CCA's Graduate Studies in Visual Criticism Program. Her graduate and undergraduate courses address contemporary visual culture and critical theory, with a special emphasis on artists who create frameworks for social interactions within the public sphere. Lydia's publications include *Site to Sight: Mapping Bay Area Visual Culture* (1995), which charts the histories and curatorial practices of local art exhibition spaces, from small-scale, artist-run venues to major museums. Her critical essays and reviews have appeared in a variety of journals, including *The Drama Review, Camerawork: A Journal of Photographic Arts,* and *Arcade.* Lydia has lectured nationally and internationally and is an educational advisor at the San Francisco Museum of Modern Art, *Southern Exposure,* and the Luggage Store Gallery. She also serves on the curatorial board of SF Camerawork Gallery.

Jim O'Quinn has served as editor-in-chief of *American Theatre* since the monthly national arts magazine, published by Theatre Communications Group, was founded in 1984. He has also been editor of the biannual *Journal* of the Stage Directors and Choreographers Foundation; managing editor of *The Drama Review;* and editor and publisher of *The DeQuincy Journal,* an award-winning weekly

newspaper in southwest Louisiana. Jim reviewed theatre regularly for the now-defunct Manhattan weekly, *7 Days*, and his articles and reviews have appeared in *Stagebill, Theatre Heute, Tatler, High Performance,* and other publications. He has also worked as a city-desk reporter for the *New Orleans Times Picayune*, and as a composer and music arranger for theatre. Jim's children's opera, *The Littlest Emperor*, was produced in 1978 at New Orleans's Contemporary Arts Center.

David Rooks is executive director of Loneman School Foundation, a nonprofit organization on the Pine Ridge Indian Reservation in southwestern South Dakota. Among other projects, the foundation seeks to fuse modern performing and media arts with current Lakota culture to give voice to rapidly changing native experiences. The hope is that these tools can then be integrated into local school curricula. An enrolled member of the Oglala Sioux Tribe, he was born in Phoenix, AZ, March 21, 1956. He attended Red Cloud Indian School where he graduated in 1974. His next ten years were spent kicking about in various, mostly itinerant "professions." From oilfield hand to railroad track-gang member, the pay was decent, the future nonexistent. After a five-year stint in the Army, with the GI Bill, and honorable discharge, for the past 10 years he has worked as an area journalist chronicling life in western South Dakota. He was a senior staff writer for *Indian Country Today* and an Op Ed and Life & Style columnist for the *Rapid City Journal*. He and his wife, Sandra, have six children and currently reside in the southern Black Hills near Hot Springs, SD, where he continues to work as a freelance writer.

Renato Rosaldo is professor of anthropology at New York University. Rosaldo's published works include: *Ilongot Headhunting, 1883–1974: A Study in Society and History* (1980); and *Culture and Truth: The Remaking of Social Analysis* (1989). His co-edited work, *The Inca and Aztec States, 1400–1800: Anthropology and History,* appeared in 1982, and *Anthropology/Creativity* appeared in 1993. Based on field research in San Jose, CA, Renato contributed the introduction and an article to *Latino Cultural Citizenship: Claiming Identity, Space, and Rights* (1997). Rosaldo has served as president of the American Ethnological Society, director of the Stanford Center for Chicano Research, and chair of the Department of Anthropology at Stanford University. He is a member of the American Academy of Arts and Sciences. Renato's bilingual volume of poetry, *Prayer to Spider Woman/Rezo a la mujer araña*, received an American Book Award from the Before Columbus Foundation in 2004.

Michael J. Rosenfeld is an assistant professor of sociology at Stanford University. He has just completed the manuscript for his book, *The Age of*

Independence, about the changing American family and the rise of interracial and same-sex unions. *The Age of Independence* argues that young adults in the U.S. are more independent from their parents than ever before, and that the independent life stage is one reason for the increased diversity of American families. Michael had former lives as a freelance journalist and as a political activist.

Rodger Taylor Born in Brooklyn. Grew in New York City. Music, poetry, songwriting, and writing are passions. Public Librarian supervising downtown branch in Manhattan, Hamilton Fish Park Library. Wife best pal. Married since 1985, father. Got a great son. Loves jazz and the history of African American New York and history. Discovery of the African Burial Ground. Wrote about, went down there often, sponsored and recorded events at the archeological site; liaison for State Senator Paterson's Public Over-site Committee. Likes to jog but doesn't. Published *New York Newsday Part II Magazine*, etc., speaking and performing engagements, schools, church, a few television and radio interviews. Co-author of *Albert Einstein on Race and Racism,* a Rutgers University Press publication due to be released in July 2005. Started local history website for teens and others.

John Kuo Wei Tchen is a historian and cultural activist. Since 1975, he has been studying interethnic and interracial relations between Asians and Americans, helping to build cultural organizations and research collections, and exploring how dialogue in the humanities and society can deepen the quality of public discourse and policy. John is currently the founding director of the Asian/ Pacific/American Studies Program and Institute at New York University. He is an associate professor of the Gallatin School for Individualized Study and associate professor in History Department of the Faculty of Arts and Sciences at NYU. In 1980, he and Charles Lai co-founded the New York Chinatown History Project. Since its inception, this project has enabled the largest Chinese settlement outside of Asia to document and explore its 160-year-long history. Renamed the Museum of Chinese in the Americas, the museum has broadened its scope to document, analyze, and compare the diaspora of settlers and sojourners in the Caribbean, along with North, Central, and South America. John's most recent book is the award-winning *New York Before Chinatown: Orientalism and the Shaping of American Culture, 1776–1882.* His 1984 book, *Genthe's Photographs of San Francisco's Old Chinatown,* won an American Book Award from the Before Columbus Foundation. His recent exhibit, "Archivist of the 'Yellow Peril': Yoshio Kishi Collecting for a New America," highlights items from a major research collection that will be hosted by NYU. He has also written and spoken on museums, immigration, race relations, New York City, and cross-cultural studies.

ILLUSTRATIONS

THE DENTALIUM PROJECT
Project Overview
page 1
Michael Fields as Buddy O'Hanlan.
Wild Card, June 2002.
Photo © Carol Eckstein.

Notes on *Wild Card*
page 5
"It Sucks for Jane," a song about
living on the road to the casino.
Wild Card, June 2002.
Photo © Carol Eckstein.

page 10
Dead aunt Dorothy Dugan
encourages citizens to take action.
Wild Card, June 2002.
Photo © Carol Eckstein.

**"To save paradise
they put up a parking lot"**
page 15
The Blue Lake City Council
portrayed as a boy band.
Wild Card, June 2002.
Photo © Carol Eckstein.

**The Arts and Development:
An Essential Tension**
page 25
The No Lake Players in
"We Got a Grant!"
Wild Card, June 2002.
Photo © Carol Eckstein.

page 36
A reprised *Wild Card* includes
a Native American character.
Wild Card 1.5, June 2003.
Photo © Carol Eckstein.

A Response to the Essays
page 43
"Tomorrow Belongs to Me"
Wild Card, June 2002.
Photo © Carol Eckstein.

page 50
Finale. Dell'Arte.
Wild Card, June 2002.
Photo © Carol Eckstein.

THE SLAVE GALLERIES PROJECT
Project Overview
page 53
View of the west slave gallery
located behind the balcony as
seen from the front of St.
Augustine's Church, 2005.
Photo © Hector Peña.

The Colors of Soul
page 59
Narrow stairs leading up
to the west slave gallery, 2005.
Photo © Hector Peña.

page 65
Bleachers in the west
slave gallery, 2005.
Photo © Hector Peña.

St. Augustine's Church
Slave Galleries Project
page 69
A view from the balcony of the east
and west slave galleries, 2005.
Photo © Hector Peña.

page 75
Deacon Hopper with a group of
visitors in the west slave gallery,
2005. Photo © Hector Peña.

Freedom's Perch: The Slave Galleries and the Importance of Historical Dialogue

page 83
Perspective from the west slave gallery looking down to the sanctuary of St. Augustine's Church, 2005.
Photo © Hector Peña.

page 97
A community member responds to the slave galleries, 2005.
Photo © Hector Peña.

Building Upon a Strange and Startling Truth
page 99
A group of students experience the west slave gallery, 2005.
Photo © Hector Peña.

page 104
Deacon Hopper addresses a group of students in the west slave gallery, 2005.
Photo © Hector Peña.

TIES THAT BIND
Project Overview
page 107
Hanging Wall of Photos, including small caches of organic materials and eating utensils hanging from the edge.
Ties That Bind, MACLA, 2002.
Photo © Bubu Alvarez.

Intermarriage and Public Life
page 109
Photo installation by Jennifer Ahn and Lissa Jones representing a Korean mother dressing her Mexican-Korean daughter in traditional Korean dress.
Ties That Bind, MACLA, 2002.
Photo © Bubu Alvarez.

Ties That Bind/Ties That Bond: A Community-Based Art Project in Silicon Valley
page 121
The first photograph to greet visitors in the gallery.
Ties That Bind, MACLA, 2002.
Photo © Bubu Alvarez.

page 123
Stained Sheets installation by Jennifer Ahn.
Ties That Bind, MACLA, 2002.
Photo © Bubu Alvarez.

The Social Life of an Art Installation
page 135
Detail of *Deep Fry Strainers*, by Jennifer Ahn and Lissa Jones. Strainers are covered with silk in which photos of the families have been impressed.
Ties That Bind, MACLA, 2002.
Photo © Bubu Alvarez.

Dialogic Gestures: Doing Artistic Things with Ethnographic Methods
page 141
Shadowbox, by Jennifer Ahn and Lissa Jones.
Ties That Bind, MACLA, 2002.
Photo © Bubu Alvarez.

page 148
Detail of the installation, by Jennifer Ahn and Lissa Jones.
Ties That Bind, MACLA, 2002.
Photo © Bubu Alvarez.

ABOUT AMERICANS FOR THE ARTS AND
ANIMATING DEMOCRACY

AMERICANS FOR THE ARTS is the nation's leading nonprofit organization for advancing the arts in America. With more than 40 years of service, it is dedicated to representing and serving local communities and creating opportunities for every American to participate in and appreciate all forms of the arts.

To learn more about programs, membership, and how you can support Americans for the Arts, call 202.371.2830 or visit www.AmericansForTheArts.org.

ANIMATING DEMOCRACY, a program of Americans for the Arts' Institute for Community Development and the Arts, fosters arts and cultural activity that encourages and enhances civic engagement and dialogue. Animating Democracy is a resource for linking the arts and humanities to civic engagement initiatives. Animating Democracy helps to build the capacity of artists and cultural organizations involved in a wide sphere of civic engagement work through programs and services, including:

- A website providing practical and theoretical resources related to the arts as a form and forum for civic engagement and dialogue;
- Referrals of artists and cultural institutions experienced in designing creative civic engagement and dialogue programs on a wide array of contemporary issues;
- Learning exchanges and professional development programs that offer opportunities to learn and share practices and innovative methods in arts-based civic dialogue/ engagement work;
- Technical assistance and consultation for museums, historic sites, and community groups seeking to develop arts- and humanities-based civic engagement initiatives; and
- Publications featuring books, essays, and reports exploring arts- and humanities-based civic engagement.

For more information about Animating Democracy call 202.371.2830 or visit www.AmericansForTheArts.org/AnimatingDemocracy.

OTHER PUBLICATIONS FROM ANIMATING DEMOCRACY

Critical Perspectives is a publication of Animating Democracy, a program of Americans for the Arts, which seeks to foster civic engagement through arts and culture. Other Animating Democracy publications include:

CIVIC DIALOGUE, ARTS & CULTURE: FINDINGS FROM ANIMATING DEMOCRACY (2005)

ART & CIVIC ENGAGEMENT SERIES (2005)

Dialogue in Artistic Practice: Case Studies from Animating Democracy

Hair Parties Project, Urban Bush Women

Faith-Based Theater Cycle, Cornerstone Theater Company

An Aesthetic of Inquiry, an Ethos of Dialogue, Liz Lerman Dance Exchange

Cultural Perspectives in Civic Dialogue: Case Studies from Animating Democracy

King Kamehameha Statue Conservation Project, Hawai'i Alliance for Arts Education

African in Maine, Center for Cultural Exchange

Arte es Vida, The Esperanza Peace and Justice Center

Museums and Civic Dialogue: Case Studies from Animating Democracy

Gene(sis):Contemporary Art Explores Human Genomics, The Henry Art Gallery

Mirroring Evil: Nazi Imagery/Recent Art, The Jewish Museum

The Without Sanctuary Project, The Andy Warhol Museum

History as Catalyst for Civic Dialogue: Case Studies from Animating Democracy

The Slave Galleries Restoration Project, St. Augustine's Church and the Lower East Side Tenement Museum

Traces of the Trade, Katrina Browne and the Rhode Island Council for the Humanities

The Without Sanctuary Project, The Andy Warhol Museum

Art, Dialogue, Action, Activism: Case Studies from Animating Democracy

Common Threads Theater Project, Arts Council of Greater Lima

Agents & Assets, Los Angeles Poverty Department

Arte es Vida, The Esperanza Peace and Justice Center

Understanding Neighbors, Out North Contemporary Art House

ANIMATING DEMOCRACY: THE ARTISTIC IMAGINATION AS A FORCE IN CIVIC DIALOGUE (1999)

To order these publications, visit the Americans for the Arts online bookstore: www.AmericansForTheArts.org/bookstore

Visit the Animating Democracy website for other case studies and writings on art and civic dialogue. www.AmericansForTheArts.org/AnimatingDemocracy